MW00783735

能・狂言面

北澤秀太

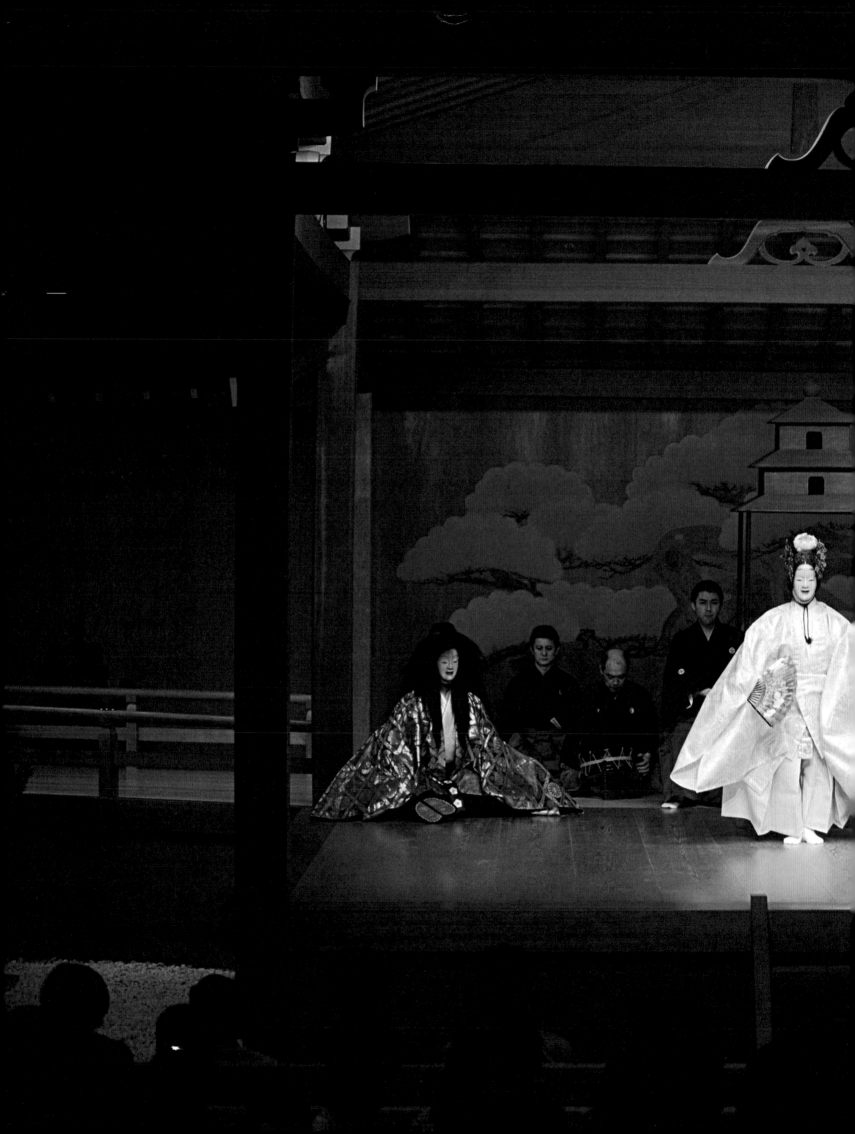

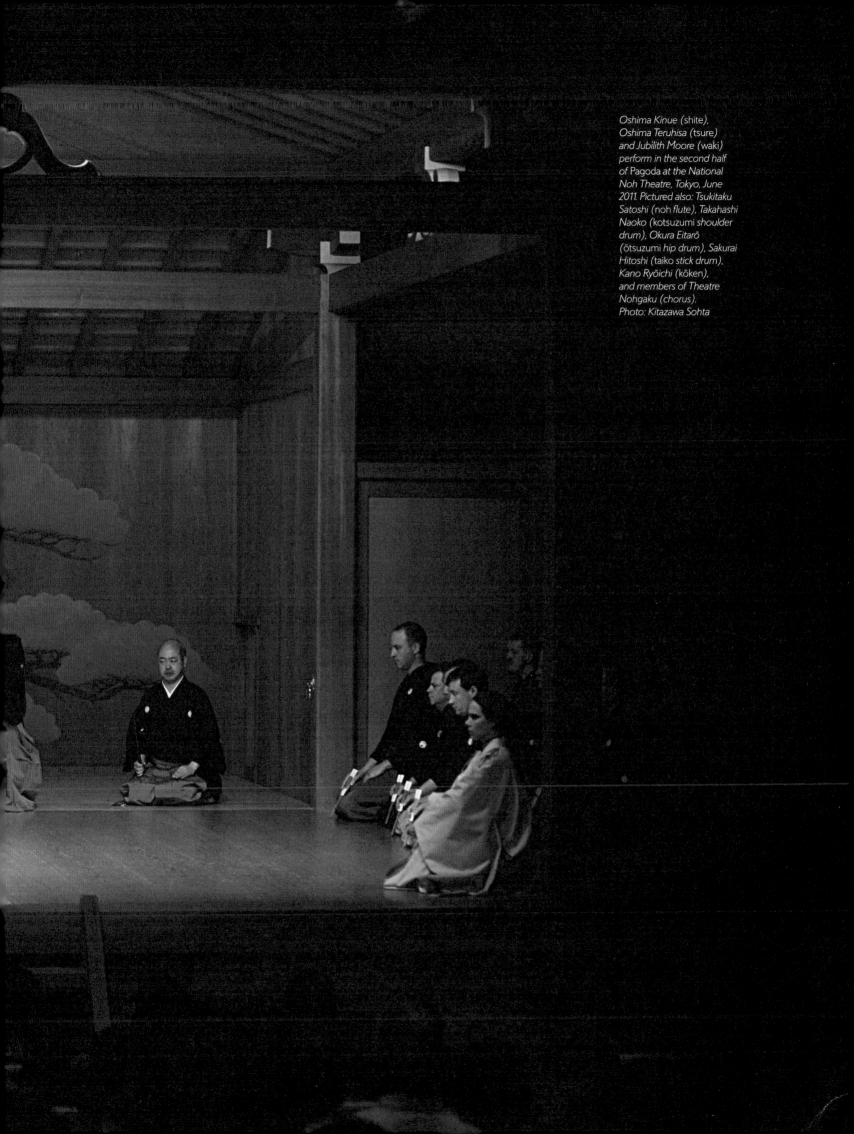

*Oshima Kinue (shite),
Oshima Teruhisa (tsure)
and Jubilith Moore (waki)
perform in the second half
of Pagoda at the National
Noh Theatre, Tokyo, June
2011. Pictured also: Tsukitaku
Satoshi (noh flute), Takahashi
Naoko (kotsuzumi shoulder
drum), Okura Eitarō
(ōtsuzumi hip drum), Sakurai
Hitoshi (taiko stick drum),
Kano Ryōichi (kōken),
and members of Theatre
Nohgaku (chorus).
Photo: Kitazawa Sohta*

written and edited by
Jannette Cheong and Richard Emmert

mask commentary contributions by Kitazawa Hideta
mask photography by Kitazawa Sohta
design by Jannette Cheong

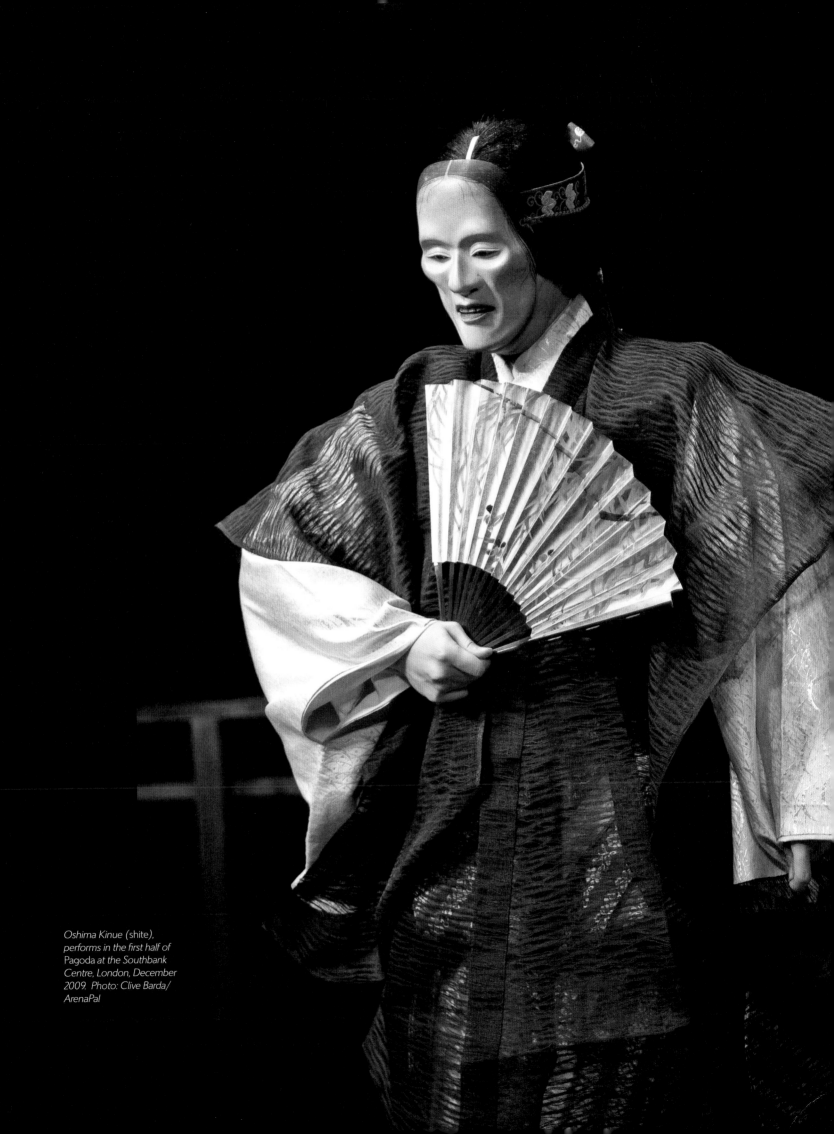

Oshima Kinue (shite), performs in the first half of Pagoda at the Southbank Centre, London, December 2009. Photo: Clive Barda/ ArenaPal

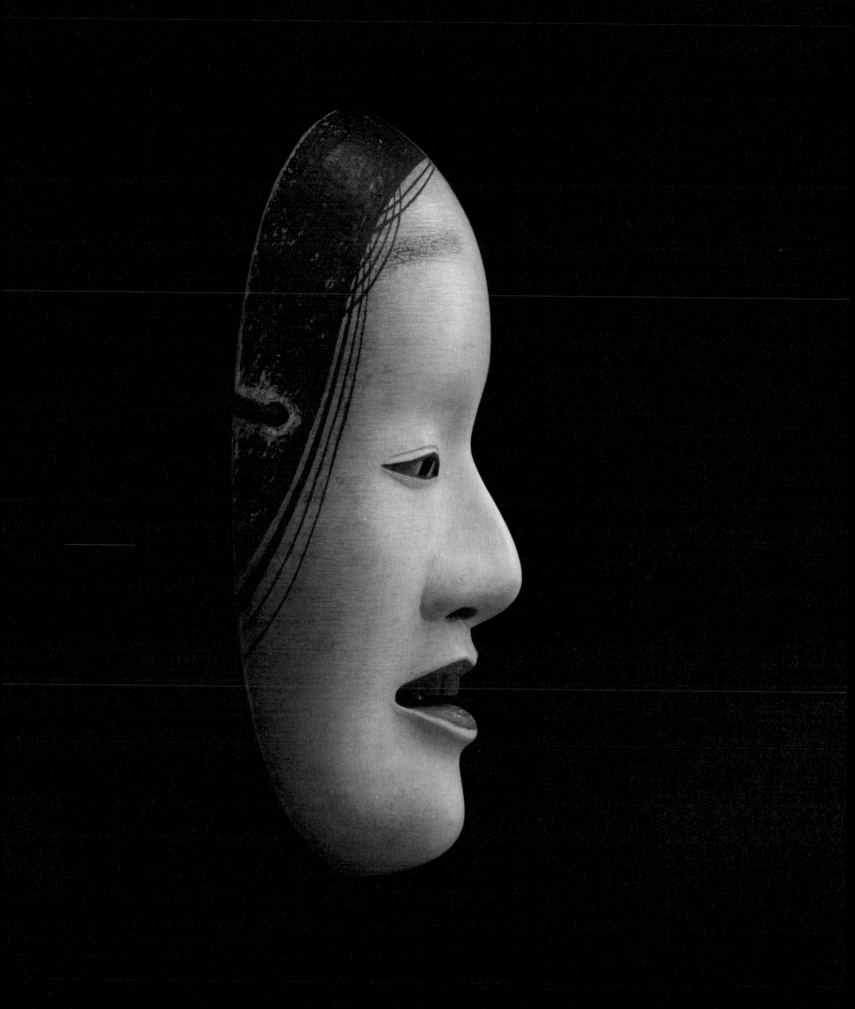

NOH AND KYOGEN MASKS

TRADITION AND MODERNITY IN THE ART OF KITAZAWA HIDETA

a Japanese traditional craftsman
of classical and contemporary noh

PRESTEL

Munich • London • New York

Contents

'Traditional culture consists of a treasure trove of wisdom from our ancestors.'

Oshima Kinue
Kita School Noh Actor

Oshima Kinue performing the
Spirit Mother in Pagoda, December 2009.
Photo: Clive Barda/ArenaPal

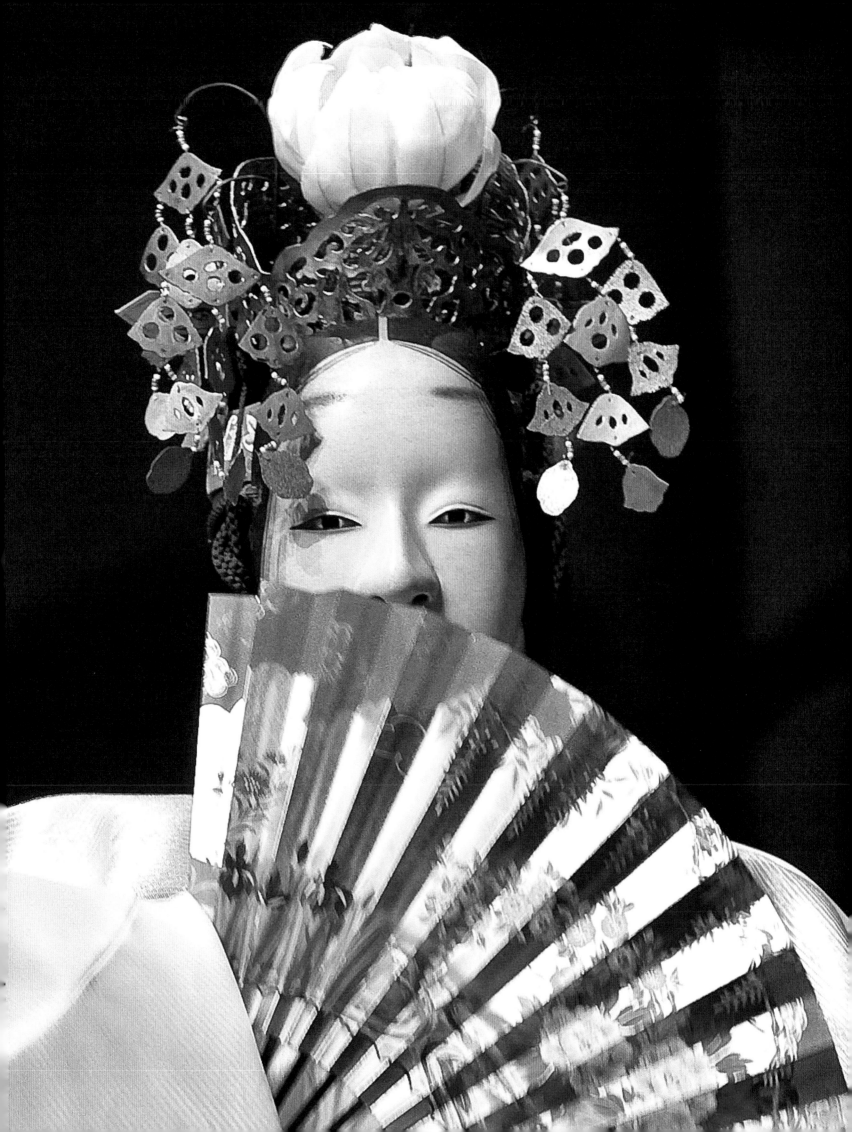

Foreword

In the presence of masks, few people fail to feel their power, sometimes unsettling, sometimes liberating. As old as humankind itself, they are to be found in every culture; in many societies, notably in Africa and India, they remain central to religious practices. They are among the most striking manifestations of Inca and Aztec civilisations, those of the Incas radiantly embodying their worship of the sun; and even now, in the 21st century, every November Mexicans celebrate the *día de los muertos* by donning skull-like masks. Merely to be in the presence of any of these masks is to feel oneself directly in touch with what Carl Jung called the collective unconscious, the deeply submerged impulses and understandings common to us all.

But masks are not confined to the sacred. The profane world of performance also avails itself of this high road to the inner life. Masks are integral to two of the most influential traditions of theatre in the West – the classical Greek theatre, both comic and tragic, and the Italian *commedia dell'arte*. In these traditions, masks crystallise the categories and varieties of human life: the tragic masks representing kings, queens, priests, gods; the comic ones lovers, aged husbands, fathers, servants. In Britain, masks were more likely to be found at harvest festivals and in fairground booths, finally ending up in Punch and Judy shows, but the Greek and Italian traditions had a profound impact on our theatre, until, as psychological realism became increasingly valued by theatregoers, they fell into desuetude, held to be hopelessly old-fashioned. Towards the end of the 19th century, however, new interest in other cultures, a growing fascination with the possibilities of heightened expression and a sense of the expressive limitations of individual psychology brought the mask back into the theatrical fold; the great late-19th-century innovator Edward Gordon Craig named his hugely influential magazine simply *The Mask*.

I was a late beneficiary of all this. At drama school in the early 1970s I learned the power of the mask, its ability to release emotion and to facilitate physical transformation. Ours were comic masks, but the respect they demanded was relentlessly dinned into us: never, ever, once it was on, must we speak or even move except under its influence. Wearing it, we had to look into the mirror, allowing ourselves to fall under the mask's influence. Surprisingly soon, a Jekyll/ Hyde transformation was underway: the body would begin to shift shape, one's centre of gravity changing as one fell under the spell of the face that had replaced one's own; sounds, words one had never before uttered, emerged from the mask's rigid mouth. For many of us tyro actors, me included, this was a somewhat daunting experience; a handful, however, were suddenly liberated, freed both physically and imaginatively, in ways that were startling to behold.

I was not one of those who were released. I hated losing my facial expressiveness and felt blocked and painfully self-conscious. I retreated from the mask. Some years later, however, when I was preparing to play Brecht's Hitlerian gangster Arturo Ui, I had a notion that Ui – who is a caricature, half clown, half psychopath – should appear to have been assembled from spare parts. I turned to the designer for help. She handed me an ill-fitting and moth-eaten wig she had found in a dustbin outside the Royal Opera House. It didn't quite fit, which was interestingly disturbing. Then I was electrified to spot, hanging on her wall, a plastic Hitler nose and moustache she'd picked up at a fairground somewhere. I tied it on at an angle, so that its elastic band bisected my face diagonally, fragmenting my features to startling effect. Looking in the mirror, I stood up and found that I had become someone quite different: my spine had reshaped itself. I sank into a simian slouch, and when I spoke, my voice came out differently. I had, I realised, created a mask, and it had transformed me.

The masks in Jannette Cheong and Richard Emmert's fascinating and sumptuously produced book are most certainly not the result of any such hit-and-miss procedures. They are deeply imagined works of art in their own right, exquisitely crafted, springing from an ancient and profound tradition; and the performers who are privileged to wear them will form intense relationships with them. These artists are highly trained physically, acquiring iron control over their every muscle and their spines, but at the heart of their relationship with the mask is the submission of their own psyches to its power. I have been privileged to witness noh plays both in Japan and in Britain, and though it would be idle not to acknowledge that they are more demanding to watch than kabuki – so fabulously colourful and vigorous – they have, in their very austerity, a cumulative emotional power and an inner life which is both intensely dramatic and spiritually elevated. Noh, austere and distilled, demands masks of the greatest beauty and the most focused imagination. In this book we see the masterful Kitazawa Hideta at work, performing his miracles of carving and finish. I have never seen kyogen, traditional Japanese comic theatre, but the masks Kitazawa has created convey an irresistible sense of hilarity. Cheong and Emmert have laboured tirelessly, in numberless ways, to create bridges between Western culture and these profoundly rewarding manifestations of a deeply different society. The present volume must count as one of the most useful and most beautiful of their initiatives.

Simon Callow
Actor/Director/Writer

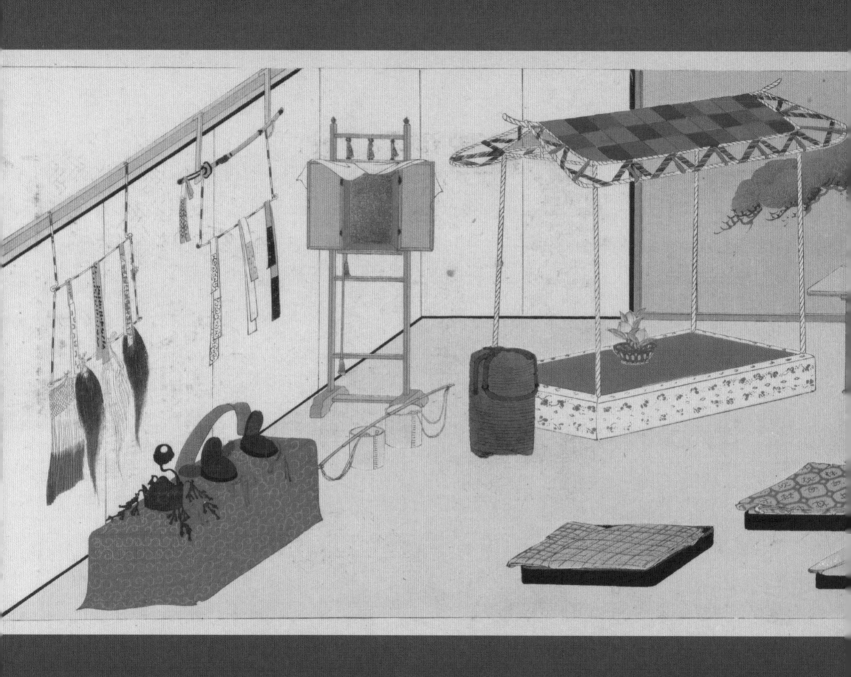

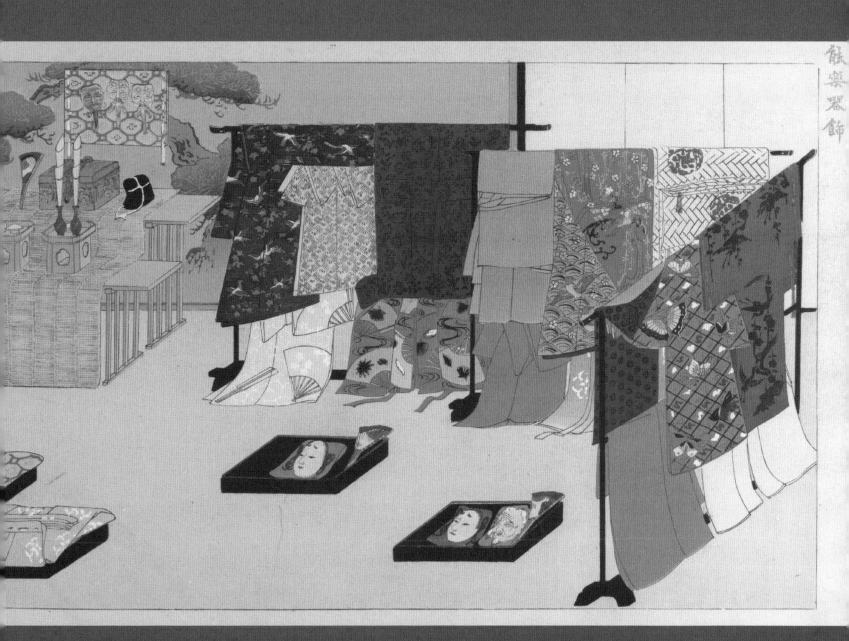

能樂器飾

Noh backstage, from the Kyūgi sōshoku jūrokushiki zufu
(Sixteen illustrations for traditional ceremonial decoration),
published in 1903. Courtesy of The British Library.
(ORB. 40/1068)

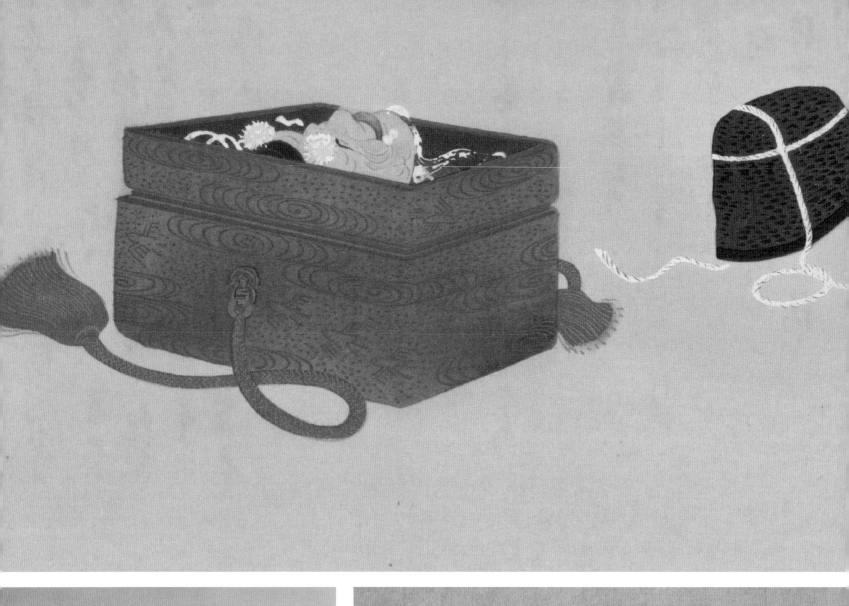

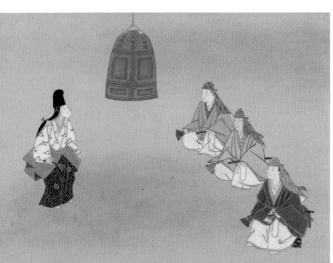

天保四年孟夏摸寫

曉齋
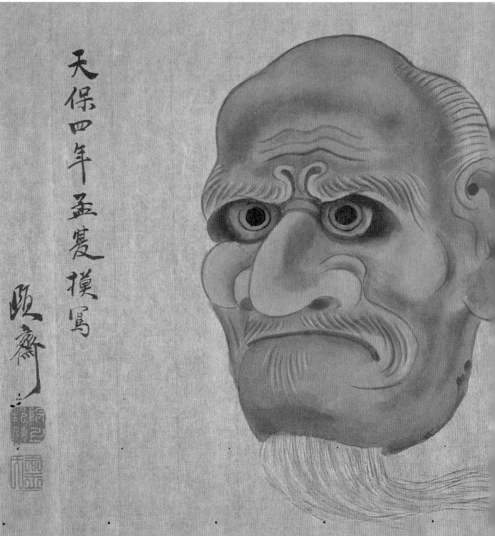

Preface

In recent years The British Library has had the good fortune of presenting a series of events working with the Oshima Noh Theatre and Theatre Nohgaku as part of a programme of 'Getting to Noh' educational activities which feature Japan's 650-year-old classical theatre, noh or nohgaku. As well as providing an opportunity for audiences to experience aspects of noh, this engagement has also been a stimulus to us further developing our collection of material relating to noh and other Japanese classical theatre forms.

Many of these works have now been digitised and made available online by the British Library. For example: *Nōmenzu* (Noh mask illustrations), a manuscript scroll (1833) containing 45 colour illustrations of traditional noh masks; the *Nōgu Taikan* (Compendium of noh equipment) a collection of paintings by Yamaguchi Ryōshō (1886–1966); *O-ekagami* (Mirror of pictures), a lavish late-17th-century album compiled by members of the Imperial Court with depictions of scenes from celebrated noh; and *Kyūgi sōshoku jūrokushiki zufu* (Sixteen illustrations for traditional ceremonial decoration) by Inokuma Asamaro (1870–1945), published in 1903, which includes a glimpse backstage at the costumes and props for a noh performance.

In 2001, UNESCO proclaimed nohgaku (noh and kyogen theatre) as an Intangible Cultural Heritage of the World in its first such listing. Among the recent British Library noh events, we have had the privilege of seeing the noh mask maker Kitazawa Hideta in action demonstrating and explaining his craft with his characteristic good humour and engaging delivery.

This volume of Kitazawa-san's masks not only helps us to recognise his unique artistic skills and passion for his work, but also opens up a window into noh and kyogen through the mask as one of this performance art's most important aspects. It is particularly inspiring to see both the traditional masks as well as the contemporary masks in the hands of this master craftsman. As an added bonus, there are also photographs of the mask maker as he performs kyogen – the humorous sidekick to noh. We are also delighted that we can see this exquisite work up close thanks to the wonderful photographs of his photographer brother, Kitazawa Sohta.

I am confident that both first-time viewers of noh masks as well as specialists in the field will be excited to see this volume and the beauty that lies within.

Hamish Todd
Head of East Asian collections, The British Library

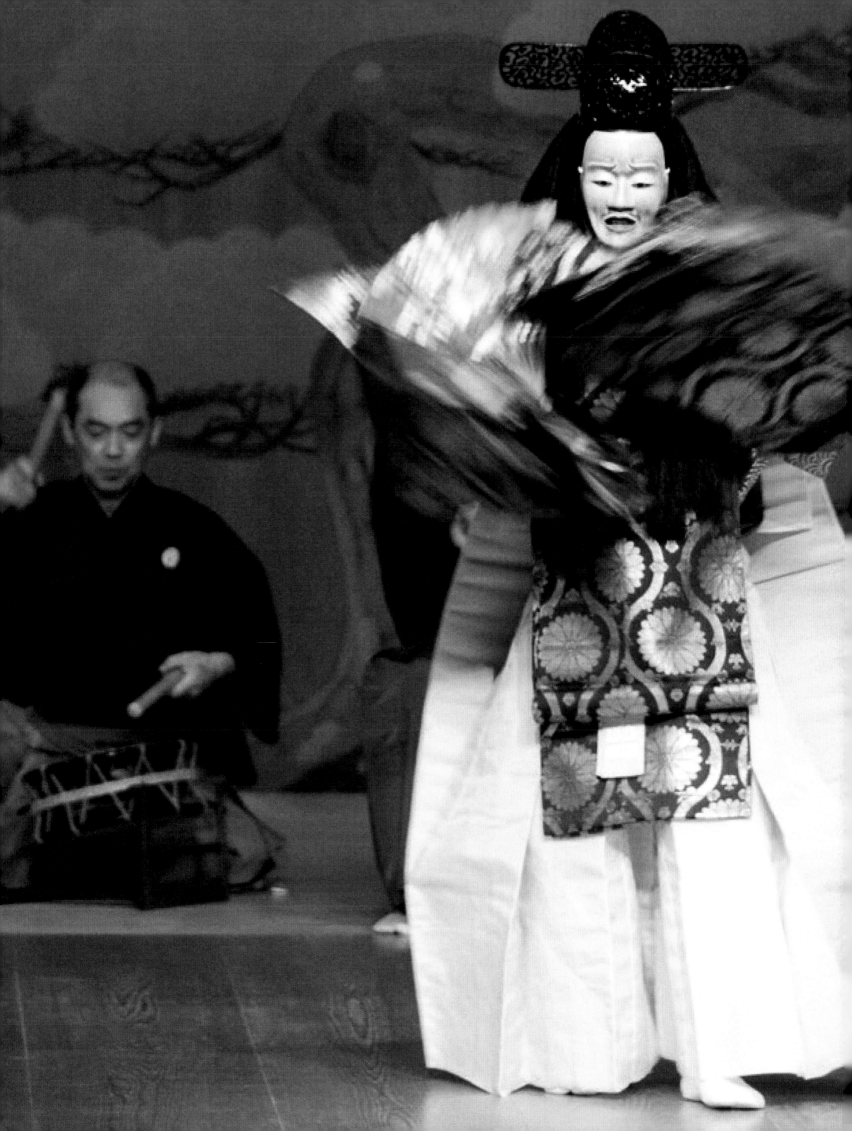

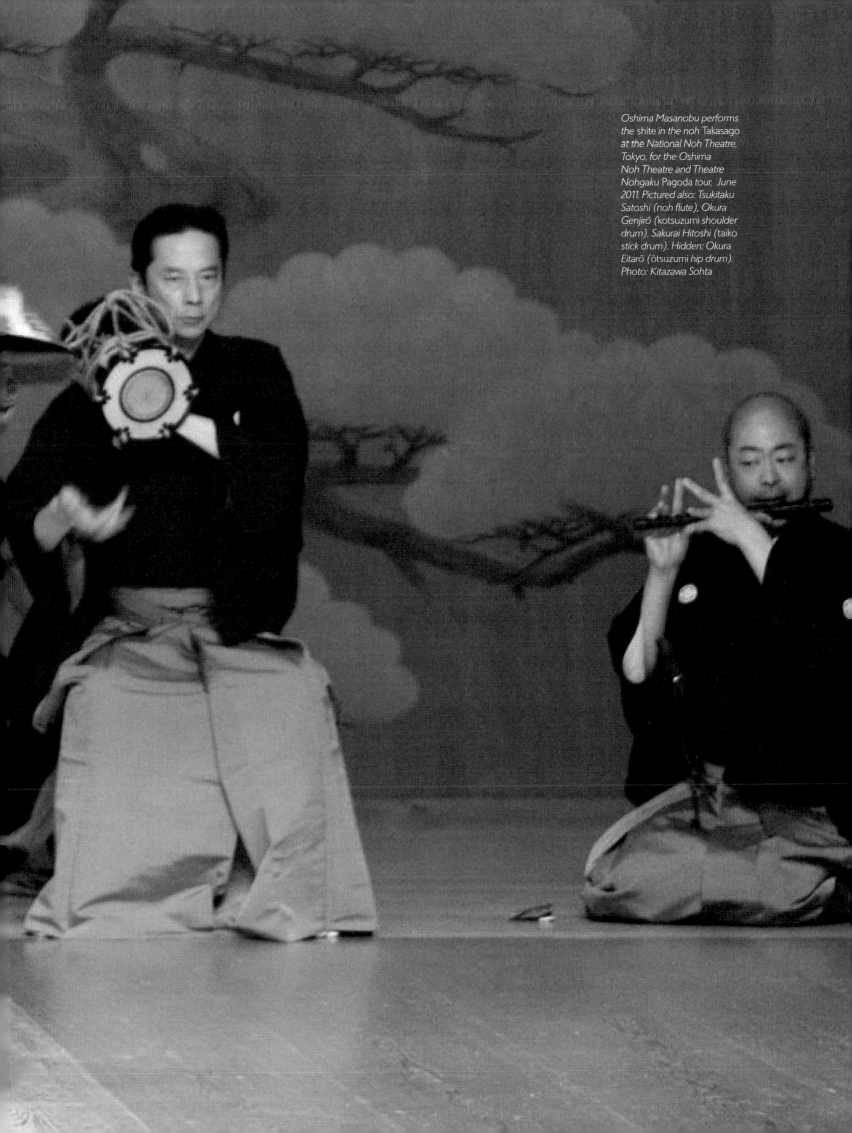

Oshima Masanobu performs the shite *in the noh* Takasago *at the National Noh Theatre, Tokyo, for the Oshima Noh Theatre and Theatre Nohgaku Pagoda tour, June 2011. Pictured also: Tsukitaku Satoshi (noh flute), Okura Genjirō (kotsuzumi shoulder drum), Sakurai Hitoshi (taiko stick drum). Hidden: Okura Eitarō (ōtsuzumi hip drum). Photo: Kitazawa Sohta*

Introduction

We are delighted to present the noh and kyogen masks created by Kitazawa Hideta. One of a small number of professional noh mask makers in Japan, Kitazawa's beautiful work has been widely appreciated and commissioned both in Japan and internationally.

Kitazawa Hideta is a unique artist. His work covers not only classical noh and kyogen masks for use on stage by professional Japanese noh artists, but also non-classical, newly created masks commissioned by international artists. The work in this book represents masks that have all been used for performance, though his masks are also held in permanent museum, gallery and private collections, including the British Royal Collection.

Through his performance-related work he has been able to interpret ideas related to a wide range of dramatic characters that have appeared before both Japanese and international audiences. Many of the contemporary masks were made for English-language noh (generally referred to here as just English noh) and use traditional noh mask making techniques.

As a second-generation wood carver, Kitazawa inherited a love of wood from his father, yet he embraced the art of sculpting noh masks on his own. While this volume introduces the Kitazawa family tradition of Buddhist temple and Shinto shrine carving which is at the heart of his passion for wood, the main focus of the book is on an extensive selection of his noh and kyogen masks. We have been supported in creating this book by the many Japanese and international collaborative partners who have worked closely with Kitazawa. We owe them a tremendous debt of gratitude.

The book in large part has also been made possible due to the professional skills of Kitazawa's brother, Sohta, whose beautiful mask photographs predominate throughout the volume. Sohta has spent many years following his brother's career and making numerous photographic studies of Kitazawa's masks and of him carving in his studio. Sohta has also taken many delightful photographs of Kitazawa as an amateur performer of kyogen, a number of which are also included in the book.

Over many years we have worked extensively with Kitazawa on numerous projects. David Crandall of Theatre Nohgaku first met him in 2004 when Kitazawa was a guest artist at a Japanese Cultural Arts Festival in Seattle (USA), and then introduced him to Richard Emmert in Tokyo. Emmert and Kitazawa discussed how mask makers were traditionally attached to noh

companies, and thereafter Kitazawa was invited to make masks for most of Theatre Nohgaku's English noh productions, as well as related productions of its members. Kitazawa met Jannette Cheong in 2009 and soon became an important part of the 'Getting to Noh' projects conceived by Cheong and Emmert. These include the first Oshima Noh Theatre/Theatre Nohgaku production of the English-language noh *Pagoda,* one of the most internationally toured English-language noh, and marked the beginning of a long-standing relationship also with the Oshima family. Kitazawa not only made the four masks for this production, but also toured with the company in 2009 to the UK, Ireland and France, and in 2011 to Japan, China and Hong Kong. Kitazawa also made the pagoda prop, and gave numerous mask making demonstrations while touring with the company. He had a similar role in other Cheong-Emmert projects: *Noh Time Like the Present* – the 2017 London LSO tribute programme for Matsui Akira, and *Between the Stones*, the 2020 Oshima Theatre/Theatre Nohgaku/Unanico production tour, again to the UK, Ireland and France. The extensive 'Getting to Noh' education and outreach programme of the *Between the Stones* project included special workshops undertaken by professional noh performer Oshima Kinue, Kitazawa and ourselves over a number of years. This inspired the UNESCO ASPnet Arts & Culture for Peace Initiative which was launched by UNESCO UK and the *Between the Stones* project.

We are extremely grateful to all who have contributed to the book, including actor/director/writer Simon Callow, whose kindness also extended to supporting other past 'Getting to Noh' education and outreach activities, and Hamish Todd, Head of East Asian collections at The British Library, with whom we have collaborated on a number of occasions.

We hope this volume will be of interest not only to those learning about noh for the first time, but also to those who are already attracted to the many aspects of noh theatre and who are excited to dig deeper into its acclaimed aesthetic through its exquisite masks.

Jannette Cheong and Richard Emmert

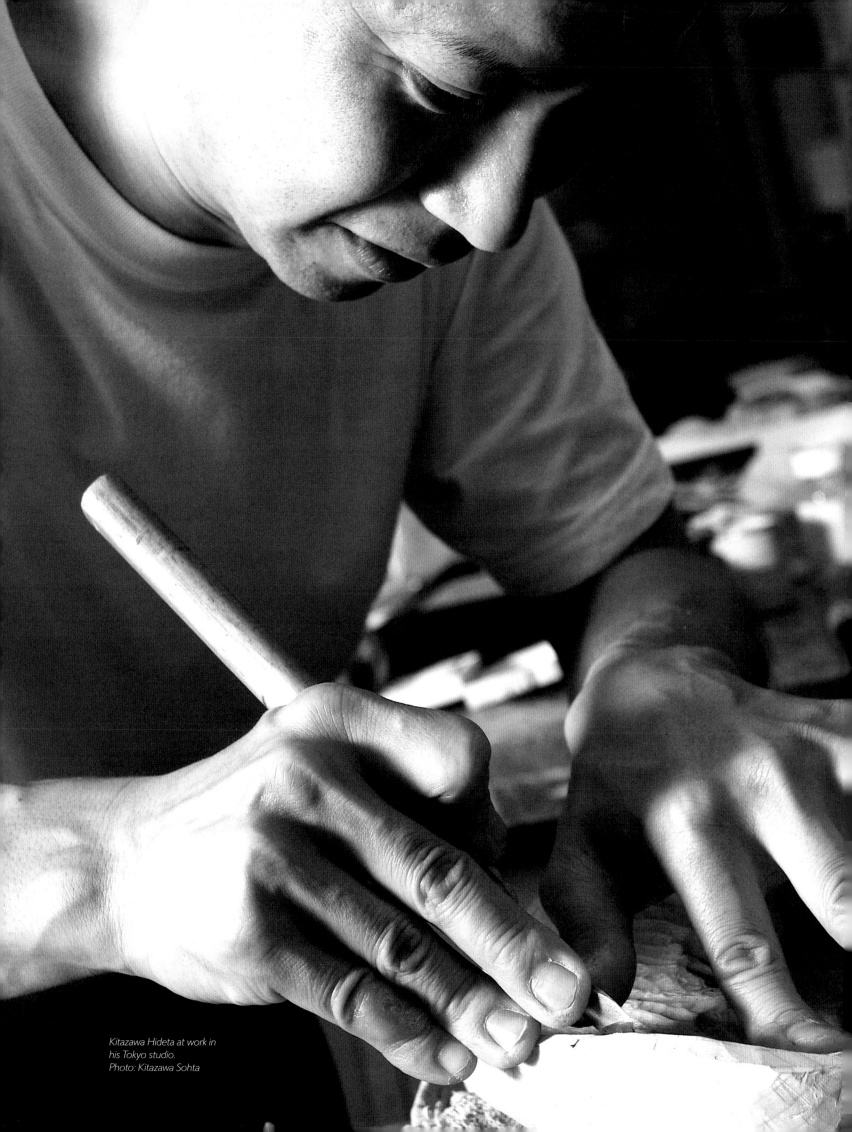

Kitazawa Hideta at work in
his Tokyo studio.
Photo: Kitazawa Sohta

Kitazawa Hideta and Family

a love of wood, trees and forests

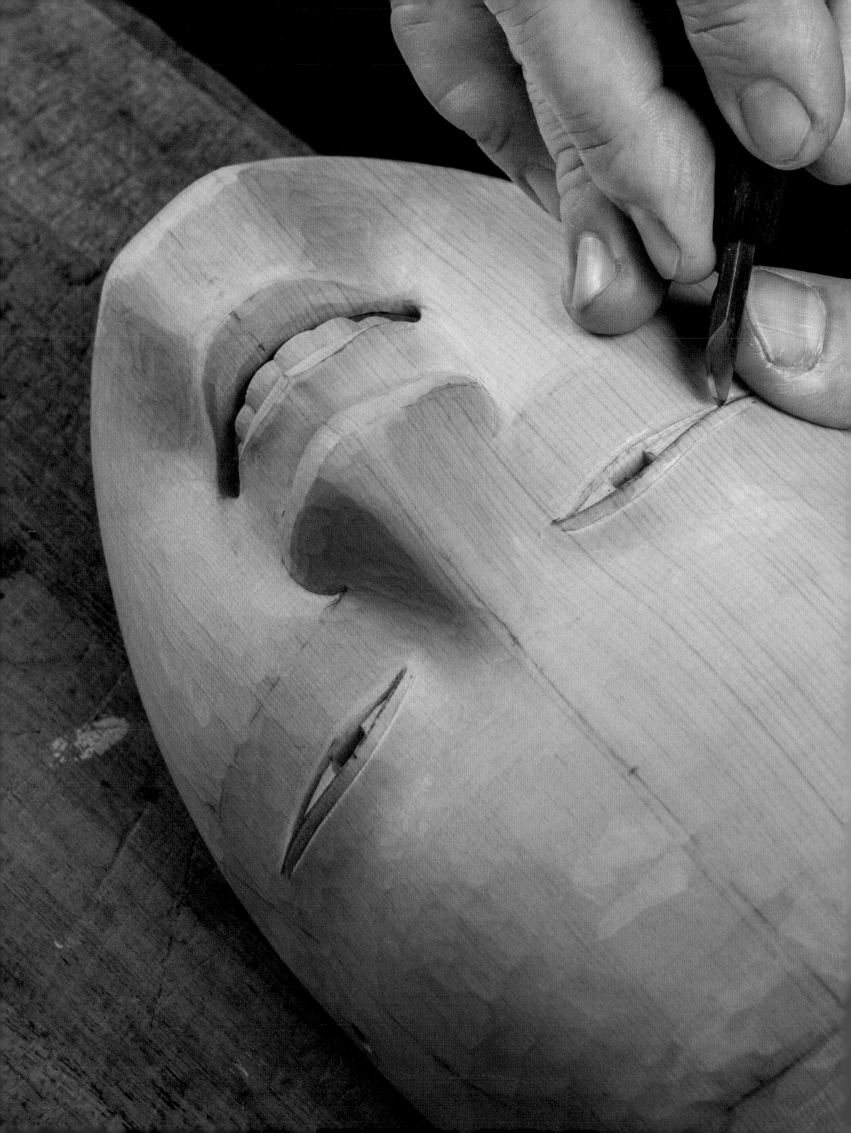

Kitazawa Hideta working on a zō mask.
Photo: Kitazawa Sohta

Lecture-Demonstrations

2004 Aki Matsuri (Japanese Autumn Festival) Seattle, USA (Sep)
2005 North Carolina School of the Arts, Winston-Salem, NC, USA (Aug)
2006 North Carolina School of the Arts, Winston-Salem, NC, USA (Sep
 Asian Civilisations Museum, Singapore (Oct)
2009 East–West Center Gallery, Honolulu, USA (Jan)
 Crow Collection of Asian Art, Dallas, TX, USA (Mar)
 Oshima Noh Theatre/Theatre Nohgaku *Pagoda* **Tour** (Dec)
 Victoria & Albert Museum, London, UK
 Pitt Rivers Museum, University of Oxford, UK
 Maison de la Culture du Japon, Paris, France
2011 Stanford University, Stanford, CA, USA (April)
 Oshima Noh Theatre/Theatre Nohgaku *Pagoda* **Tour** (July)
 University of Beijing, Beijing, China
 World Theatre Festival, Beijing, China
 International Arts Carnival, Hong Kong, China
 International Wood Culture Society Conference, Art & Joy of Wood:
 Japanese Noh Masks, India (Oct)
2014 Wenzhou Special Education School, China (Mar)
 International Woodcarving Competition, Dongyang, China (Oct)
2015 US Institute for Theater Technology Conference, USA (Mar)
 International Ancient Mask Summit, Surakarta, Java, Indonesia (Sep)
 The Japan Foundation Gallery, Sydney, Australia (Sep)
 Cultural Ambassador, Japanese Ministry of Foreign Affairs Tour
 University of Ljubljana, Slovenia
 Ethnographic Museum, Zagreb, Croatia
 University of Vienna, Austria
 Agricultural Museum, Bucharest, Romania
2016 Honolulu Museum of Art, Honolulu, USA (Nov)
 University of California Santa Cruz, CA, USA (Nov)
2017 *Noh Time Like the Present,* **Project Tour** (Feb)
 Sainsbury Institute for Japan Arts & Cultures, Norwich, UK
 Japan Foundation London (Foyles Bookshop), UK
 Oriental Museum, Durham University, Durham, UK
 Pitt Rivers Museum, University of Oxford, UK
 Dublin City University, Ireland
2018 University of California Los Angeles, USA (Oct)
 University of Iowa, USA (Nov)
 University of Winnipeg, Canada (Nov)
2020 *Between the Stones* **Project Tour** (Jan–Feb)
 The British Library, London, UK
 Japan House, London, UK
 Watergate Theatre, Kilkenny, Ireland
 National Opera House, Wexford, Ireland
 Museé Guimet (National Museum of Asian Arts), Paris, France
 Coventry Schools Cities of Peace Projects, Coventry, UK
 University of Technology Sydney, Australia (Mar)

Workshops

2005 North Carolina School of the Arts, NC, USA (Aug)
2006 North Carolina School of the Arts, NC, USA (Aug–Sep)
2009 Dept of Theatre, University of Hawai'i, Honolulu, USA (Jan–Feb)
 Southern Methodist University, Dallas, USA (Mar–Apr)
2015 University of Technology Sydney, Australia (Sep)
 University of the Incarnate Word, San Antonio, TX, USA (Oct–Nov)
 Dept of Theatre, University of Vienna, Austria
2016 Dept of Theatre, University of Hawai'i, Honolulu, USA (Oct–Nov)
 Dept of Theatre Arts, University of California Santa Cruz, USA (Nov)
2017 East 15 Acting School, University of Essex, UK (Feb)
 Nippon Connection (Japanese film festival), Frankfurt, Germany (May)
2019 Siebold Museum, Würzburg, Germany (Jun)
2020 East 15 Acting School, University of Essex, UK (Jan)
2023 Tusitalas Artes escénicas, Mexico City (Nov)

Exhibitions

2009 East–West Centre Gallery, Honolulu, USA (Jan–Mar)
 Crow Collection of Asian Art, Dallas, TX, USA (Mar)
2015 San Antonio Central Library, San Antonio, TX, USA
 Japan Foundation Gallery, Sydney, Australia (Sep)
2019 Siebold Museum, Würzburg, Germany (Jun–Sep)
2019 Art Gallery of New South Wales (Japan Supernatural),
–20 Sydney, Australia (Oct–Mar)
2023 National Folk Museum of Korea, Seoul, Korea (Oct)
 Centro Nacional de los Artes, Mexico (Nov)

Public Collections

2015 Pitt Rivers Museum, University of Oxford, UK
2018 Oriental Museum, Durham University, UK
2020 Art Gallery of New South Wales, Sydney, Australia
2023 National Folk Museum of Korea, Seoul, Korea

Media

2011 Conference video, International Wood Culture Society, Art
 and Joy of Wood: Japanese Noh Masks
2019 Film by Jeffrey Dym: *Noh Masks – The Spirit of Noh*
2020 TV Programme, *NHK World: A Treasured Creation:
 Noh Masks, Hideta Kitazawa*
2023 Film by Jeffrey Dym: *Three New Noh Masks by Kitazawa Hideta*

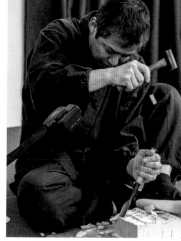

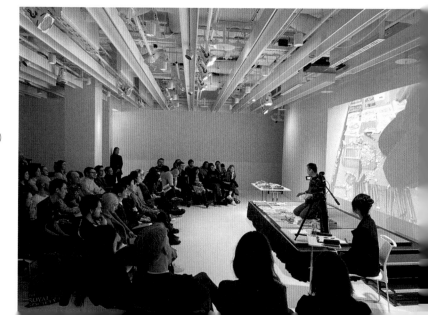

Kitazawa Hideta was born in 1968 in Katsushika Ward, Tokyo. The son of one of the foremost Edo-style traditional woodcarvers, as a child he often played in his father's workshop and began carving small objects. Through this he developed a love of wood, trees and forests and attended Tokyo University of Agriculture and Technology (Tokyo Nōkō Daigaku) where he majored in forestry studies. While he was at university, a visiting Canadian high-school teacher who came to his father's workshop encouraged Hideta to follow in his father's footsteps, after which he began to think of woodcarving as a possible future.

After graduating from university in 1991, Hideta decided to become a wood carving apprentice under his father's tutelage. However, in 1993, his world opened wider when he attended an Edo-style Traditional Woodcarving Association (Edo Moku Chōkoku Kumiai) seminar in which the noh mask maker Itō Michihiko (1942–) demonstrated mask making. Fascinated by this carving style, unlike anything his father was doing, the following year he began to study all aspects of noh mask making with Itō, which he did for the following decade. During that time, he was awarded two major prizes for his work: the Outstanding Young Artisan Award for Tokyo (Tokyo-to Seinen Yūshū Ginōsha) in 1997, and the Yokohama Noh Theatre Director's Prize (Yokohama Nohgaku Kanchō-shō) for mask making in 2003. He has since continued to carve temple and shrine sculptures as well as make noh masks. His carvings of Shinto floats and portable shrines (o-mikoshi) are currently in use throughout Japan's Kanto area and his masks are used extensively by a number of prominent noh and kyogen professionals.

In 1998, Hideta sought to develop his understanding of nohgaku by taking lessons in kyogen performance with kyogen master Nomura Manzō IX (1965–). He has since performed in a number of kyogen productions.

In 2004, Hideta was introduced to members of Theatre Nohgaku and thereafter began making masks for the company's English noh productions. He was also invited to give workshops and demonstrations internationally, travelling with noh troupes on performance tours in the US, Europe and Asia, notably in the 'Getting to Noh' projects of Jannette Cheong and Richard Emmert. He also received commissions from professional noh and kyogen performers and international productions. His masks are in the permanent collections of the Pitt Rivers Museum in Oxford and the Durham University Oriental Museum in the UK, the Art Gallery of New South Wales in Sydney, Australia, and the National Folk Museum of Korea in Seoul.

In 2015, the Japanese Ministry of Foreign Affairs (Gaimushō) sent him to give demonstrations and meet artists in several Eastern European countries. His education outreach activities continued in 2020 as a part of the Between the Stones project, with which he gave a number of lecture-demonstrations in the UK, Ireland and France. His education support work included the Coventry Schools Cities of Peace Projects with the Japan Society, London.

In 2023 he was awarded the title Traditional Master Craftman (Dentō Kōgeishi) by Koike Yuriko, the Governor of Tokyo.

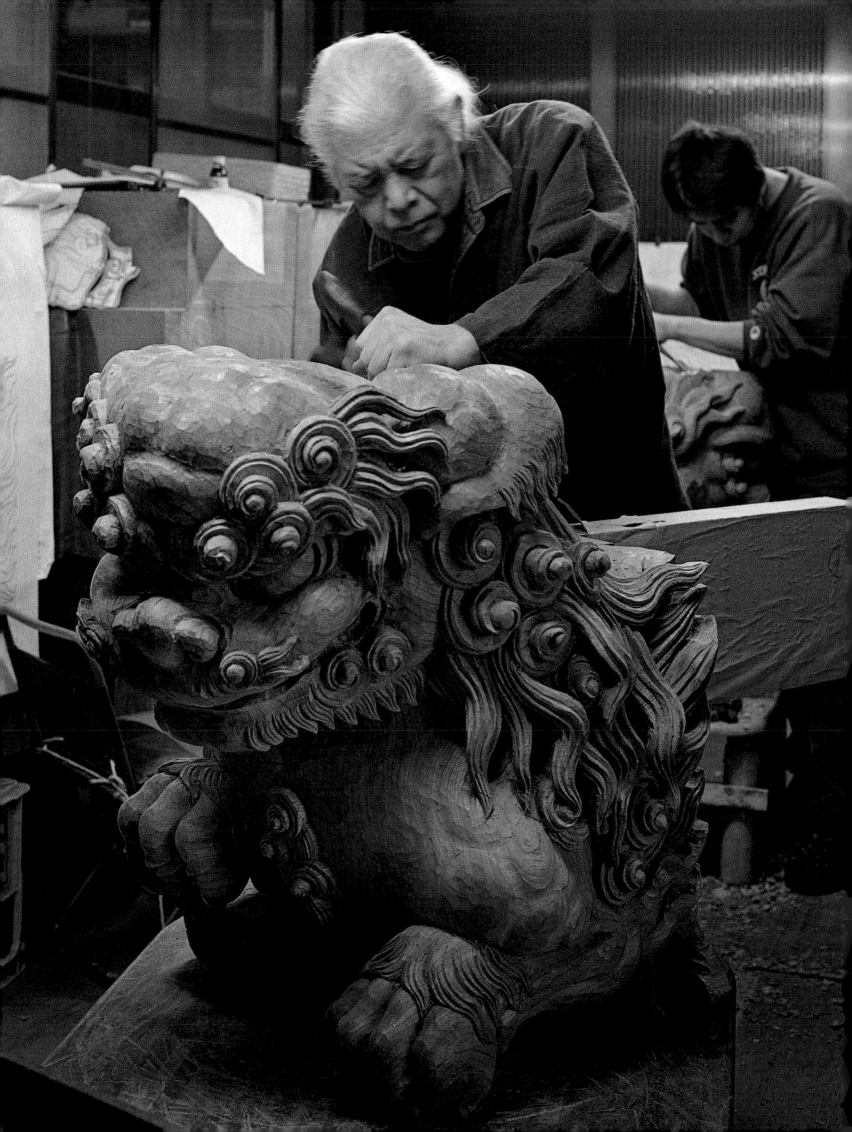

Kitazawa Hideta is a third-generation artist. His grandfather, Kitazawa Ichimatsu (ca. 1902–ca. 1943), was a professional painter and designer of kimono. He died in World War II while on a boat headed to Singapore that was bombed by the American military. Neither Hideta nor his father, who was three years old at the time, ever knew him.

Hideta's father, Kitazawa Ikkyō, was born in 1940 in Ashikaga City, Tochigi Prefecture, about 100 kilometres north of Tokyo. After graduating from junior high school, he moved to Asakusa in Tokyo, which was the heart of traditional craft activities in the city, and became apprentice to master woodcarver Iijima Beizan (ca. 1913–ca. 1993). Ikkyō spent the next ten years learning the art of woodcarving before becoming an independent woodcarver and setting up his own workshop in Katsushika Ward.

Ikkyō is a specialist in traditional woodcarving decoration, carving dragons, lions and phoenixes for temples, shrines, family altars and traditional festival floats. He was designated by the City of Tokyo as a *Dentō Kōgeishi*, a Traditional Master Craftsman. Now in his eighties, he continues to carve in his workshop every day.

Hideta's younger brother, Sohta, is a professional photographer. Born in 1975, he studied photograhy at Tokyo YMCA Design Research Institute (YMCA Dezain Kenkyūjo). He travelled extensively in Latin America photographing the jungles and mountains and has journeyed to the North Pole on assignment. He is a member of the Japan Professional Photographers' Society (Nihon Shashinka Kyōkai) and now works as a freelance photographer.

In 1997, Hideta married artist Yoshiya Miyoko (1965–). Miyoko is a textile and textile-installation artist who has had numerous solo exhibitions as well as participating in many group exhibitions throughout Japan. Outside Japan, she has participated in group exhibitions in Taipei, Paris and Cheongju, Korea. She has also given textile workshops at the University of Bucharest and the University of Hawai'i, and has had an exhibition with Hideta at the Seibold Museum in Würzburg, Germany.

*Kitazawa Hideta (behind) and his father Ikkyō, working together on lions for Narita Temple (right) in Narita City, Chiba Prefecture.
All family photos: Kitazawa Sohta*

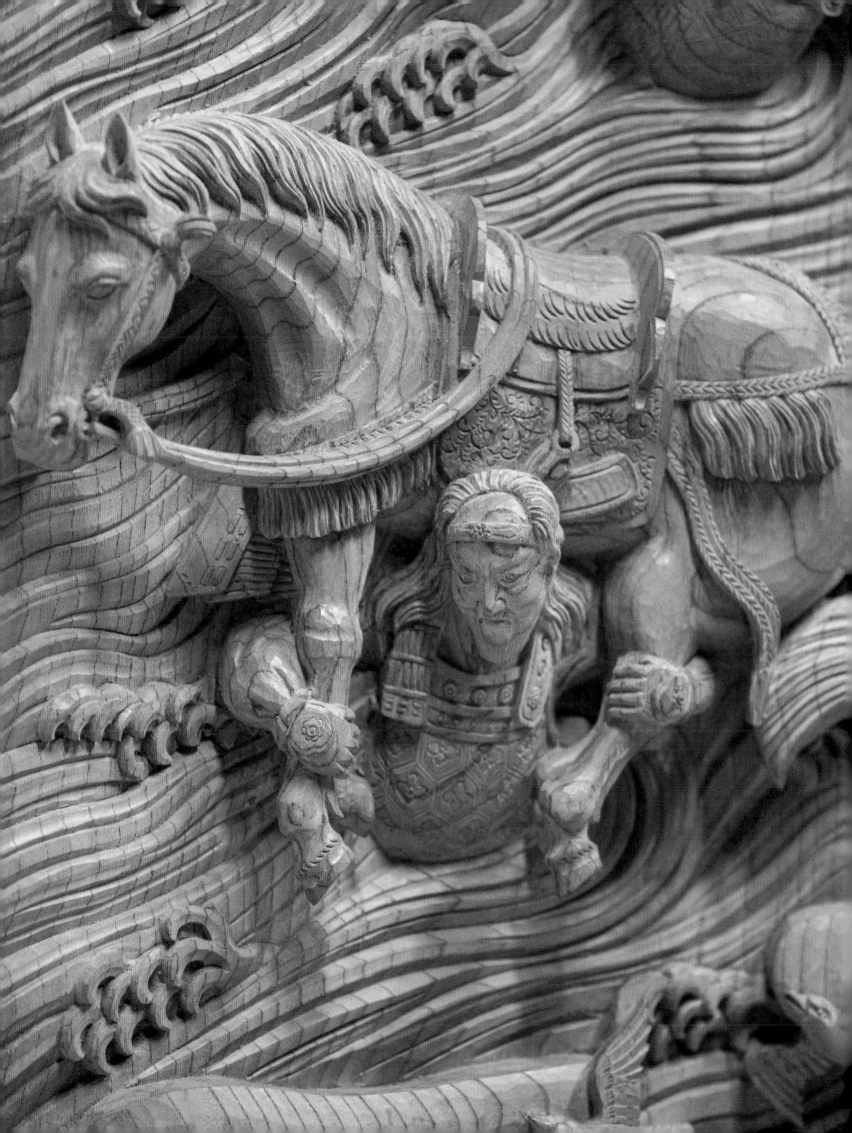

Sawara Festival Floats

These relief sculptures are based on Japanese historical and legendary figures carved over several years by Ikkyō and Hideta for the Sawara Grand Festival (Sawara-no-Taisai) floats. The festival is held in Katori City, Chiba Prefecture, in both summer and autumn. It is one of the three greatest float festivals in the Kantō (Tokyo) region of Japan.

The carvings decorating these Sawara floats depict scenes from the famous Taiheiki (Chronicles of Great Peace) historical epic which established the Muromachi government (1336–1573).
Photos: Kitazawa Sohta

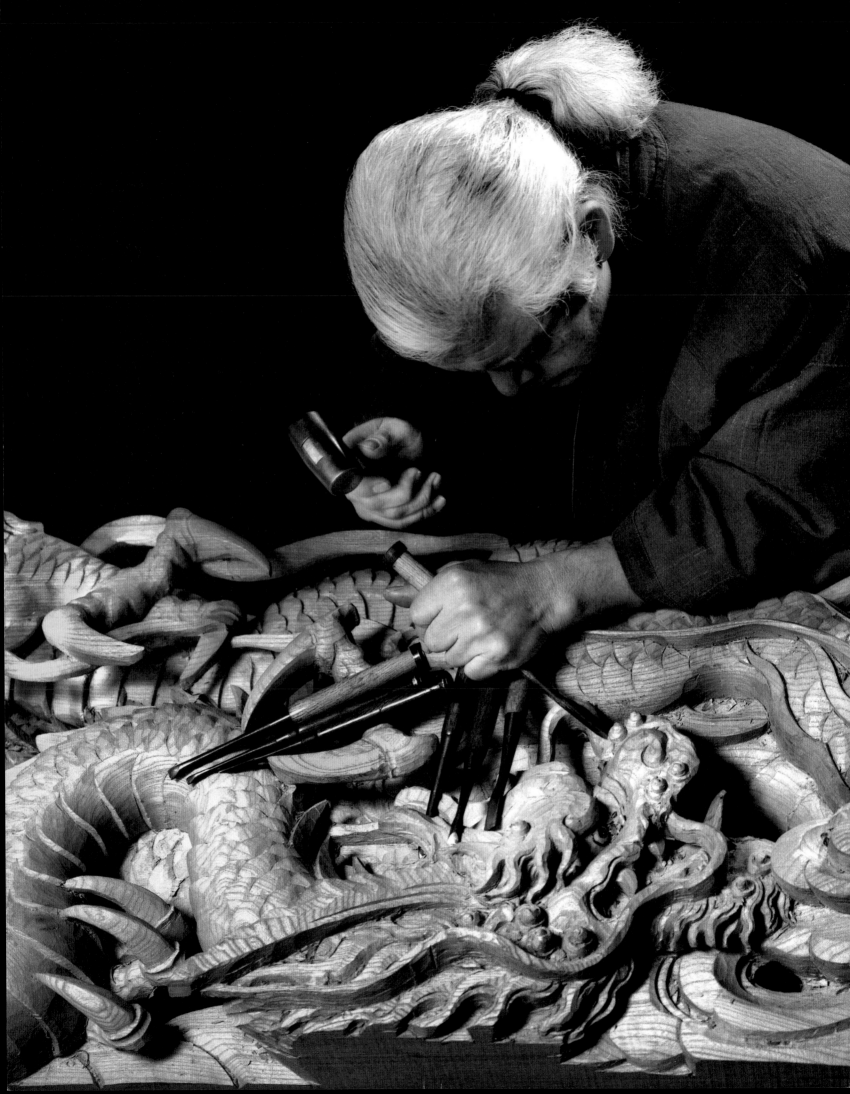

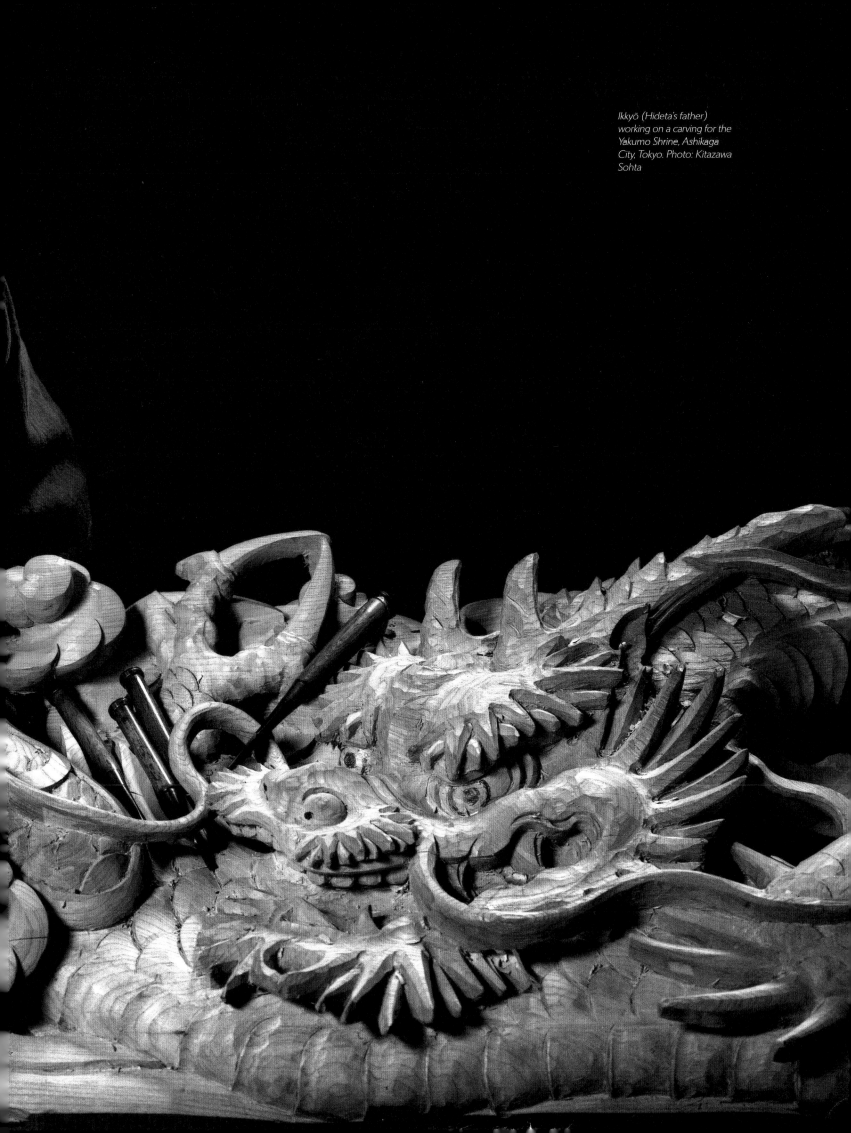

Ikkyō (Hideta's father) working on a carving for the Yakumo Shrine, Ashikaga City, Tokyo. Photo: Kitazawa Sohta

The Masks

Classical
Noh Masks

Classical noh masks developed along with the art of noh. Some original masks (*honmen*) are still in use today with the oldest dating back to the Muromachi period (1336–1573). Most masks used in current performances are copies (*utsushi*) of those classical masks. Many of these copies are highly valued and have been used by noh performers for generations. Today, there are a small number of professional mask makers whose copies of classical masks are also used on the noh stage.

Classical noh masks are generally categorised as follows: *Okina*, female, male, old men, gods, goblins and demons. Within these categories, according to the *Nohgaku Daijiten* (Nohgaku Encyclopedia, Chikuma Shobō, Tokyo, 2012), there are 133 types of noh masks, and a number of key examples are featured in this book.

Each category of mask has a particular style or pattern. These styles have been carefully developed through the generations and passed down among noh mask makers and performers. Kitazawa's noh masks are based on these classical styles and patterns. He believes that he must create the traditional atmosphere that the mask represents. He constantly studies the detailed aspects of classical masks, not only viewing noh performances, but also studying noh masks in museums and private collections around the world.

The most important parts of a mask are the eyes and the mouth. Kitazawa's approach is to take a long time to create these delicate parts of the mask until they reach the image that he has for them. In a well-constructed noh mask, the eyes of the mask appear to be looking at the observer and the mouth seems to be speaking the story being performed.

A noh mask is a beautiful work of art, but it is also a tool for a performer. When Kitazawa makes a mask, he believes it should inspire the performance as well as fit comfortably. Looking at the mask from different angles gives it different expressions. Indeed, noh performers learn to use delicate movements to change the mask's expression to joy, sorrow or anger just by tilting it. The realism of the masks and the stylism of the performers' movements creates an intriguing juxtaposition.

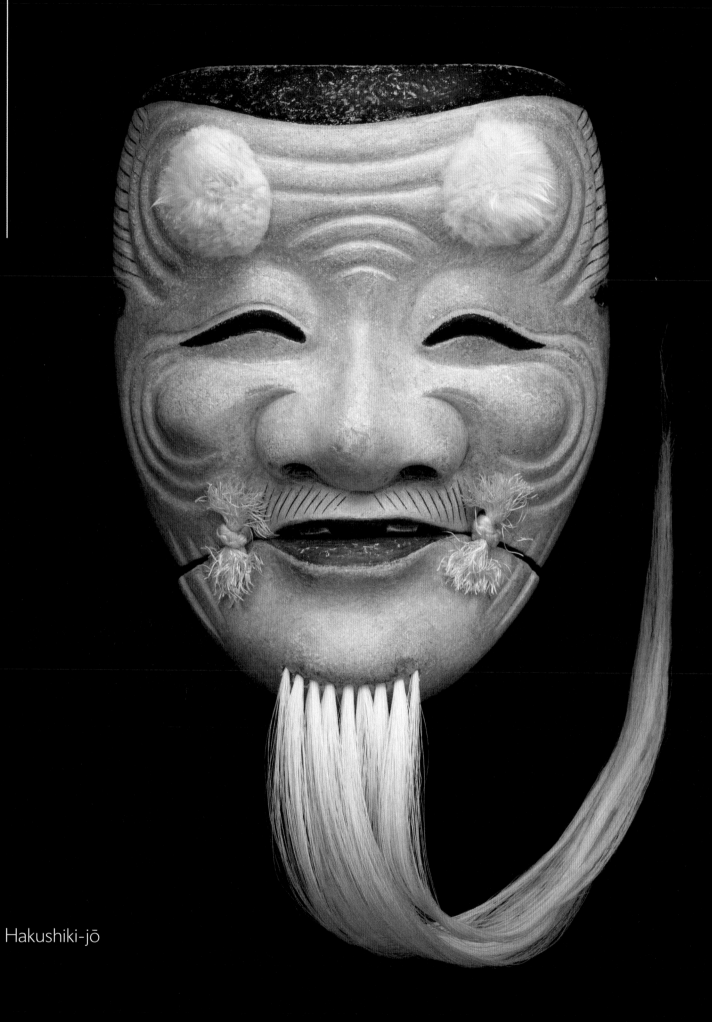

白式尉

Hakushiki-jō

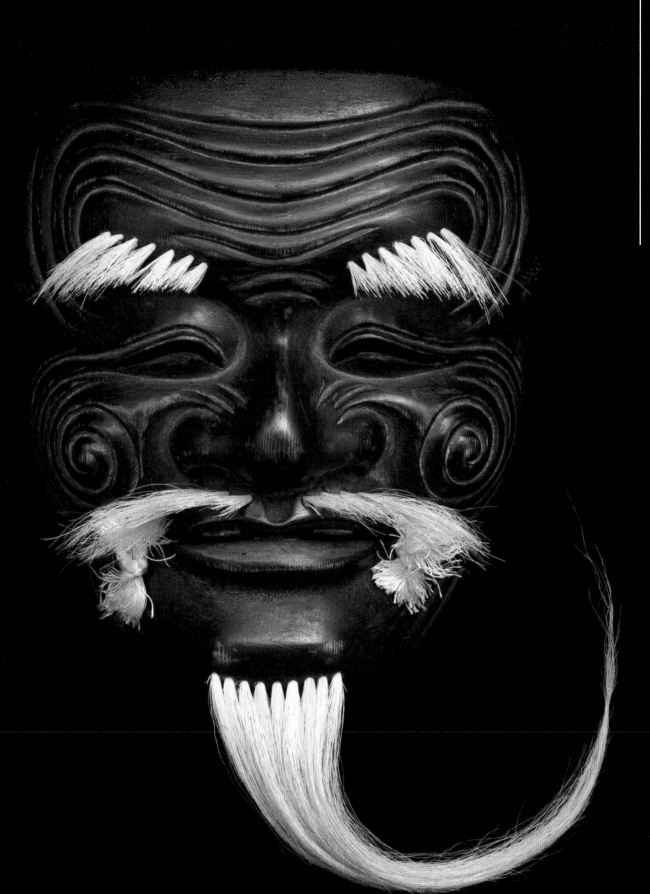

Kokushiki-jō

Okina

Okina is an ancient rite which predates the development of noh. It is often said that '*Okina* is of noh, but is not noh.' This saying is meant to indicate that the piece is in a class of its own. It has no storyline, nor is its structure like that of any other noh piece.

Okina masks are considered to be the oldest noh masks. The two masks most commonly used for *Okina* are a white old man mask known as *hakushiki-jō* and a black old man mask known as *kokushiki-jō*. Both have long white beards (horsehair) and feature split movable jaws and bushy eyebrows. These old men express the wisdom of age.

The *hakushiki-jō* performer is always a *shite* main role actor who first dances a slow and stately dance. In the second half, a kyogen actor dances with the *kokushiki-jō* mask in the *Sanbasō* section. Its hypnotic dance mimes the planting and growing of rice.

Okina is a sacred rite praying for peace, prosperity, and safety across the land. It is performed today at the beginning of the new year, at the opening of a new stage, and on other celebratory occasions.

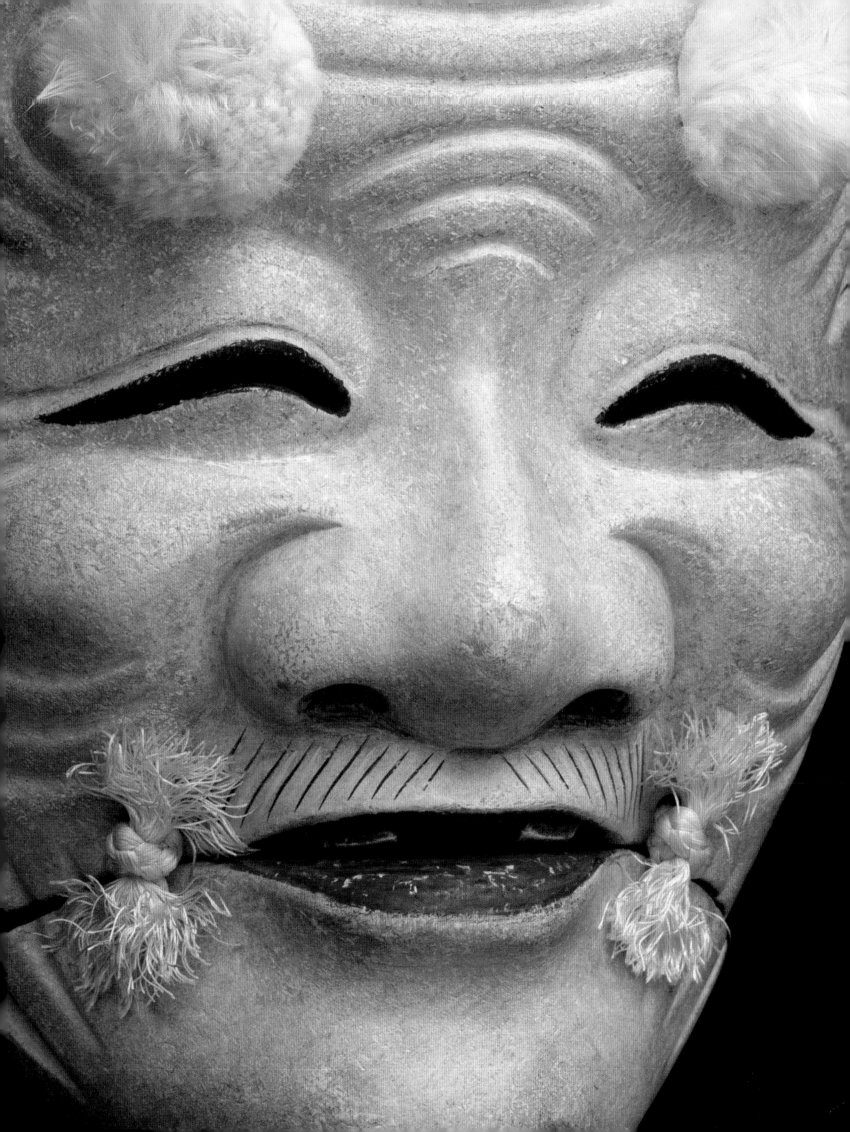

Female Masks

女面

There are a wide variety of female masks: beautiful young women (such as *ko-omote*), perhaps as young as 18–20 years of age; middle-aged women (such as *zō*) whose faces reflect more experience in life; slightly crazed women (such as *shakumi*) reflecting more serious trauma, such as the deep concern for the loss of a child; women with emaciated faces (*yaseonna*) reflecting a variety of experiences of pain and suffering; and old women (such as *uba*) who have reached an age of experience and wisdom and who have weathered life's difficulties.

Generally, female masks are worn by *shite* main actors appearing in third- and fourth-category noh.

Third-category noh (women noh) usually feature young women masks, such as in *Izutsu, Nonomiya* and *Matsukaze*. Young women in the main role are considered the most beautiful in terms of story and poetic text as well as costume and mask, though their deliberateness in tempo can make them difficult for first-time viewers.

Fourth-category noh (miscellaneous noh) also include female main characters in more dramatic circumstances. These are often slightly crazed characters, such as in the noh *Sumidagawa, Miidera* or *Fujito*. Old women, such as in *Obasute* or *Sotoba Komachi,* are classified as either third- or fourth-category noh.

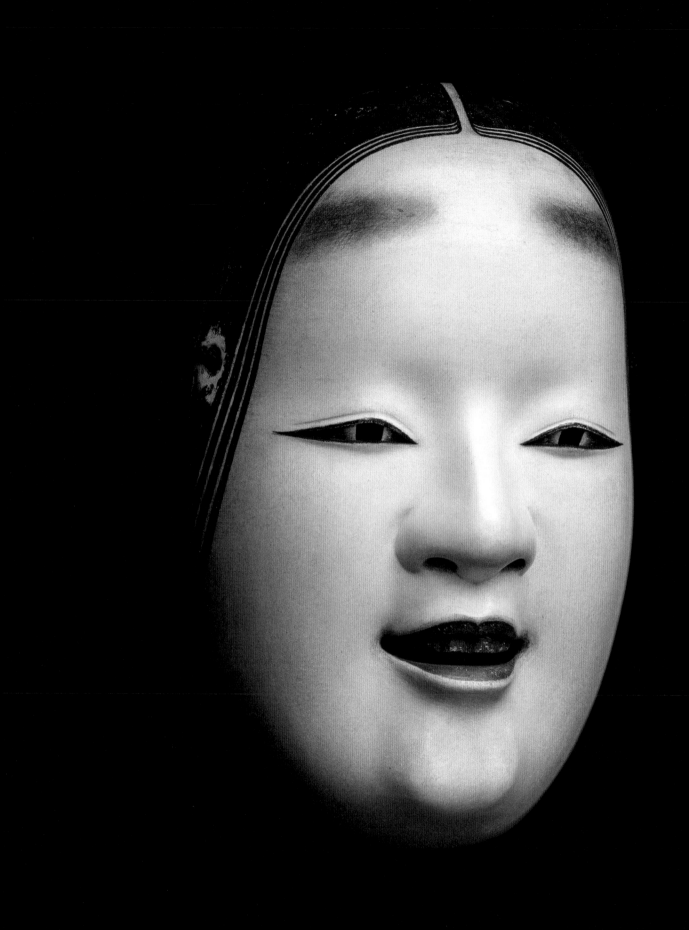

Ko-omote

Small Face

In the Kita and Komparu *shite* schools, the *ko-omote* (small face) is used as the standard young woman mask. The *ko* of *ko-omote* is thought to indicate an attractive, youthful character. The late 16th-century shogun, feudal lord and so-called unifier of Japan Toyotomi Hideyoshi (1537–1598) was a performer and supporter of noh. He gave the names *yuki* (snow), *tsuki* (moon) and *hana* (flower) to three of his favourite *ko-omote* masks. The *tsuki* mask was destroyed in a fire at Edo Castle; the *hana* mask is now the property of the Mitsui Memorial Museum (Mitsui Kinen Bijutsukan); and the *yuki* mask is in the collection of the Kongō school. These masks were made by the great mask maker Ishikawa Tatsuemon in the late 14th century. From the Edo period on, the *yuki* mask style became the standard for almost all *ko-omote* masks.

Two different painting techniques were also developed for the *ko-omote* in the early Edo period (17th century). One has a hard finish resembling chinaware with a glossy and clear surface (left). The other has a soft finish and appears like human skin with a more textured antique look, such as in the performance photograph of Oshima Kinue (overleaf). This is a copy (*utsushi*) from an Oshima family mask made in the early Edo period (1603–1867) by the mask maker Deme Tōhaku (–1715).

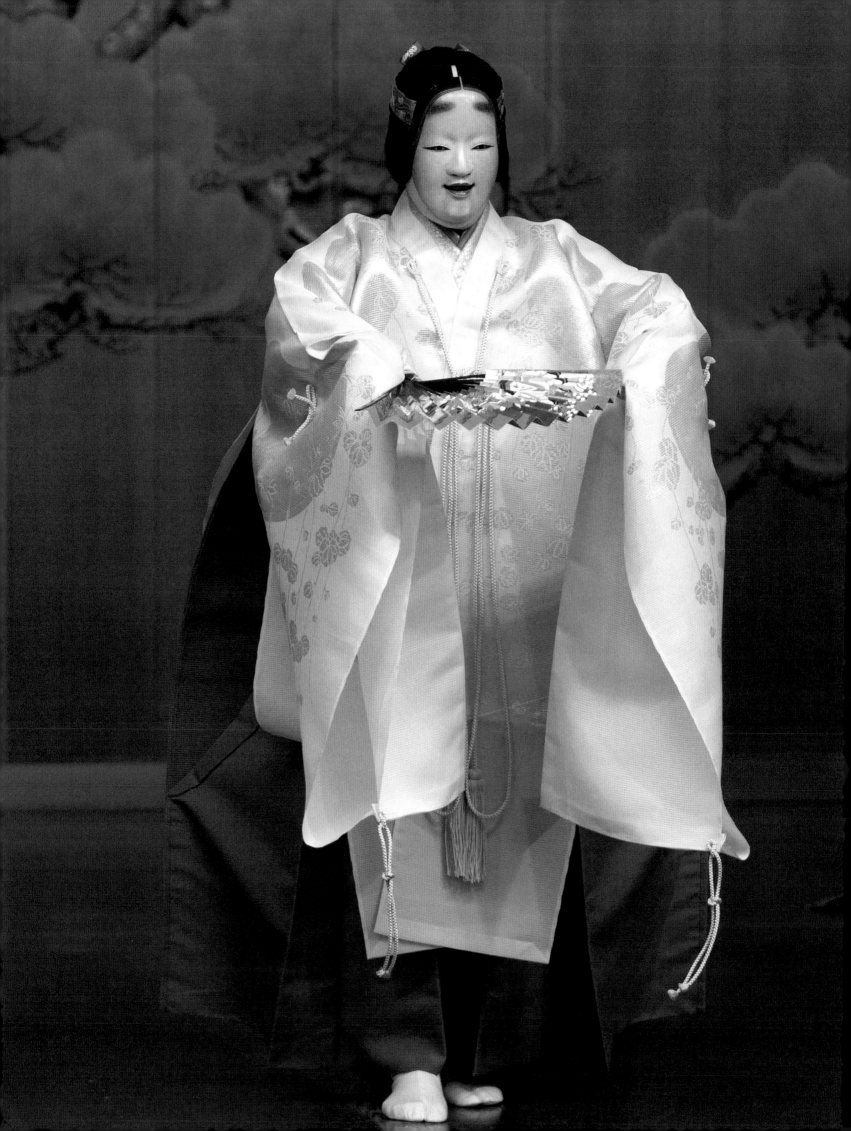

Hashitomi (Hajitomi)
The Half-Size Lattice Shutter

Author: Naitō Saemon
(ca. 14–15th century)

Setting: Unrin-in Temple,
in the capital, present-day
Kyoto

Season: Autumn

Category: Third-category
woman (plant spirit,
real wig) noh, *mugen*
(phantasm) noh in two acts,
jo-no-mai (elegant slow
dance) piece, without
taiko drum

Mask Type: *ko-omote*

Synopsis

A priest of the Unrin-in Temple in the northern hills of the capital, present-day Kyoto, announces a Buddhist service on behalf of the flowers used as altar offerings. A woman suddenly appears, offers a *yūgao* flower and mentions the home of the court lady Yūgao from *The Tale of Genji* before vanishing. Later, the priest visits the woman's home. Yūgao's ghost appears from behind a half-size lattice shutter, tells of the romantic beginning of Genji's affair with Yūgao, then dances and disappears with the dawn.

This noh is based on the Yūgao chapter from *The Tale of Genji* in which Prince Genji, calling at the home of his old nurse, notices unfamiliar white flowers growing on a fence of the house next door, which has its lattice shutters open. He has his attendant pick some of these flowers and thereby meets the beautiful woman inside, with whom he has a short and intense affair before she tragically dies. The name of both the flower and the woman is Yūgao, literally 'evening face', and also known as 'moonflower'.

*Left: Oshima Kinue
performing the second half
of* Hashitomi *at the Oshima
Noh Theatre, Fukuyama,
September 2019.
Photo: Kuwada Naomi.
Courtesy of the Oshima
Noh Theatre*

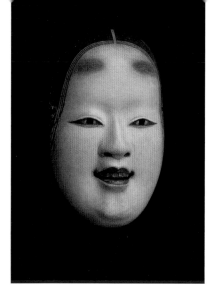

Manbi

Ten Thousand Temptations

A *manbi* mask is a variation of the *ko-omote* mask and represents a more seductive and mature young woman. Compared to a *ko-omote*, the eyes of the *manbi* are slightly bigger, the mouth is a little more open and the cheeks are a bit fuller. There are also small differences in the rendering of the hair strands.

Though often used in noh such as *Momijigari* and *Sesshōseki,* which feature a seductive character who is actually a demon, in general *manbi* masks are less frequently used than *ko-omote* across the repertory of noh. Sometimes a more mature noh performer may choose to use a *manbi* mask instead of a *ko-omote*.

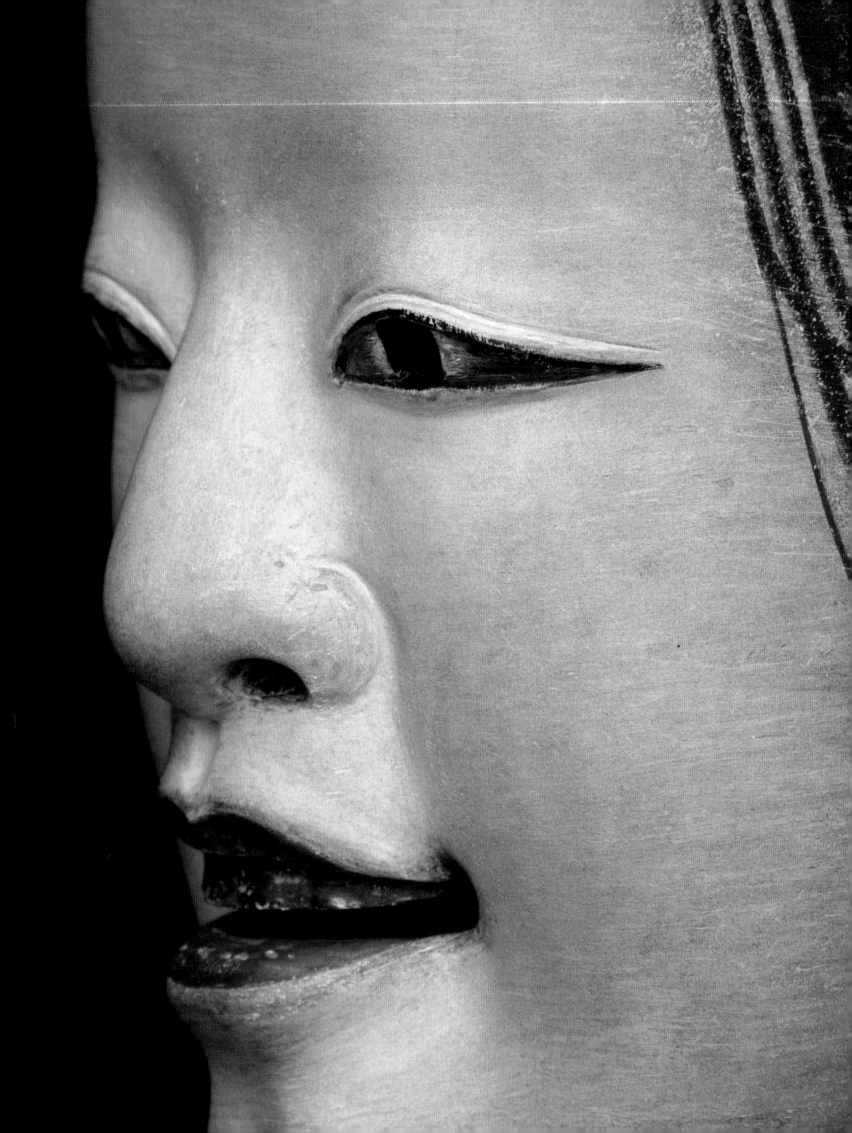

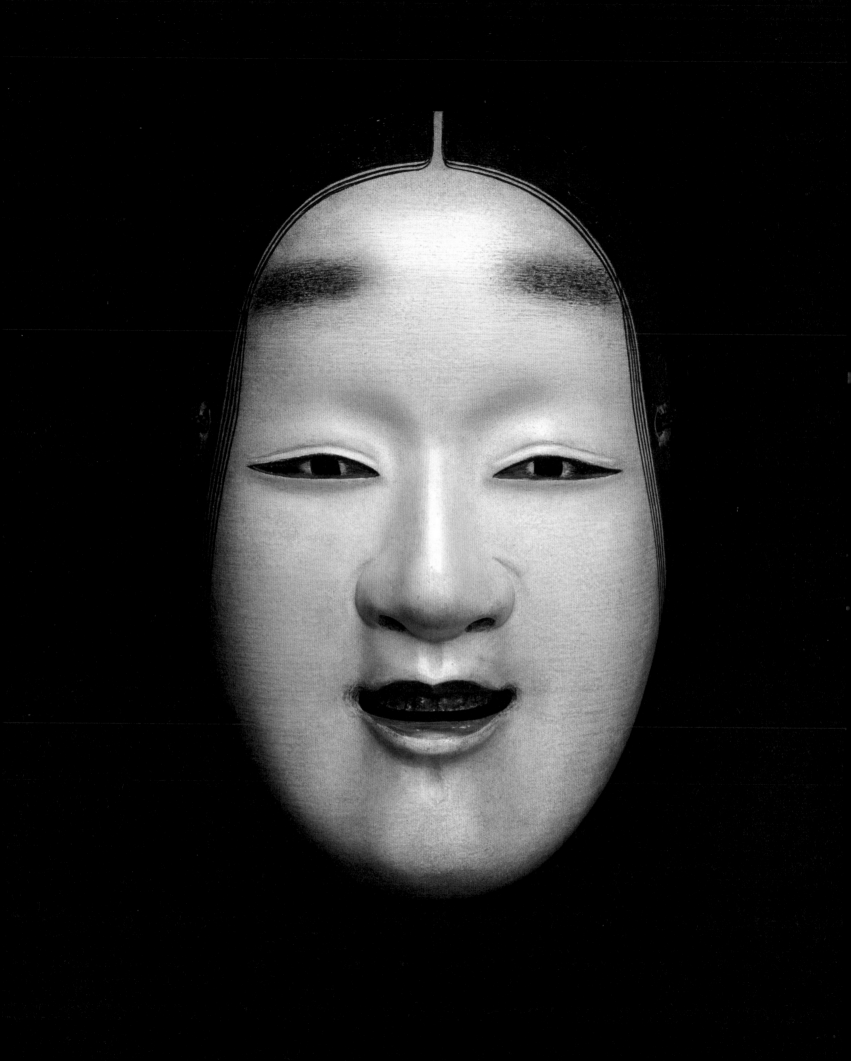

Magojirō

Another mask of a young woman, the noh performer and mask maker Kongō Magojirō (hence the name of the mask) is said to have made this mask in memory of his wife after her death. It is the standard young woman mask of the Kongō school and has similar features to other young woman masks, including its square eyeholes.

Similar to *ko-omote*, it is notably used in third-category noh such as *Izutsu, Nonomiya* and *Matsukaze*.

孫次郎

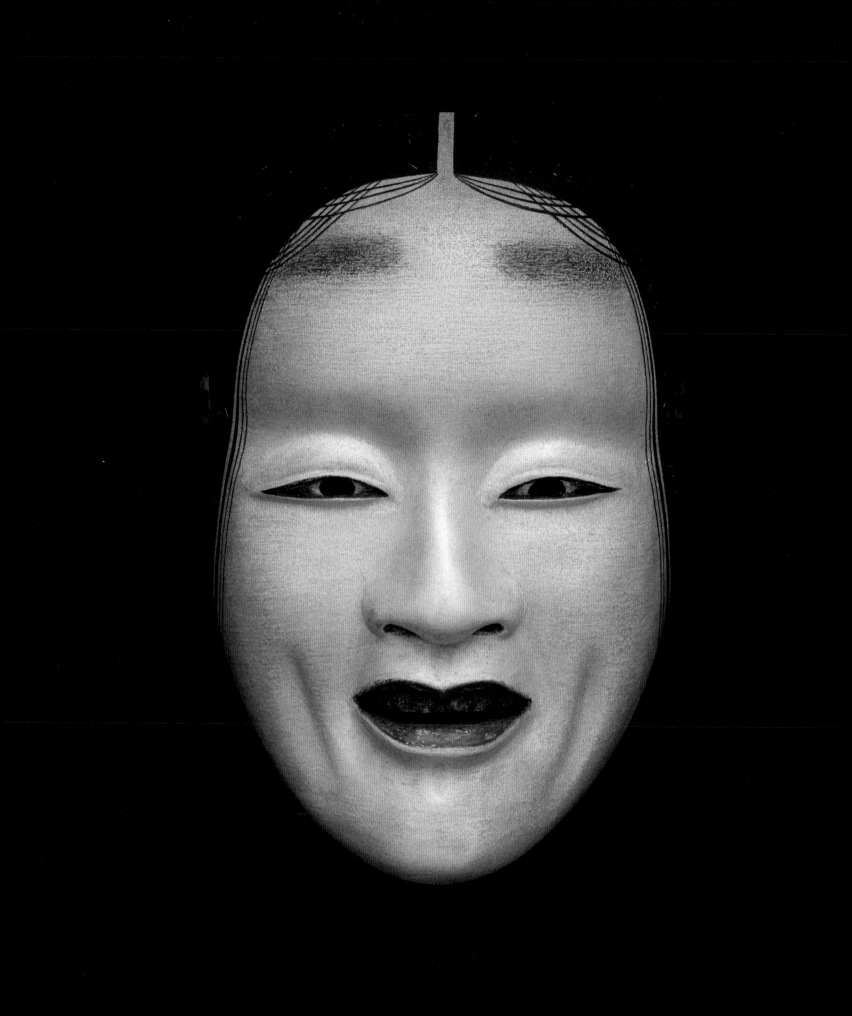

Fukai

Deep Well

Fukai means 'deep well' and it is generally thought that the name of the mask comes from the fact that it represents a mature middle-aged woman. Although there are a wide variety of *fukai* masks, generally the eyeholes are round, the cheeks are slim with dimples, and the hairline begins from the central parting and is looped in three sets of strands.

The mask is used in third- or fourth-category noh for goddesses and spirits. It is commonly used in the Kanze and Hōshō schools, while the Kita, Komparu and Kongō schools use the *shakumi* mask instead. There are approximately 50 noh that use the *fukai* mask.

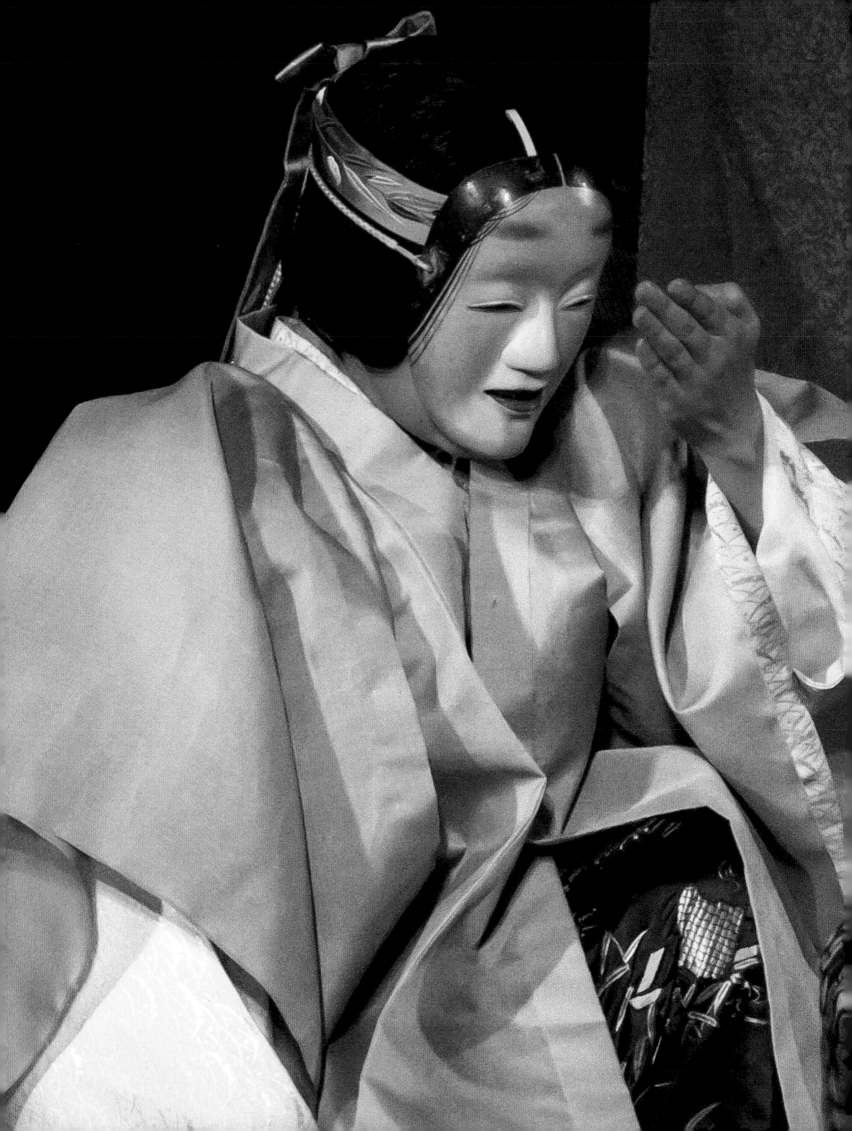

Sumidagawa
Sumida River

Synopsis

Author: Kanze Motomasa
(ca. 1400–1432)

Setting: The Sumida River in
Musashi Province, present-
day Sumida Ward, Tokyo

Season: Early spring, 3rd
month, 15th day

Category: Fourth-category
miscellaneous (crazed
woman) noh, *genzai*
(present-time), *kakeri*
(anguish dance) piece,
without *taiko* drum

Mask Type: *fukai/shakumi*

A ferryman on the Sumida River is about to take a traveller across, but decides to wait for a disturbed woman who is following close behind. The woman arrives and relates that she is searching for her son who has been kidnapped by slave traders. As the three cross the river they notice a crowd on the opposite bank conducting a Buddhist memorial service. The ferryman tells the story of how a boy had died exactly a year earlier having been left behind by passing slave traders. The woman realises that the boy was her own son. The ferryman takes her to the boy's grave at the side of the road. When she begins to recite prayers, the boy's voice is heard from inside the grave. He then appears to her, but when she reaches out to touch him, he slips back into the grave and disappears.

Sumidagawa is the basis for Benjamin Britten's church parable *Curlew River* first performed in Suffolk, England, in 1964. *Sumida River* is the English noh version of *Sumidagawa*.

*Oshima Kinue (*shite*)*
performing in Sumida River *at*
the University of the Incarnate
Word, San Antonio, Texas.
November 2015.
Photo: David Surtasky

Shakumi

Similar to *fukai, shakumi* represents a middle-aged woman with a sad countenance, although perhaps a slightly older woman.

It is used exclusively by actors from the Kita and Komparu schools for the same third- and fourth-category noh where the Kanze only use the *fukai* mask. Hōshō and Kongō actors use both masks almost interchangeably. There is also a whiter *shakumi* mask (*shiro-shakumi*) and a younger *shakumi* mask (*waka-shakumi*).

The *shakumi* mask is noticeably asymmetrical as the eyes appear to be looking in different directions. This aspect is most likely due to a Komparu mask that was widely copied in the Edo period. This asymmetry seems to express the disturbed heart of a character such as the mother in the noh *Sumidagawa* or the woman in *Miidera*, both of whom have travelled long distances in search of their lost children. Compared to *fukai,* the *shakumi* mask face is slightly wider and that is also the reason why the mask appears purposely unbalanced.

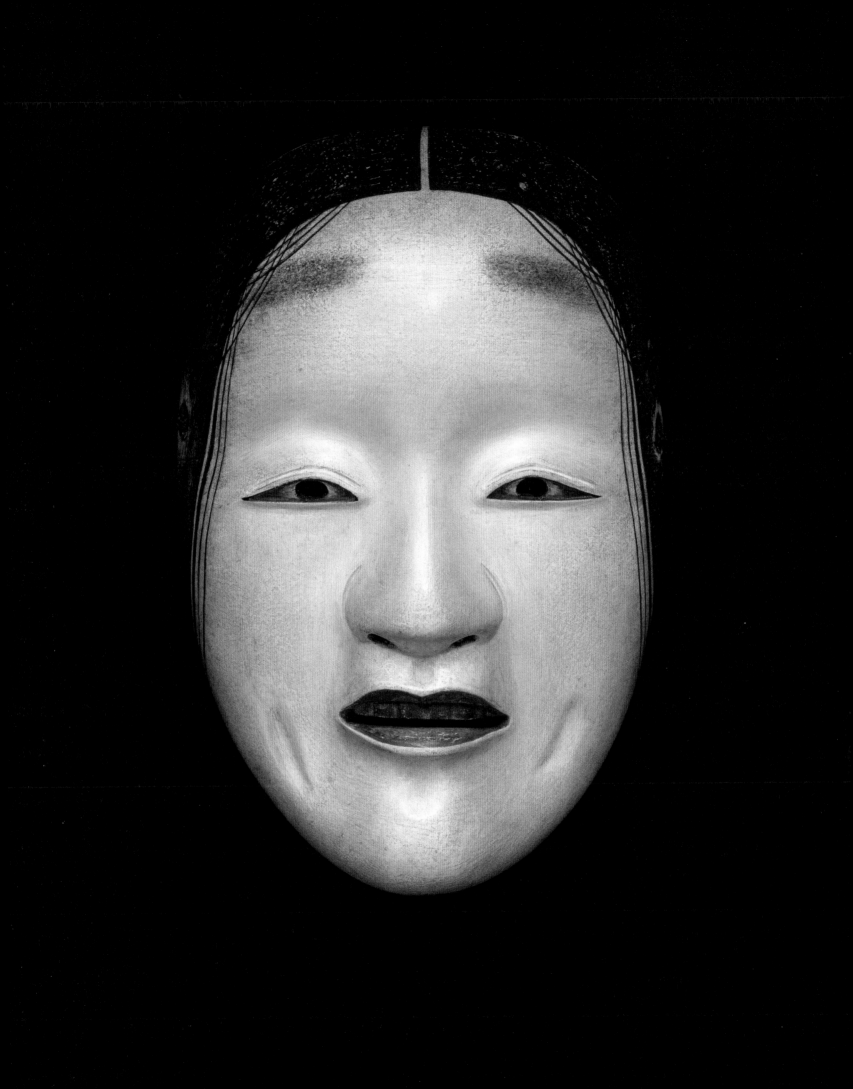

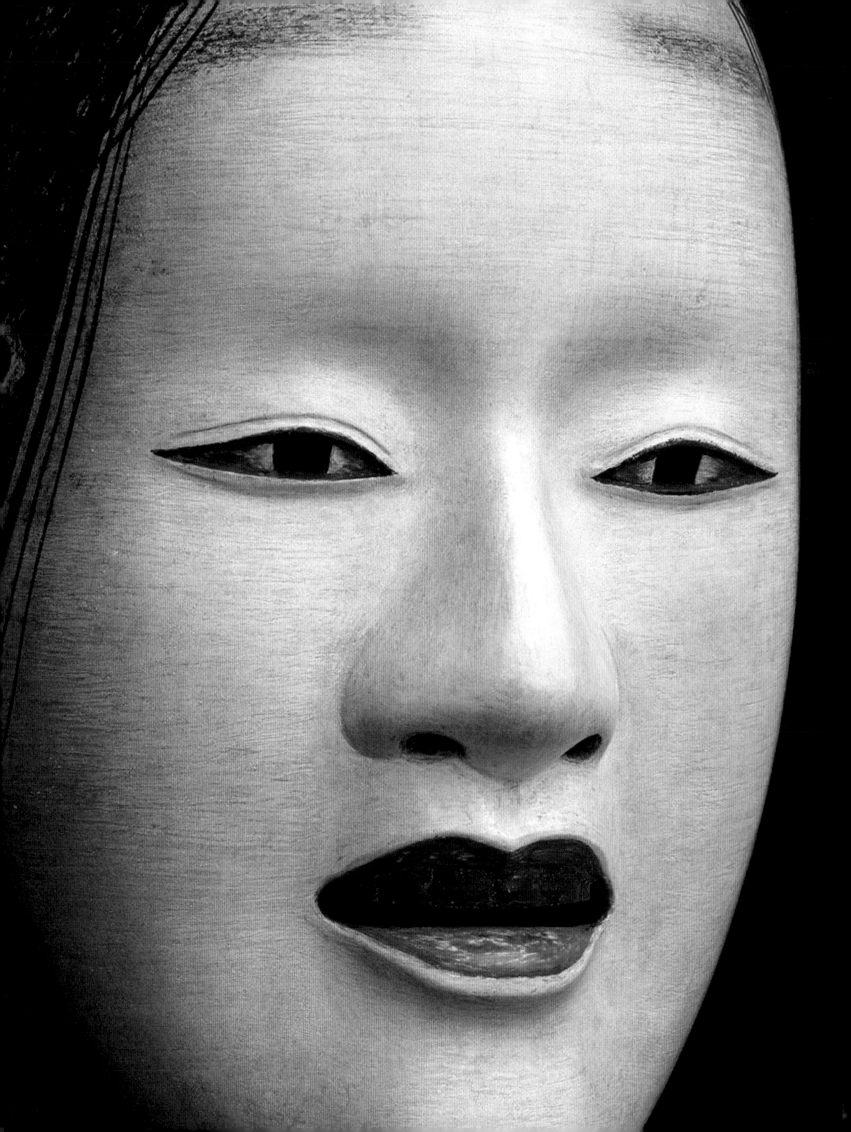

Zō

The *zō* mask, also known as *zō-onna,* is a slightly more mature and refined mask than the young women masks. It is used for refined female deities who often wear crowns. The mask and its name is said to come from the 14th-century *dengaku* actor Zōami.

Zō is one of the most difficult masks to make, and also one of the most difficult masks to wear for a noh performer. Kita actor Oshima Teruhisa reports that young noh performers are not permitted to use the *zō* mask when a *ko-omote* could be used instead. The latter is thought to be easier to use. The reason seems to be that the *zō* 'face' is neutral and mysterious. Kitazawa once heard that the famous post-war actor Kanze Hisao (1925–1978), the late leader of the Tessenkai group of the Kanze school, was a particular fan of the *zō* mask. The Tessenkai collection includes many wonderful *zō* masks. Kitazawa saw many of these when they were being 'aired' one summer after the rainy season.

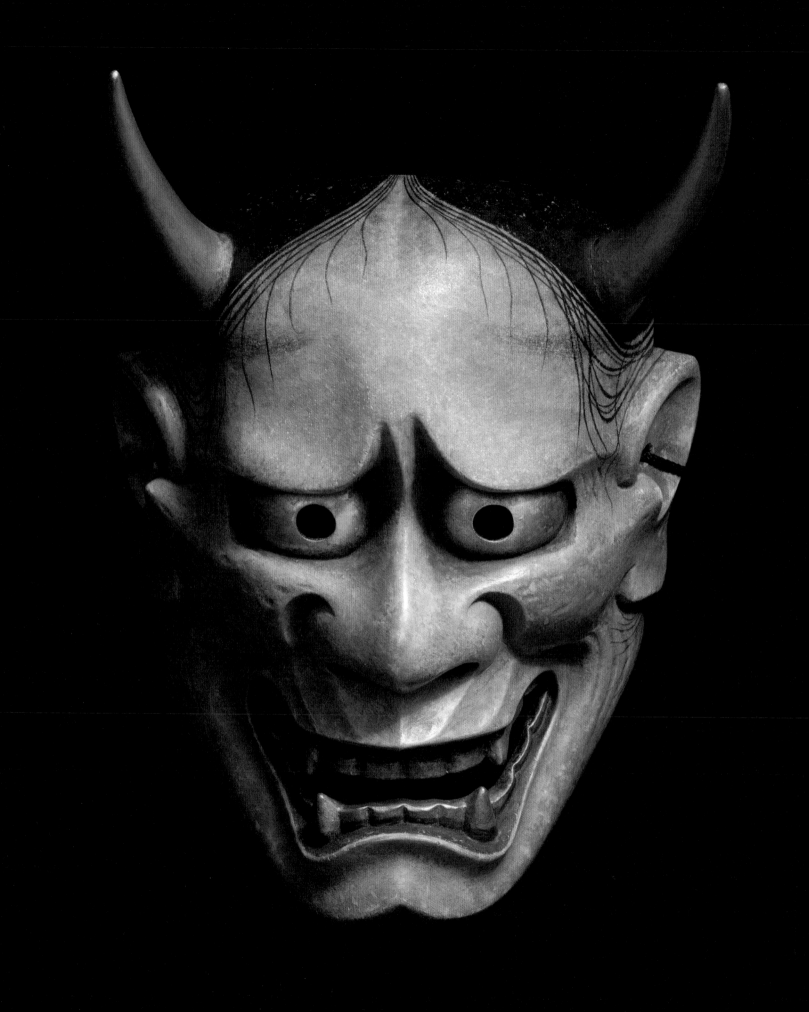

Hannya

The *hannya* mask is one of the most recognisable noh masks with its two prominent horns. It is named after its creator, Hannya-bō, who is one of the oldest known mask makers. *Hannya* represents a female character whose anger or jealousy has caused horns to grow on her head. This does not happen to angry or jealous male characters. The *hannya* mask also represents a sense of defeat and embarrassment. Its wide mouth gives the mask a demonic appearance, while the eyes appear to be sad. This suggests the character's dual personality.

The horns on *hannya* masks are made separately and are inserted in two holes at the top of the mask. The angle of the horns is important and the holes are circular to allow for adjustments. One horn is less curved than the other. This allows one to be prominent and appear more angry when the character enters the stage and less so when the character leaves the stage, a subtle difference typical of noh. The eyes and upper front teeth are made from copper covered with gold leaf, which shines, reflecting the light. Traditionally, when the eyes and teeth are painted gold, it indicates that the character is not in a 'normal human' state.

There are three types of *hannya* masks – white, red and black – and they have slightly different shapes. The white *hannya* is generally used for *Aoi-no-Ue* due to the high status of the character represented. The mask shown here is a red *hannya* often used for *Dōjōji*. *Hannya* can also be used in the noh *Kurozuka*, as well as in *Momijigari*.

Male Masks

男面

Male masks are often classified into two groups: those of old men, known as *jō-men* (old men masks), which are indicated with the word *jō* at the end of the name of the mask and reflect differing levels of refinement among old men; and *otoko-men* (male masks). The latter includes a wide age range of male characters, such as warriors (both refined and angry), temple attendants and other specific individuals. For our purposes, we have combined these two groups into one.

Takasago

Takasago Bay

Author: Zeami
(ca. 1363–ca. 1443)

Setting: Takasago in Harima
Province, present-day
Takasago City in Hyōgo
Prefecture; then Sumiyoshi
in Settsu Province, present-
day Sumiyoshi Ward in
Osaka City

Season: Early spring

Category: First-category
god (male god) noh,
phantasm (*mugen*) noh
in two acts, *kami-mai* (god
dance), with *taiko* stick
drum

Mask Type: *Kantan-otoko*
(second half)

Synopsis

Takasago deals with the legend of the twin pines of Sumiyoshi and
Takasago, personified in the first half of the play by an aged couple.
Sumiyoshi and Takasago are located across from each other on
Osaka Bay. According to legend, the spirit of the Sumiyoshi pine
travels nightly to visit his wife, the Takasago pine, in a bond that defies
age and time.

Three priests from Aso Shrine in Kyūshū are on their way by boat to
visit the capital and decide to stop off at Takasago to visit the famed
Takasago pine. There they meet an old couple sweeping the pine
needles and ask them why the Takasago pine is considered a twin
pine of the Sumiyoshi pine which is far away. The old couple tells
the legend of the pines before they reveal that they in fact are the
spirits of the two ancient pine trees. They invite the priests to visit
the Sumiyoshi Shrine to see its pine as well. In the second half, the
priests visit the Sumiyoshi Shrine, where the young vigorous god of
the shrine appears to them and dances.

Takasago, one of the best-known noh in the noh repertory due to
its auspicious nature, is popularly performed in the first month of the
new year, or for special felicitous events.

*Matsui Akira performs
Takasago at the Southbank
Centre, London, January
2020. Photo: Clive Barda/
ArenaPal*

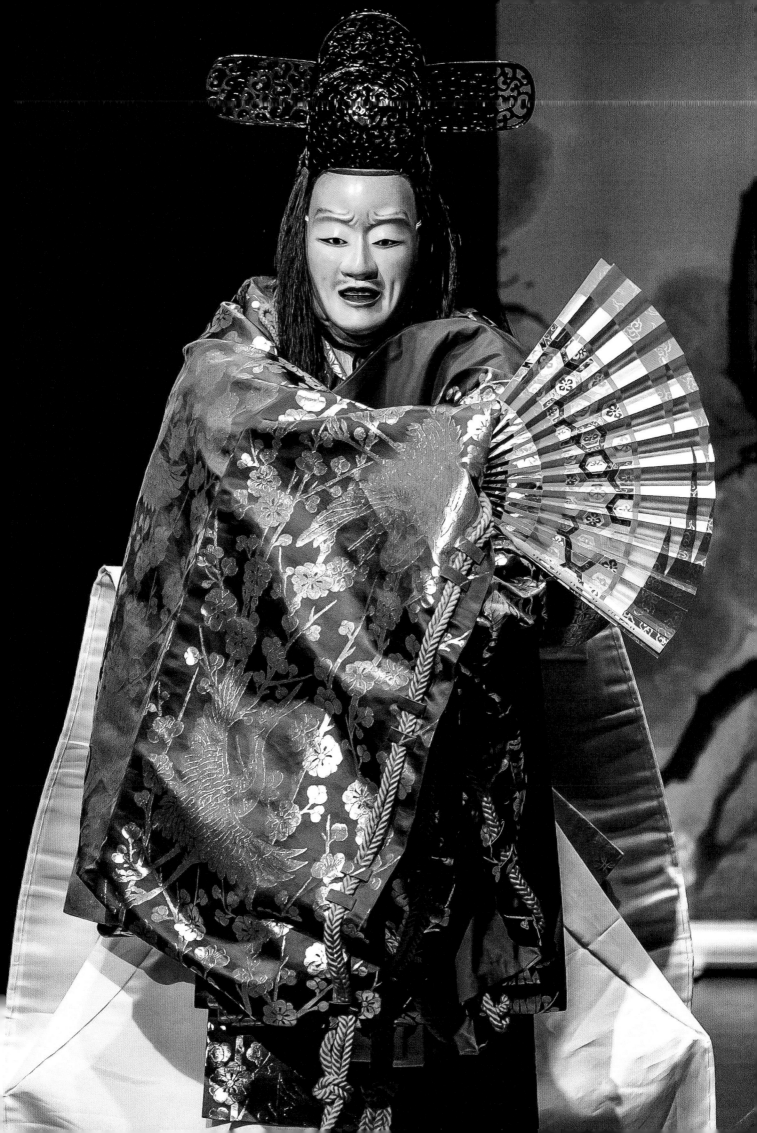

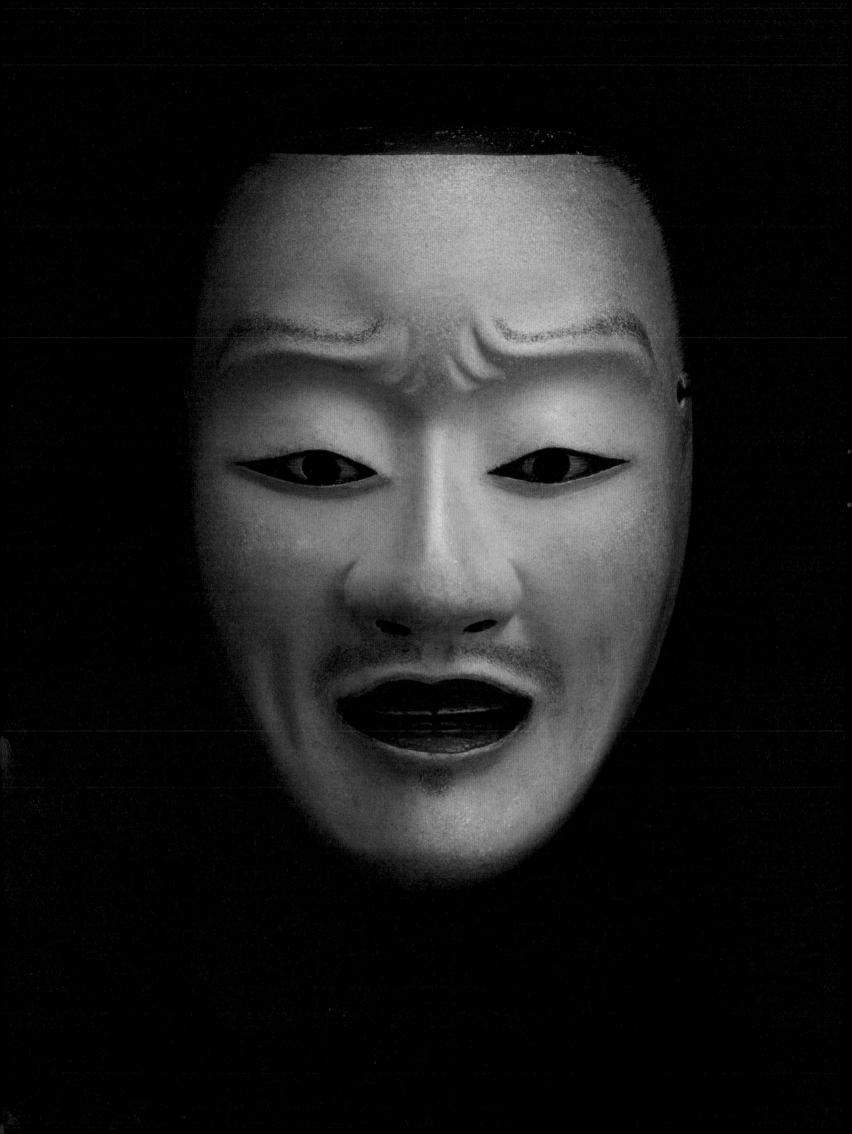

Kantan-otoko

Man of Kantan

This mask, with its prominent wrinkles between the eyebrows, was originally made for the troubled young man in the Chinese play *Kantan*, hence its name. In the Edo period, the mask came to be used for young, vigorous gods in first-category noh, including *Takasago*, *Arashiyama*, *Yumi Yawata* and *Yōrō*.

Kitazawa made this particular *kantan-otoko* for the young god in the second half of *Takasago*. It is an *utsushi* (copy) from a mask belonging to the Oshima family, but their mask was of a deeper yellow-brown colour, which works best for the fourth-category play *Kantan*. Instead, he painted this to look a bit whiter and lighter, which fits better with the idea of the young, vigorous god in *Takasago*.

邯
鄲
男

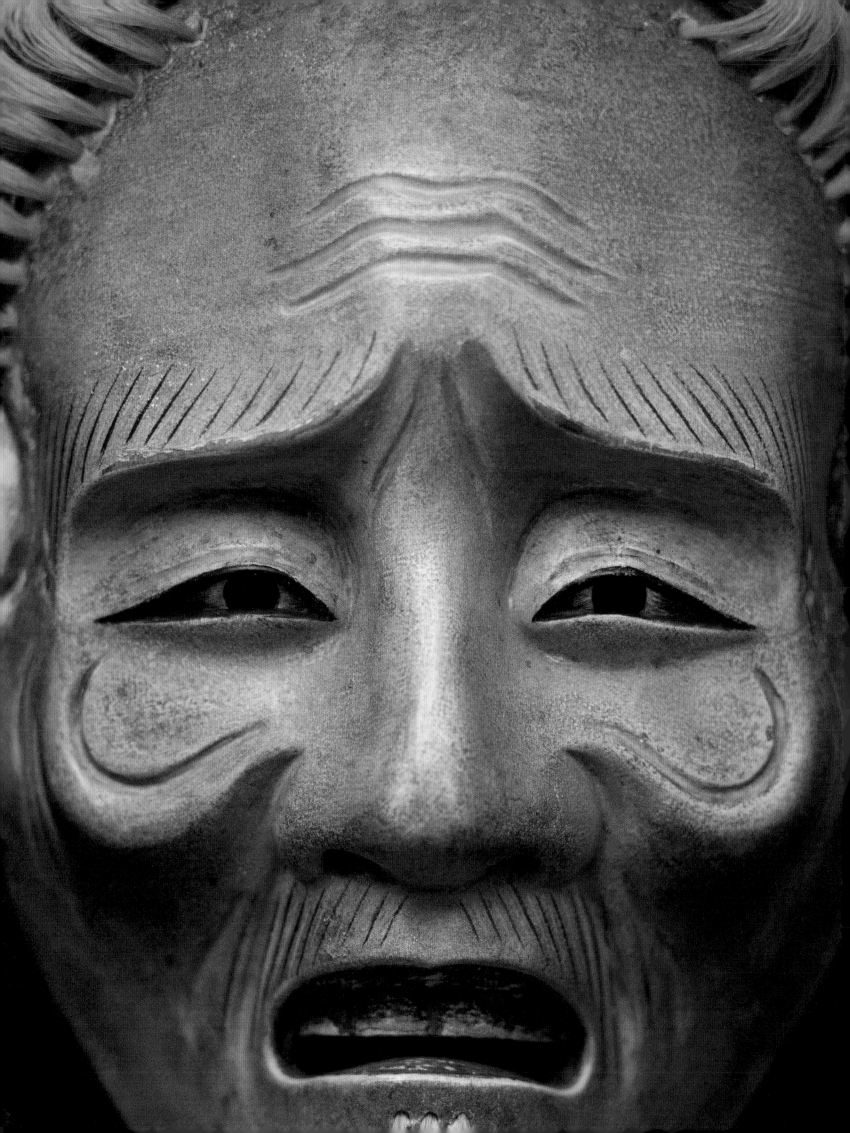

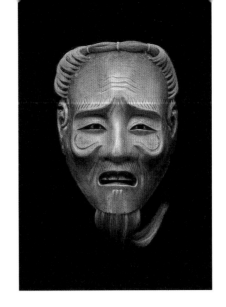

Kojō

Small Old Man

This refined old man mask was named after its creator, Ko-uji Kiyomitsu (14th century), who is one of the oldest known mask makers. The name *koushi-jō* is sometimes used for the name of the mask, though *kojō* is more common. The *kojō* mask is used in the first half of first-category god noh such as *Takasago*, *Arashiyama*, *Yumi Yawata* and *Yōrō*. It is also used for a living person representing the old father in the first half of *Tenko*. This mask was used in the contemporary work *Opposites-InVerse* (2017).

In making this mask, Kitazawa focused his attention on creating a god-like elegant old man's 'face'. The hair is made from white horsehair dyed with a liquid made from boiling Japanese green alder berries, known as *yasha* (*Alnus firma*).

Sankō-jō

Old Man

The *sankō-jō* mask is named after its creator, the mask maker Sankō-bō (–1532). It is generally used for the first half *shite* in several second-category noh to represent common folk such as a fisherman, boatman, woodsman or old soldier. Compared to the refined *kojō*, *sankō-jō* has a rustic look with more wrinkles, a tanned complexion and a face hardened with toil. Although interchangeable with two other old men masks, *asakura-jō* and *warai-jō,* while the Kanze school uses *asakura-jō* as its standard mask of this common old man type, the Kita, Komparu and Kongō schools use *sankō-jō* as its standard type. It is used in several noh pieces such as *Arashiyama*, *Kanehira*, *Yashima* and *Michimori.*

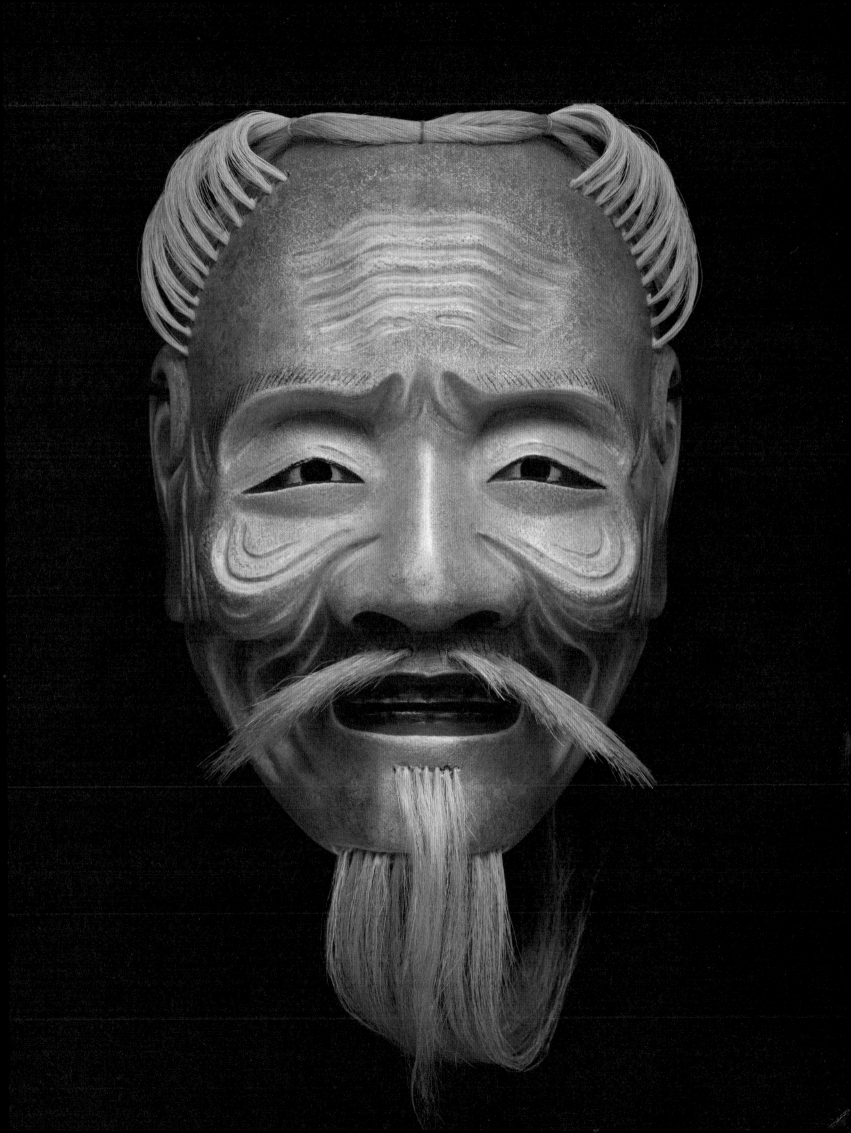

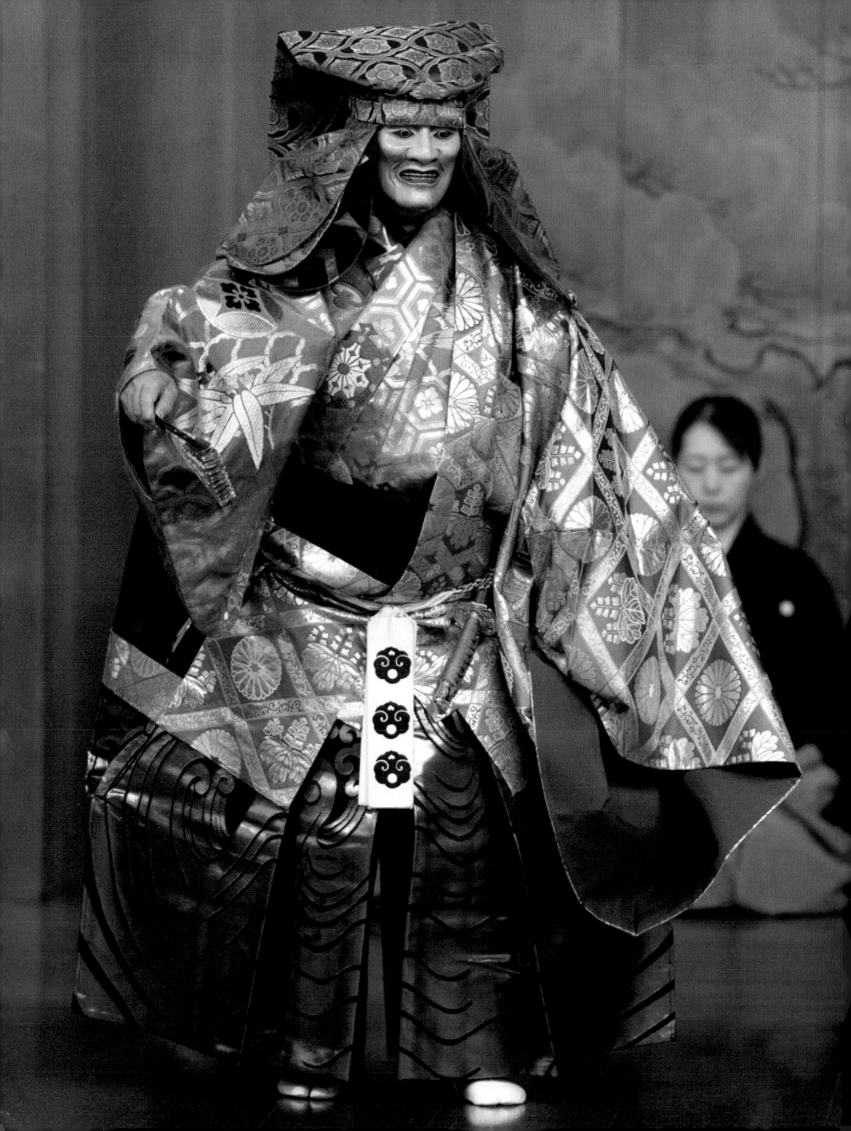

Yorimasa
The Warrior Poet Yorimasa

Author: Zeami
(ca. 1363–ca. 1443)

Setting: The banks of the Uji River, Uji in Yamashiro Province, the present city of Uji in Kyoto Prefecture; then the Byōdōin Temple in Uji

Season: Early summer

Category: Second-category warrior (old warrior) noh, phantasm (*mugen*) noh in two acts, without *taiko* stick drum

Mask Type: Special *yorimasa* mask

Synopsis

This noh concerns the 12th-century lay monk and warrior-poet Minamoto no Yorimasa, who killed himself at the Byōdōin Temple in Uji after losing in battle to the Taira. A travelling priest stops at Uji to admire the scenery and meets an old man who tells him about the area. The old man shows him a patch of grass shaped like a fan and tells him that it is where Yorimasa killed himself. He reveals that he is the spirit of Yorimasa and disappears. The priest prays for Yorimasa's ghost, which then appears again in its true form. The ghost describes in detail the circumstances of the battle and then, asking the priest to pray for him, vanishes.

Yorimasa, *Sanemori* and *Tomonaga* are considered the 'three warriors' (*san shura*) in that all three feature ghosts of old warriors and are emotionally deep in their presentational style.

頼
政

Matsui Akira performs Yorimasa at the Oshima Noh Theatre, 2023. Photo: Kuwada Naomi. Courtesy of the Oshima Noh Theatre

Yorimasa

The Warrior-Poet Yorimasa

The *Yorimasa* mask is a dedicated mask for the main actor of the noh *Yorimasa*. The key characteristics of the *Yorimasa* mask are its up-turned eyebrows, golden metallic eyes and teeth, and wrinkles on the forehead and around the nose and mouth. The mouth is the shape of a silk-moth cocoon. It is meant to represent a deeply tormented old warrior defeated in battle.

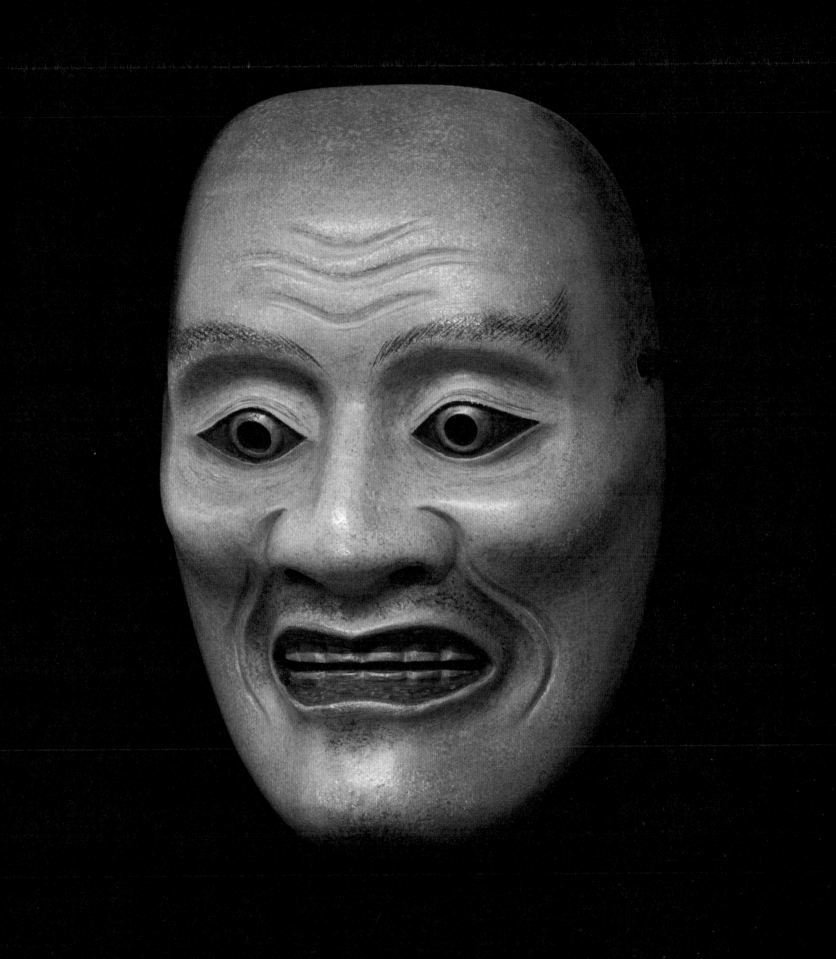

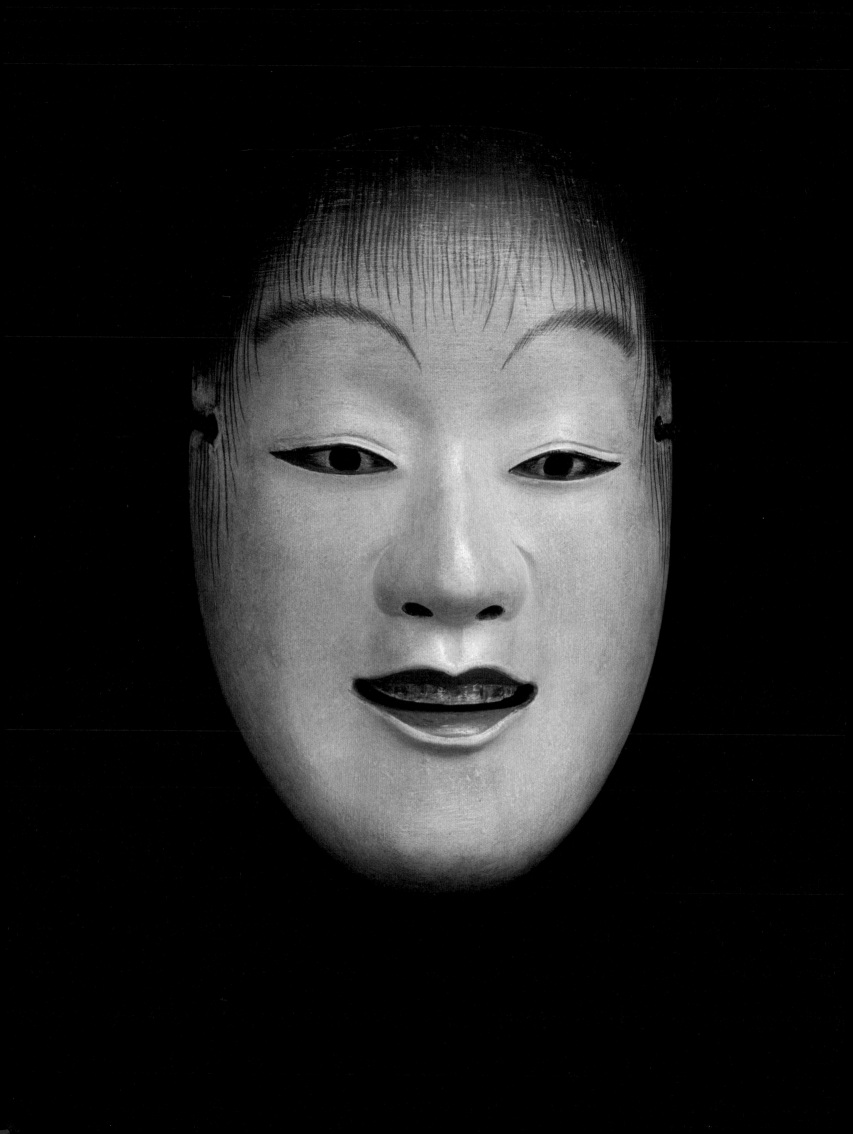

Dōji
Young Boy

This is a mask of a handsome young boy. It is used to portray the ageless 800-year-old Chinese hermit in *Makurajidō*, the ghost of the young Chinese boy in *Tenko,* the first-half young boy demon in *Oeyama*, a divine spirit youth in *Tamura* and a youth in *Raiden*.

The hair and eyebrows for *dōji* must be painted with extreme delicacy. Kitazawa made this *dōji* mask for Kita actor Matsui Akira to use in *Makurajidō*. The *Makurajidō* story is a kind of Chinese fantasy and that, according to Kitazawa, is why this *dōji* has a handsome face. For other noh such as *Tenko* or *Tamura,* he believes it would be necessary to create a more mysterious face.

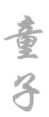

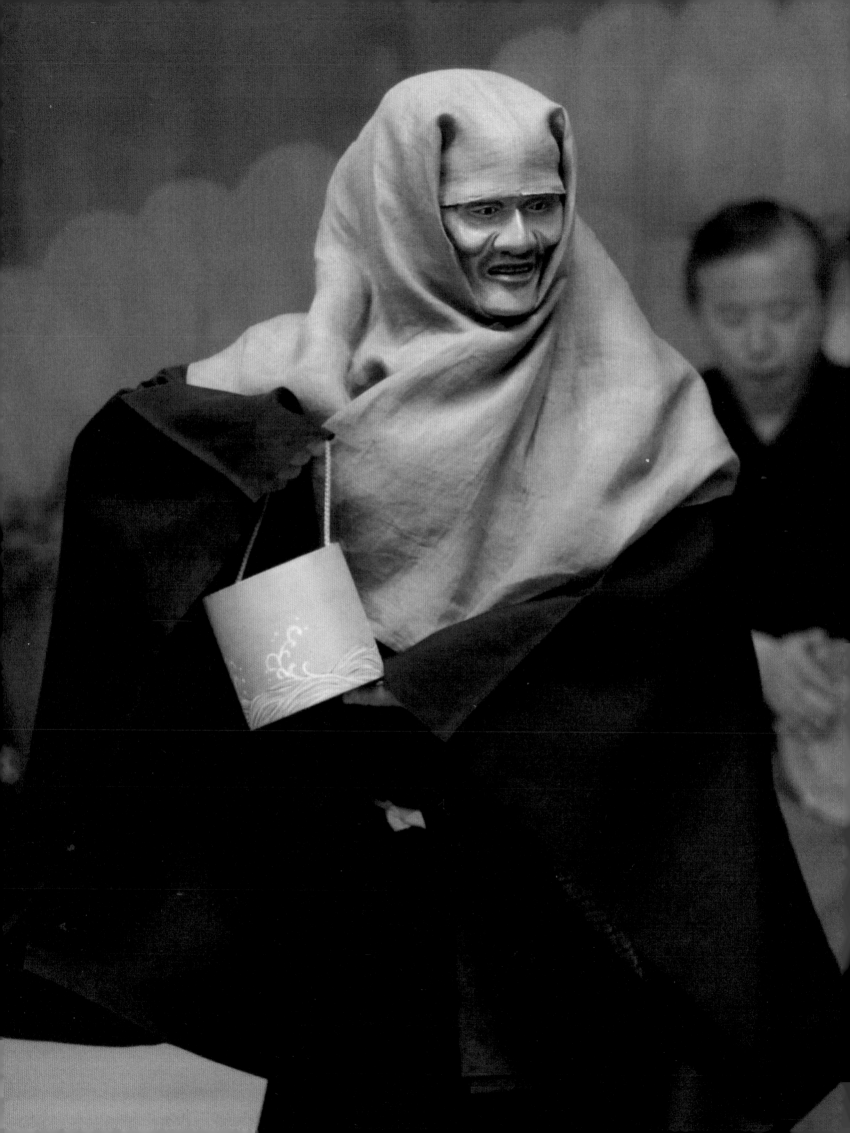

Shunkan

Priest Shunkan

Author: Unknown, though attributed to Komparu Zenchiku (1405–ca. 1470)

Setting: The second year of the Jigo era (1178). First, the capital (Kyoto); then, the island of Kikaigashima (Demon Island), located between Satsuma Province of southern Kyushu and the Ryukyu Islands, in present-day Kagoshima Prefecture, Kyushu

Season: Autumn

Category: Fourth-category miscellaneous (human feeling) noh, present-time (*genzai*) noh in two acts, without *taiko*

Mask Type: Special troubled middle-aged *shunkan* exclusive to this noh

Synopsis

Shunkan, known as *Kikaigashima* in the Kita school, features the troubled middle-aged priest Shunkan, who conspired with Fujiwara no Naritsune, the governor of Tamba, and Taira no Yasuyori, a high police official, in an attempt to overthrow the powerful prime minister, Taira no Kiyomori. As a result, they were exiled to the isolated island of Kikaigashima.

An emissary from the prime minister comes by boat to the island with a written pardon for Naritsune and Yasuyori. When Shunkan realises his name is not on the pardon, he is devastated. The emissary insists that he must be left behind. The noh ends with Shunkan left alone on the desolate island watching the boat depart.

Oshima Masanobu performs the priest Shunkan in the noh Kikaigashima *at the Kita Noh Theatre, Tokyo, 2010. Pictured also: Tsukuda Yoshikatsu (ōtsuzumi hip drum). Photo: Ikegami Yoshiharu. Courtesy of the Oshima Noh Theatre*

Shunkan

Priest Shunkan

Shunkan is a dedicated mask for the character in a piece of the same name, also known as *Kikaigashima*. Kitazawa made this mask in 2010 for Oshima Masanobu, the head of the Oshima Noh Theatre. Kitazawa usually attends the performances for which his masks have been specially commissioned and he considers Masanobu's performance to be one of the most moving noh he has seen.

There are several styles of *Shunkan* masks. When Kitazawa was commissioned to make this mask by the Oshima family of the Kita school, thinking of the Kita performance style, he knew he wanted to make a mask with a strong expression which has a moral sensibility. Though such a mask is difficult to make, he discussed his thoughts with Kita actor Oshima Teruhisa. Sharpening the angle between the eyebrows and the eyes enabled the mask to have a dark shadow, which appears when the actor lowers the mask using the typical technique known as *kumorasu* (literally, 'to cloud'). In this performance it has the effect of accentuating and deepening the expression of *Shunkan*'s loneliness.

Kitazawa tells how when he saw Teruhisa's father, Oshima Masanobu, perform with the mask, Masanobu lowered the mask in this way in the final scene of despair, holding it still for a long time. This was extremely moving for Kitazawa and he feels that this experience enabled him to gain an even deeper understanding of noh and the use of noh masks.

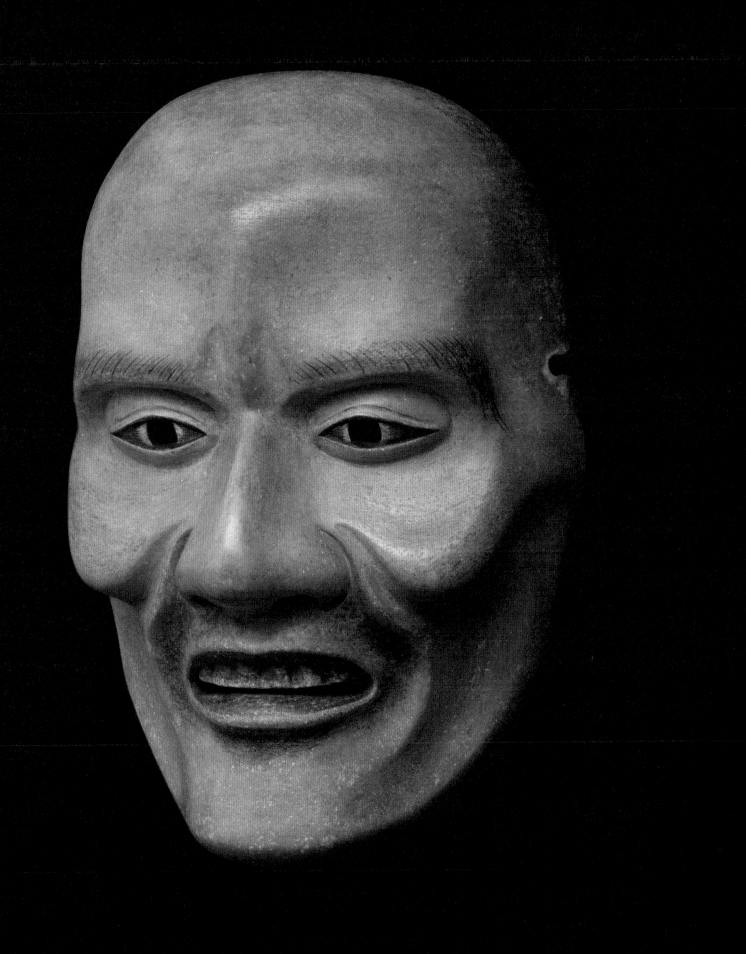

Gods and
Demons

鬼神面

Kishin-men indicates masks (*men*) for both gods (*shin*) and demons (*ki*). While the gods in first-category god noh are most notably old men of a refined character, the gods in this section are those that appear in fifth-category noh and have a much more powerful visage. Here, the line between gods and demons is a fine one in terms of their power and ferocity.

The expressions of these masks are large, often with bulging eyes and open mouths, or lips tightly clenched together to show that power. In general, the characters of these masks appear not only at the end of a fifth-category noh, but at the end of a full day of several noh. Their appearance is quick and short, and leave the audience with an intense impression, very unlike the third-category women noh that have deep internal emotions expressed in their highly refined poetic sensibility. In noh, gods are to be feared, even though they are recognised for their protection of man, and demons, though also feared, are eventually defeated by the power of Buddhist prayer. All in all, fifth-category gods/demons create a fitting ending to a traditional programme of several noh.

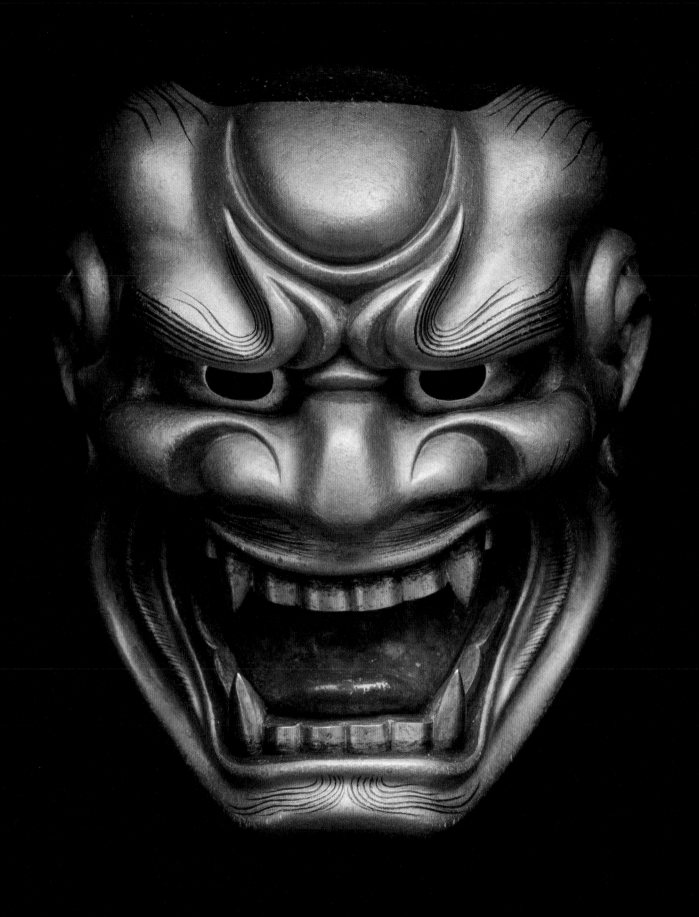

'Among all pieces in noh, the shishi "lion" dance of Shakkyō expresses the strongest and most intense sense of dynamic beauty.'

Oshima Teruhisa
Kita School Noh Actor

Shishiguchi

Lion Mouth

The *shishiguchi* mask (left) and the *kojishi* mask (overleaf) are used for the *shishi* 'lion' roles solely in the felicitous noh *Shakkyō*. Lion dances appear notably in China and other neighbouring Asian countries and are said to bring good fortune. In the noh version, lions are the attendant guardians at the stone bridge (*shakkyō*) that crosses over to the pure land of Monju Bosatsu, the Buddhist bodhisattva of wisdom. Although often performed by one *shishi* only, it is also common to have two or more, often a father lion and a son lion.

These two lion masks, *shishiguchi* ('lion mouth') for the father and *kojishi* ('young lion') for the son, were commissioned by the Oshima family as part of their 2013 celebration of the 100th anniversary of the Oshima Noh Theatre in Fukuyama, Hiroshima Prefecture. The roles were performed by Shiotsu Akio and Oshima Teruhisa as father and son lions.

This was also Teruhisa's *hiraki* – the special first performance of an important noh. In preparing the masks, Kitazawa had many discussions with Teruhisa. Before painting the mask, Teruhisa tried the mask on to assess how well it fitted his face. As *Shakkyō* is a very active dance, two sets of mask cords are used to tie the mask tightly around the head. Thus, two holes on each side of the mask are required. Such holes are made only for *shishi* masks.

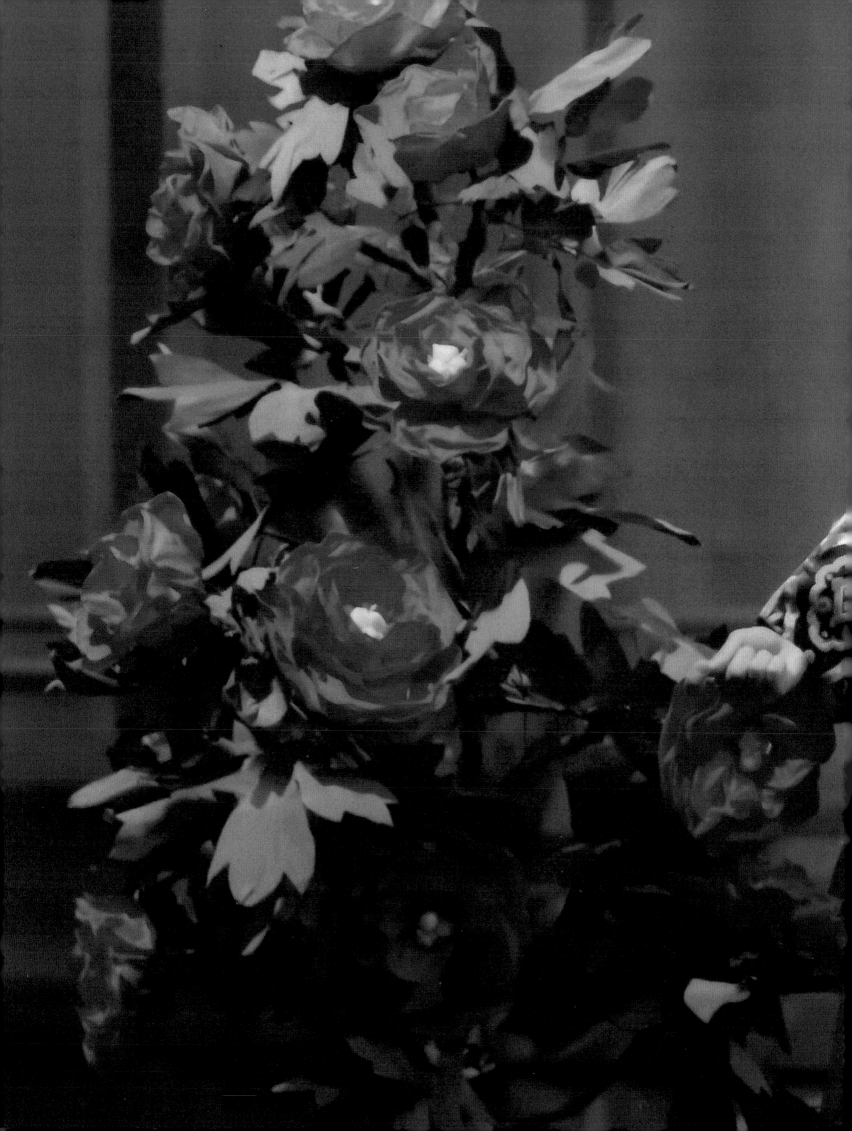

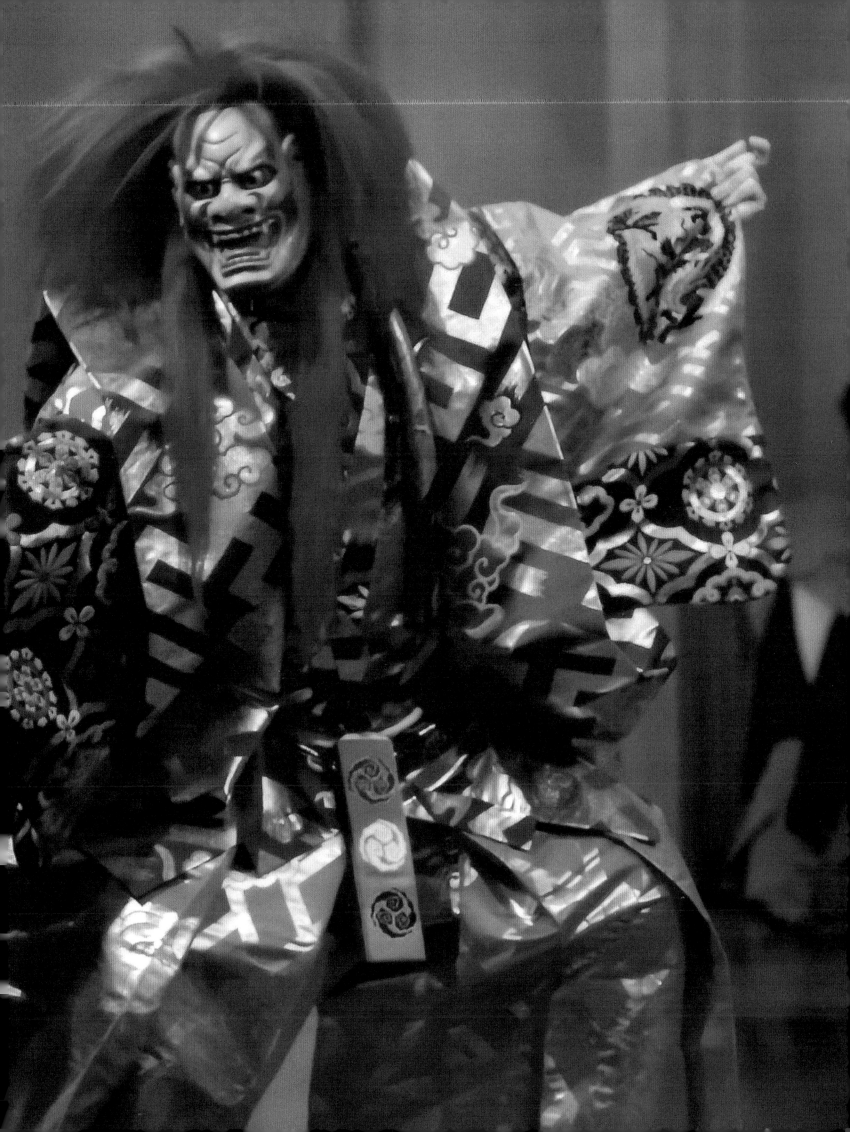

Shakkyō
The Stone Bridge

Author: Possibly one of three authors: Zeami (ca. 1363–1443), Kanze Motomasa (ca. 1401–1432) or Miyamasu (ca. 15th century)

Setting: Early 11th century. Mt. Shōryō (Ch: Ch'ing Liang Shan), present-day Shanxi province, China

Season: Early summer

Category: Fifth-category ending (celebratory) noh, phantasm (*mugen*) noh in two acts, *shishi* (lion dance) piece, with *taiko* stick drum

Mask Type: First half, the young boy (*dōji*) or old man (*kojō*) mask. Second half, a guardian lion (*shishiguchi*), see page 84, with a young lion (*kojishi*), opposite

Synopsis

Priest Jakujo is travelling to China and India to visit famous Buddhist sites. He arrives at Mount Shōryō where there is a stone bridge over a deep ravine. The bridge, it is said, leads to the 'pure land' of Monju Bosatsu, the Buddhist bodhisattva of wisdom.

Priest Jakujo is about to cross the bridge when an apparition (either a young boy or an old woodcutter) appears and stops him, saying that it is extremely difficult for humans to cross. The apparition relates stories of the bridge to the priest and then tells him that he will see something miraculous if he waits until nightfall. Later, a guardian lion and attendant of Monju Bosatsu appears and dances an auspicious dance among the beautiful blossoming peonies.

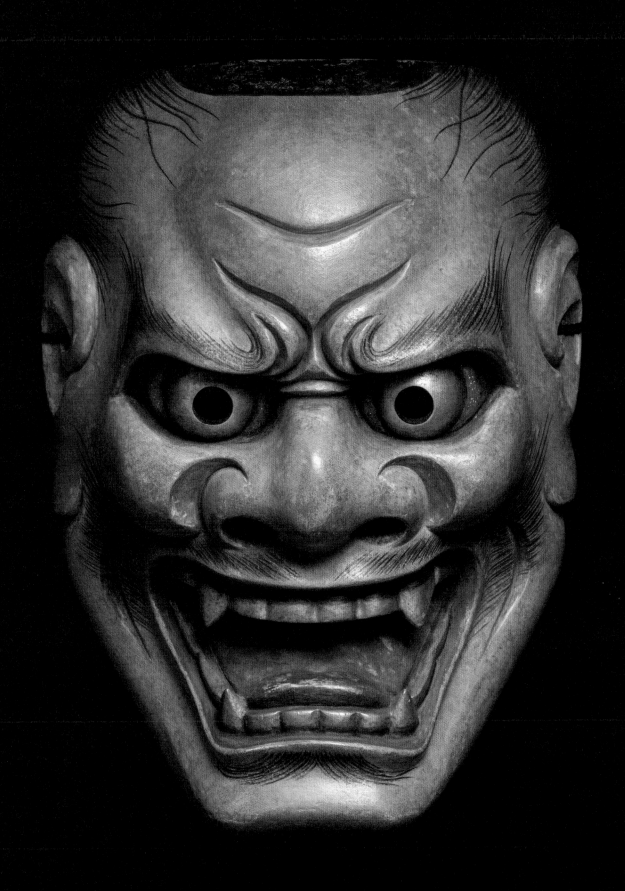

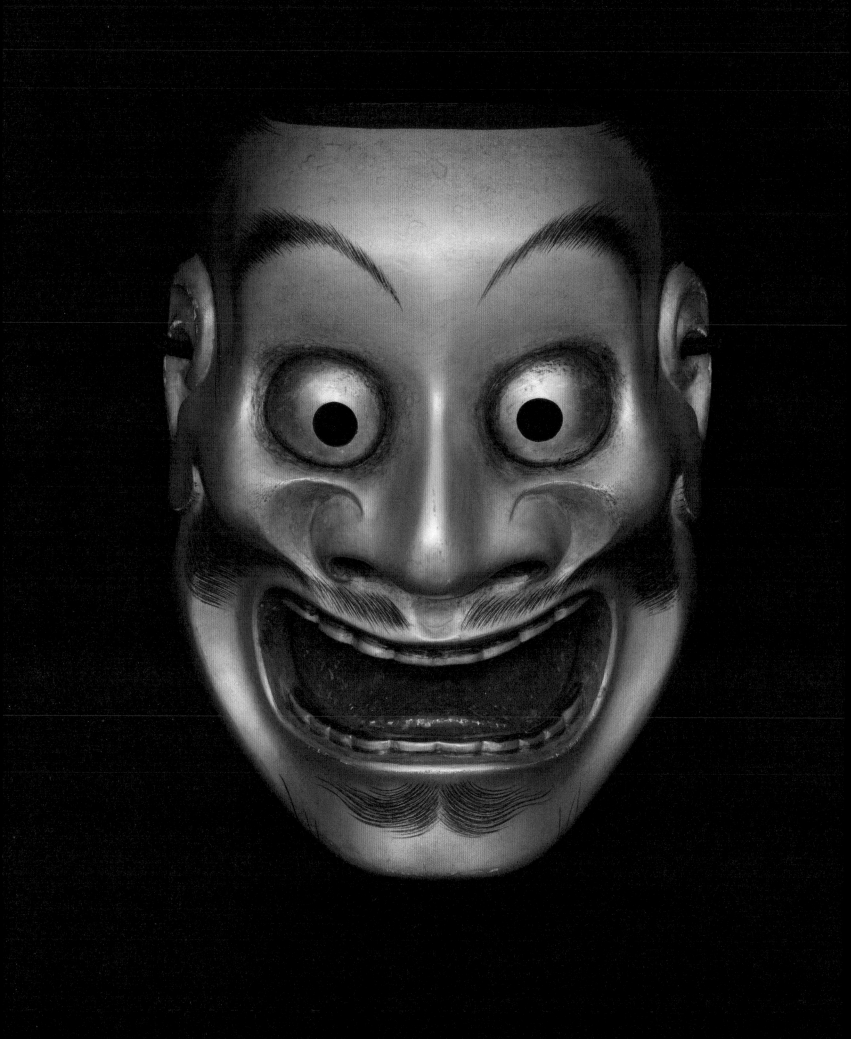

Otobide

Large Bulging Eyes

This mask is used to represent the fierce god Zao Gongen in *Arashiyama* and *Kuzu*, or the thunder god in *Kamo* as well as other fierce gods. This particular mask was used by Kita actor Matsui Akira in *Kamo* (2018). Otobide is painted using real gold powder. There is a big difference in the quality of the shine compared to imitation gold. *Otobide, shishiguchi, raiden* and *shaka* are all painted with real gold paint. Before painting the final layer of gold (and after painting the basic white *gofun* which is a layered primer on all masks), both *ōtobide* and *shishiguchi* are painted orange, *raiden* is painted a light red and *shaka* brown. These different undercoat colours create a different finish even when using the same real gold powder as the final coat. *Otobide* represents a fierce yet joyful god and the orange undercoat makes for a brilliant gold. *Shaka* is dignified and the brown undercoat gives a calmer gold.

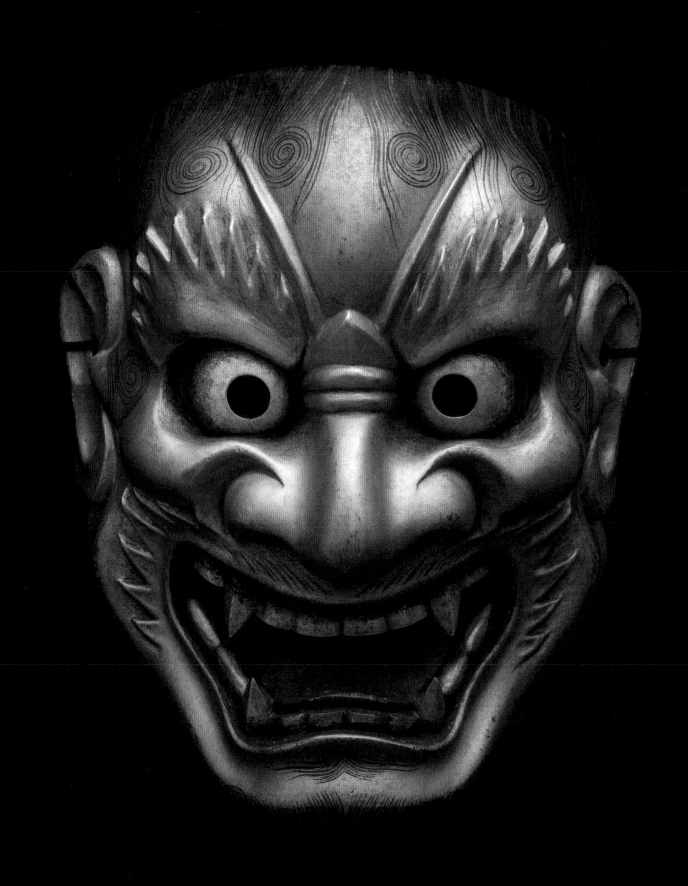

Raiden

Thunder and Lightning

The play *Raiden* usually uses the *shikami* ('grimace') mask for the second-half main character. Kitazawa had heard of a mask belonging to the Bizen Ikeda feudal lord clan which was made in the early Edo period. This mask is now in the Hayashibara Museum (Hayashibara Bijutsukan) in Okayama and appears to be the only one of its kind. Kitazawa based his *raiden* mask on a photo of the Hayashibara Museum mask.

This *raiden* mask represents the angry demonic form of the ghost of Sugawara no Michizane, the 10th-century scholar-statesman who was exiled. In the play, Michizane's angry spirit returns as the God of Thunder to attack the capital and the people in power who had exiled him. Matsui Akira used this mask when he performed *Raiden* in 2011 and again the following year.

雷電

Nue

Nightbird

Author: Zeami
(ca. 1363–1443)

Setting: Spring, Ashiya
Village, Settsu Province

Category: Fourth-category
miscellaneous or fifth-
category ending (demon)
noh, *kakeri* (action dance)
piece, phantasm (*mugen*)
noh in two acts

Mask Type: In the second
half, the male demon
(*kotobide*) as the Ghost of
the Nightbird

Synopsis

A travelling priest stops in the village of Ashiya for the night and meets a strange-looking boatman on a boat approaching the shore. The boatman is the spirit of a *nue* (nightbird), a demon chimera made of many parts: the head of a monkey, the tail of a snake, the limbs of a tiger and with the nightbird's fearsome cry. The boatman (nightbird) tells how it tortured the Emperor until the warrior Yorimasa was sent to kill it, and how it was struck down by Yorimasa's arrows. The priest prays for the boatman and in the second half the spirit appears in its true form, describes how it was a hateful demon and then re-enacts how Yorimasa's arrows killed it.

Oshima Kinue performs
Nue *at the Oshima Noh
Theatre, Fukuyama,
November 2017.
Photo: Kuwada Naomi
Courtesy of Oshima Noh
Theatre*

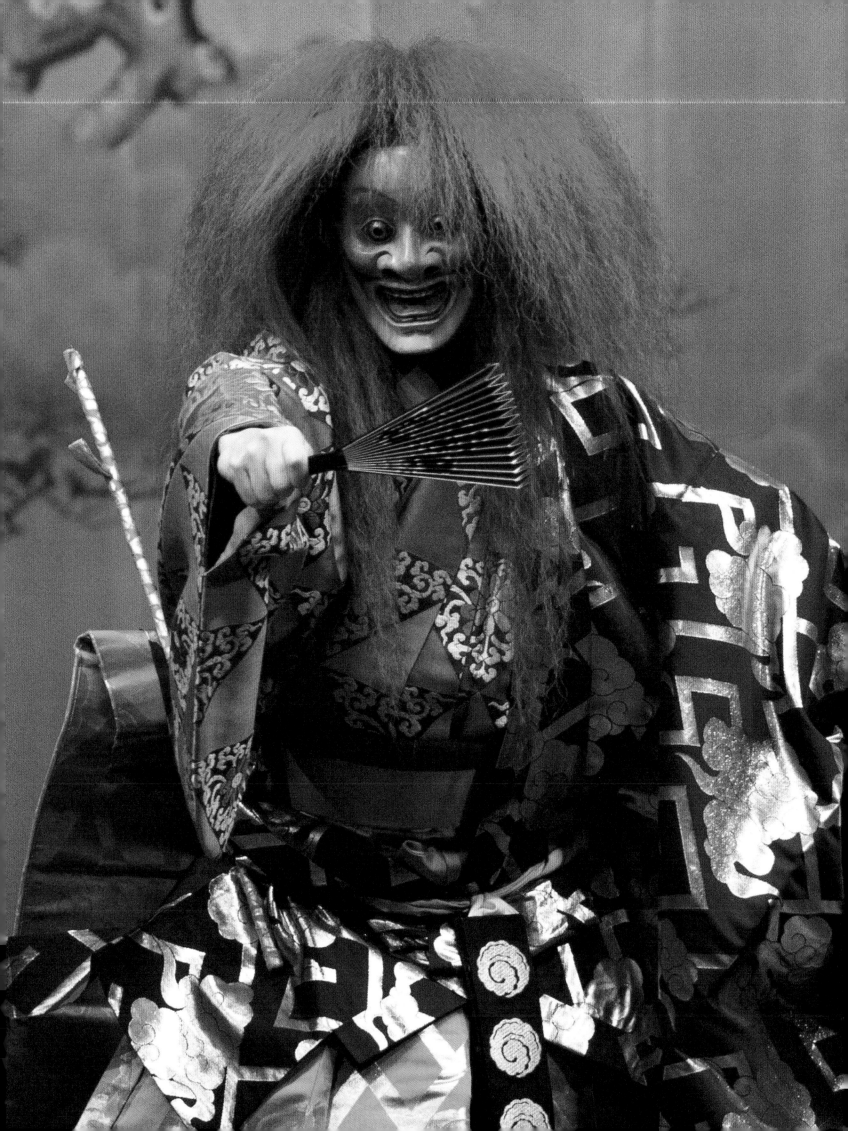

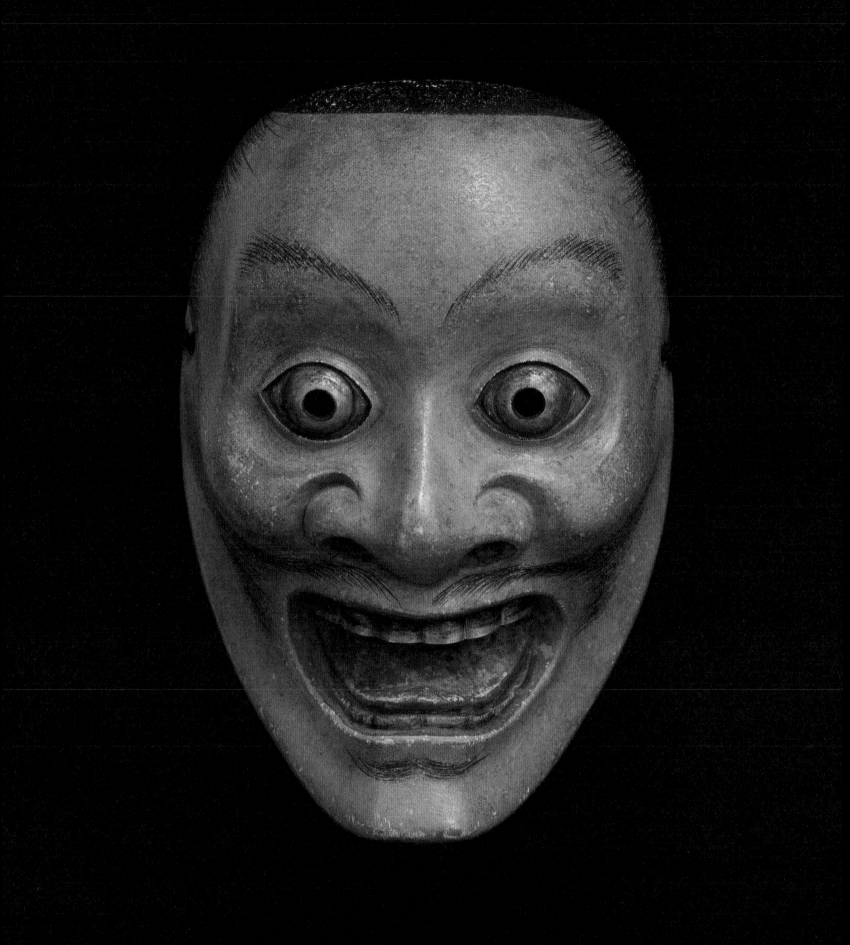

Kotobide

Small Bulging Eyes

This mask is a smaller version of the *ōtobide* mask. It represents an animal apparition such as the fox god in *Kokaji*, the fox enchantress in *Sesshōseki* or the *nue* nightbird made of several animal parts in the noh *Nue*. This particular mask was used by Kita actor Oshima Kinue in *Nue*. A *nue* is said to be a supernatural animal – part monkey, part snake and part tiger in the form of a nightbird. Kitazawa made this *kotobide* mask to have a slightly grotesque monkey-like face.

Obeshimi

Large Pursed Mouth

The characteristic pursed mouth of the ōbeshimi mask is said to be a suggestion of its supernatural powers. The ōbeshimi mask is typically used to represent a tengu, the supernatural being which is generally portrayed in Japanese folklore as having a long phallic nose. They are said to live deep in the mountains and have mysterious superpowers. The tengu in noh are portrayed in a more refined manner without the long nose, but with a somewhat humorous mien. It is used in Kurama Tengu, Kurumazō, Zegai and Dai-e. This mask was used by Kita actor Oshima Teruhisa in the noh Kurumazō.

大癋見

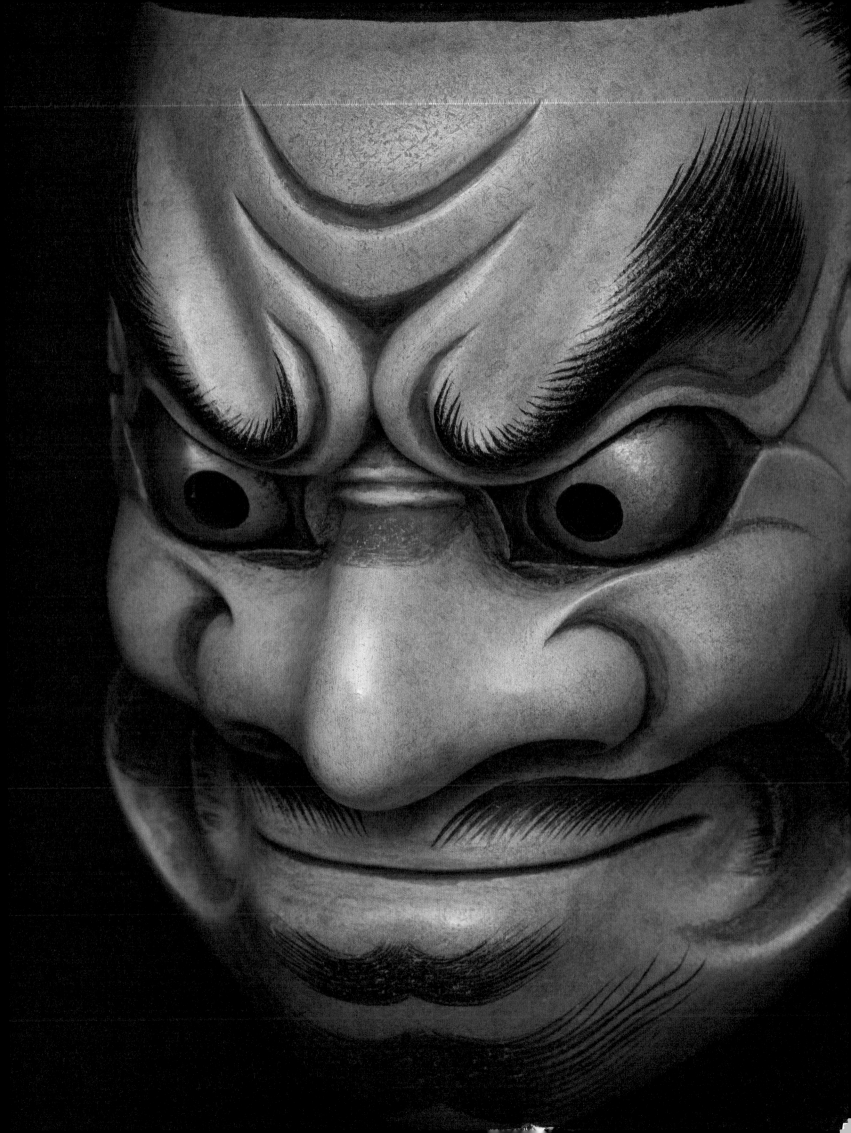

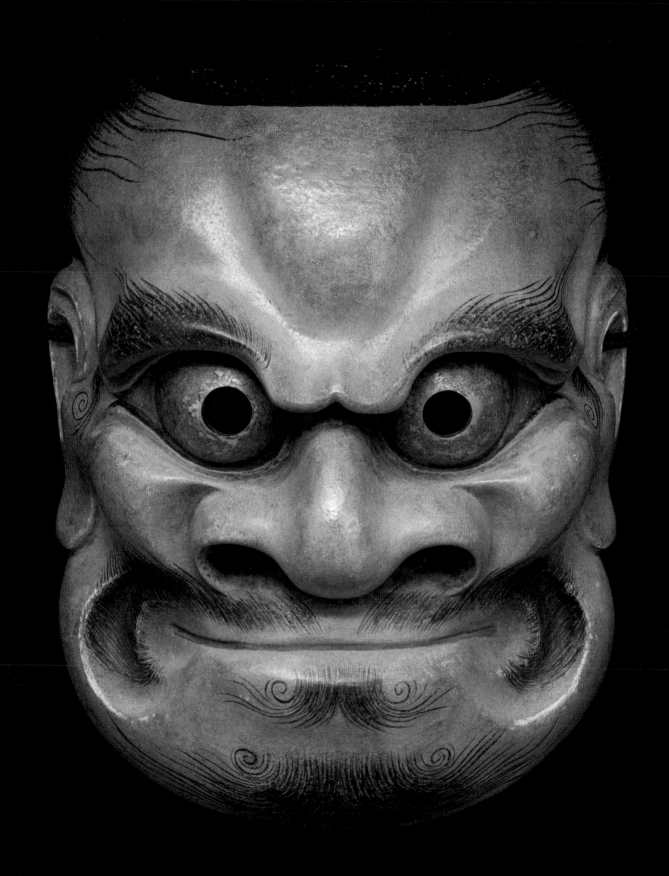

Chōrei-beshimi
Chōrei Pursed Mouth

As described for the *ōbeshimi* mask above, *beshimi* masks are used to describe 'closed', or 'pursed mouth' gods. *Chōrei-beshimi* is named after the mask maker Chōrei who first created this version of this type of mask. There are also *ō* (large) and *ko* (small) size versions of this mask. This particular mask was used by Kita actor Matsui Akira for the noh *Kumasaka,* in 2016 for an Oshima Kai in Fukuyama and again the following year for the Kita Shokubun Kai in Tokyo.

長霊癋見

Aya-no-Tsuzumi
The Damask Drum

Author: Unknown

Setting: 7th-century temporary Imperial Log Palace at Asakusa in Chikuzen Province, Fukuoka Prefecture in Kyūshū

Season: Autumn

Category: Fourth-category miscellaneous (male attachment) noh, combination present-time (*genzai*) and phantasm (*mugen*) noh in two acts, with *taiko* stick drum

Mask Type: *Oakujō*

Synopsis

An old gardener on the grounds of the 7th-century temporary Imperial Log Palace in Kyūshū has fallen in love with an imperial consort. He is told that if he can make the sound of a drum in the grounds to reach her, she will invite him to see her. When the old man strikes the drum, it does not make any sound because it has been covered with damask. The old man is overcome with anger and despair, and drowns himself in the Laurel Pond in the palace grounds. His angry ghost then appears and vents his feelings towards the consort.

Matsui Akira performs Aya-no-Tsuzumi at the Oshima Noh Theatre, Fukuyama, April 2021
Photo: Kuwada Naomi.
Courtesy of Oshima Noh Theatre

綾鼓

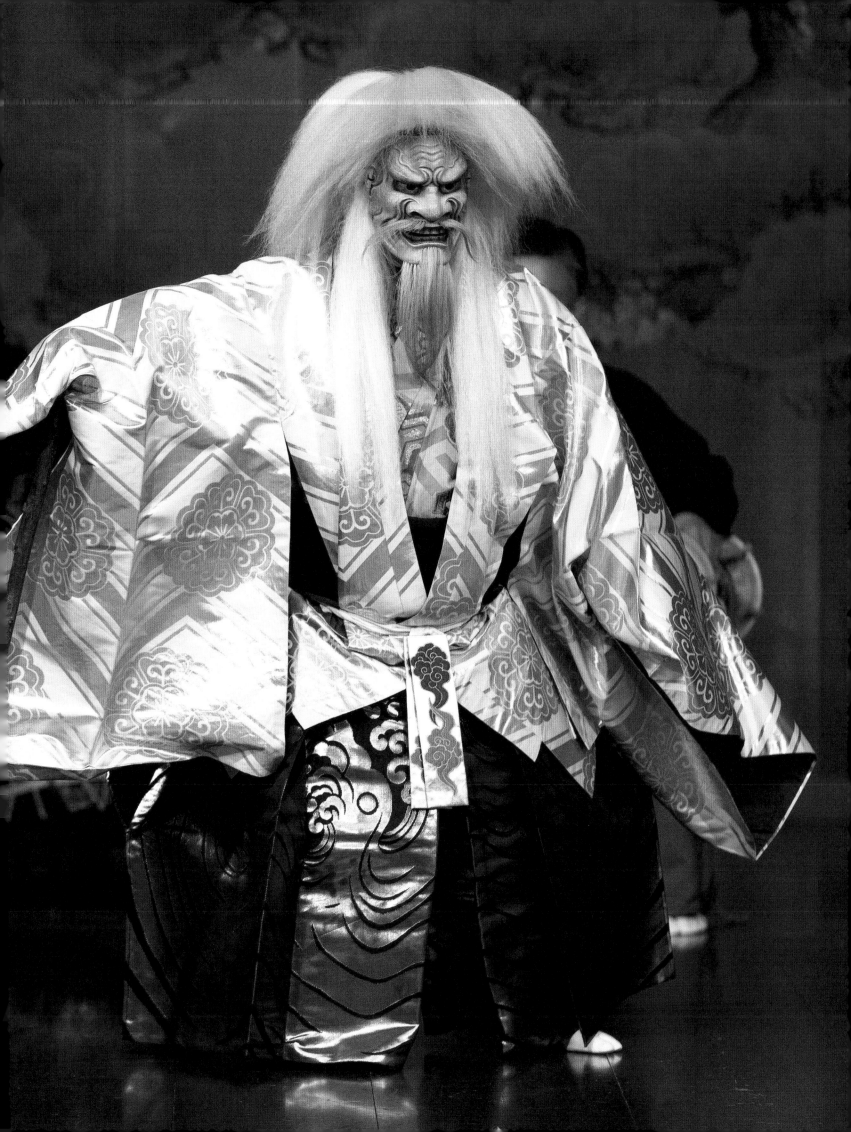

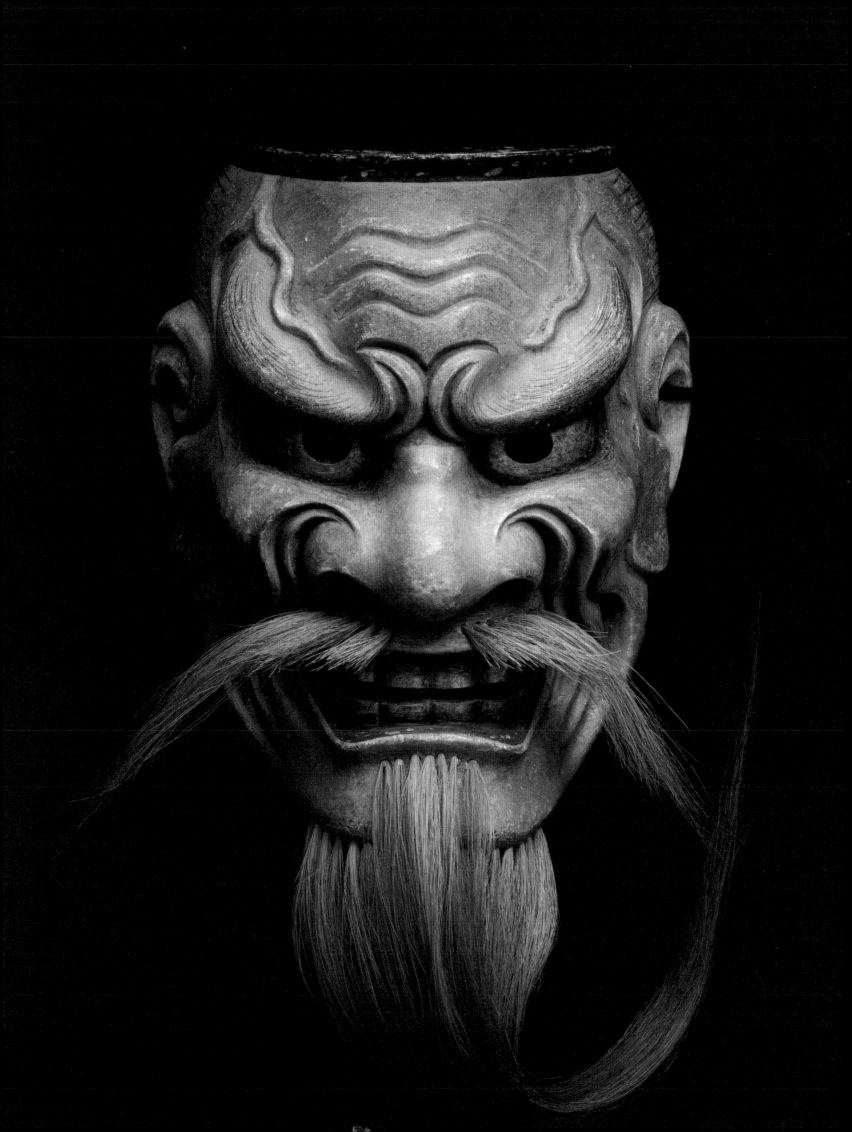

Oakujō

Large Evil Old Man

This mask represents an angry old man and is believed to be quite an old mask type. It is said to represent what Japanese people thought of as non-Japanese 'barbarian' facial features, which included a beard, clenched teeth, a wide nose and prominent blood vessels in the forehead. There are various types of *ōakujō* masks that are to some degree used interchangeably in several noh, but the noh considered most specifically for *ōakujō* include the ghost of a rejected old man in *Aya-no-Tsuzumi* (The Damask Drum), the Dragon-King in *Tamanoi* and the old hermit in *Tōbōsaku.* This mask was used in the noh *Aya-no-Tsuzumi* by Matsui Akira in 2021.

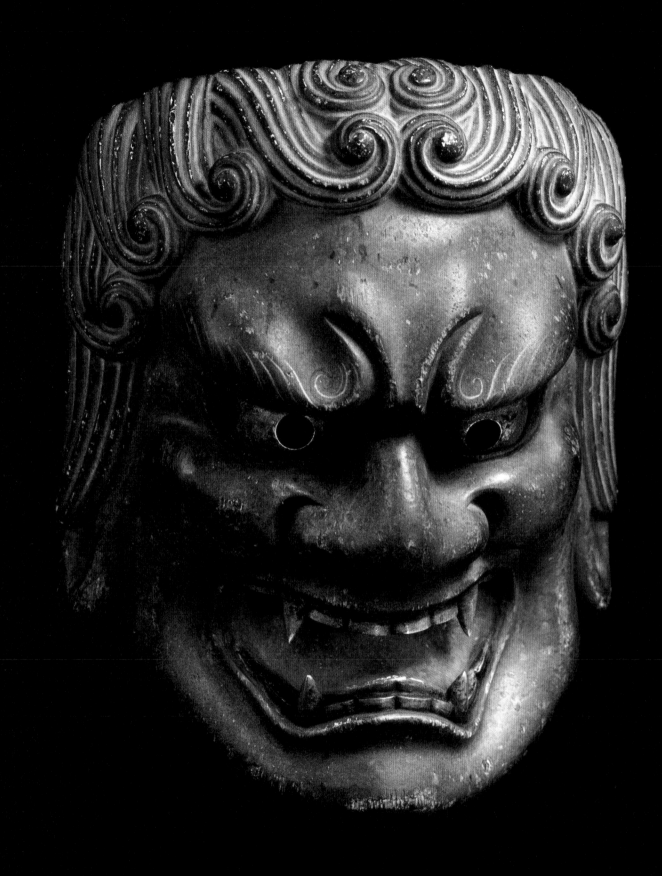

Fudō

Immovable Wisdom King

Fudō Myōō is one of the five esoteric Buddhist deities known as Wisdom Kings (*Myōō*). The *fudō* mask is based on well-known statuary of Fudō Myōō. The deity is portrayed as having a very angry face, like a mother whose children do something dangerous. Fudō's right eye looks towards the sky and his left eye down towards earth, signifying that he can see all over the world and has the ability to save humanity with love.

The mask is used in *Chōbuku Soga* as Fudō and has sometimes been used in *Danpū* as the god Kumano Gongen. This mask was used in the English noh *Oppenheimer* in 2015 and worn by Matsui Akira.

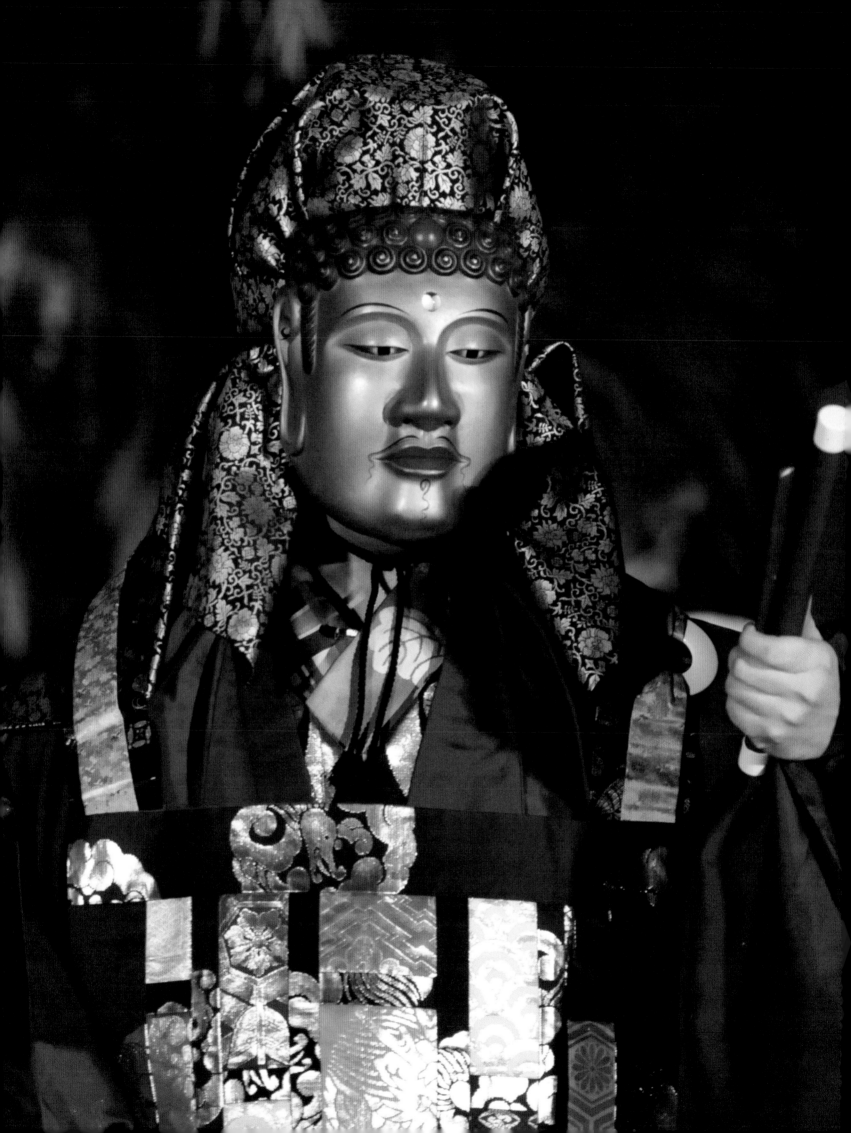

Dai-e
The Great Sermon

Author: unknown

Setting: Mt Hiei near Kyoto

Season: Unspecified

Category: Fifth-category ending (*goblin*) noh, phantasm (*mugen*) noh, *tachimawari* (circling) or *iroe* (colour) dance, *uchiai hataraki* (realistic battle dance) piece, with *taiko* drum

Performance Practice: All five schools. The *nochishite* in the Kita and Kongō schools wears the *shaka* mask over the *ōbeshimi* mask

Synopsis

A monk from Mount Hiei has retired to a hermitage. A *yamabushi* mountain priest (actually a *tengu*, half-hawk, half-man goblin) appears before the monk and offers him anything he wants for once saving his life. The monk does not desire anything of this world, but has always cherished the thought of seeing Sakyamuni's (Buddha's) great sermon on Mount Ryōju (Mount Grdhrakuta in India). The *tengu* agrees to this, but emphatically tells the monk he must not worship the vision he sees.

The *tengu* leaves, then later reappears disguised as Sakyamuni, with a host of smaller *tengu* disguised as the masses who listen to the sermon. The monk, overcome by the vision, forgets his promise and worships the false Sakyamuni. No sooner has he done this than the heavens open up and the god Indra descends in anger, destroying the illusion. The *tengu* sheds his disguise and takes on its true form, revealing the *ōbeshimi* mask. Indra chases the *tengu*, chastising him for disguising himself as Sakyamuni, until the *tengu* escapes through a crack in the cliffs.

This mask was commissioned by the Oshima family. Oshima Teruhisa performs Dai-e for the Oshima Theatre outdoor summer performance in 2014 at the Hachiman Shrine, Fukuyama.
Photo: Ikegami Yoshiharu.
Courtesy of Oshima Noh Theatre

Shaka

Buddha

This large mask is only used in the play *Dai-e* and is worn over the *ōbeshimi* mask. Together, they represent a *tengu* goblin disguised as Buddha (Sakyamuni). When the *shaka* mask is removed quickly the *ōbeshimi* mask is revealed. The *shaka* mask is made so that the performer can see through the eyes and nose holes of both masks, and the back of the *shaka* mask is carved to match the shape of the front of the *ōbeshimi* mask.

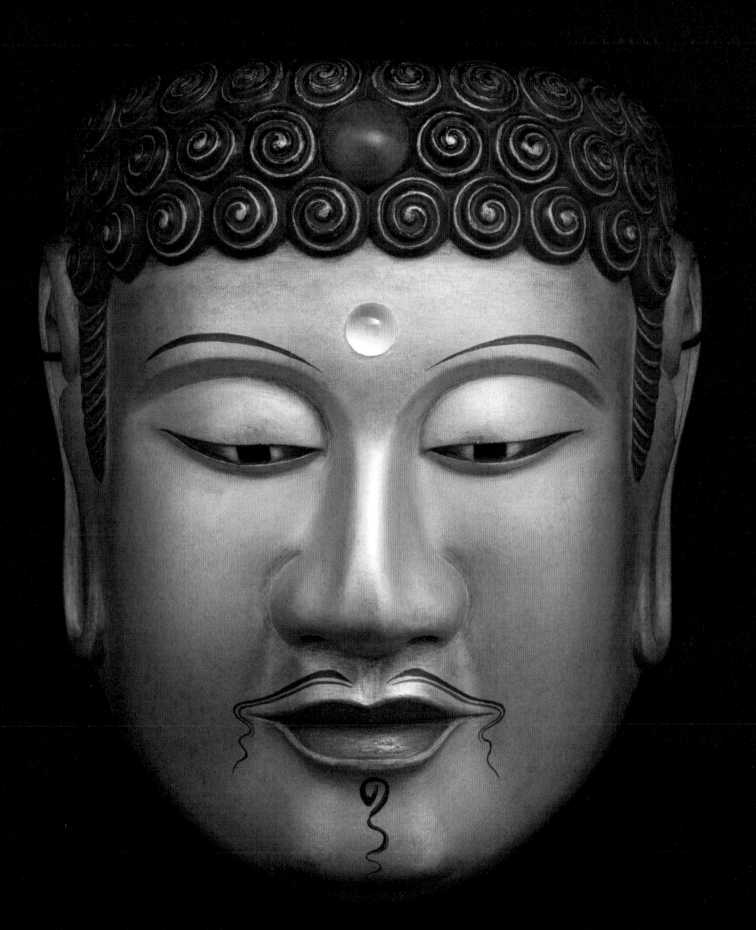

Classical-based Noh Masks

'We have seen
noh earnestly and
brilliantly cross over
national borders.'

*Nishino Haruo
(Review of* Pagoda*),*
Tokyo Shimbun, *July 2011*

These masks, used with English noh, are unique because they are based on classical noh mask types. There are two English noh, *Pagoda* and *Between the Stones*, that have used the masks from this category. In these two noh, the masks represented either Chinese or Japanese characters but were not made to resemble a known historical figure. Since they were made for contemporary noh stories, Kitazawa created them with some slight differences from the classical mask type on which they are based. These differences reflect some of his own ideas when thinking of the images of these new noh characters.

Creating masks that are very close to traditional masks was also convenient because three of the four masks created for *Pagoda* were worn by professional noh actors and both masks used in *Between the Stones* were also worn by the same professional noh actor. In addition, each of these characters wore classical noh costumes so the use of mask and costume resulted in a performance which was very close in appearance to a traditional performance, although the language was English. Also, one of the masks that was used in *Pagoda* for a Chinese character was later used in *Between the Stones* for a Japanese character. There are, of course, many such examples in classical noh of masks that are used interchangeably between Japanese and Chinese roles.

The masks in this section include the names of the classical masks on which they are based.

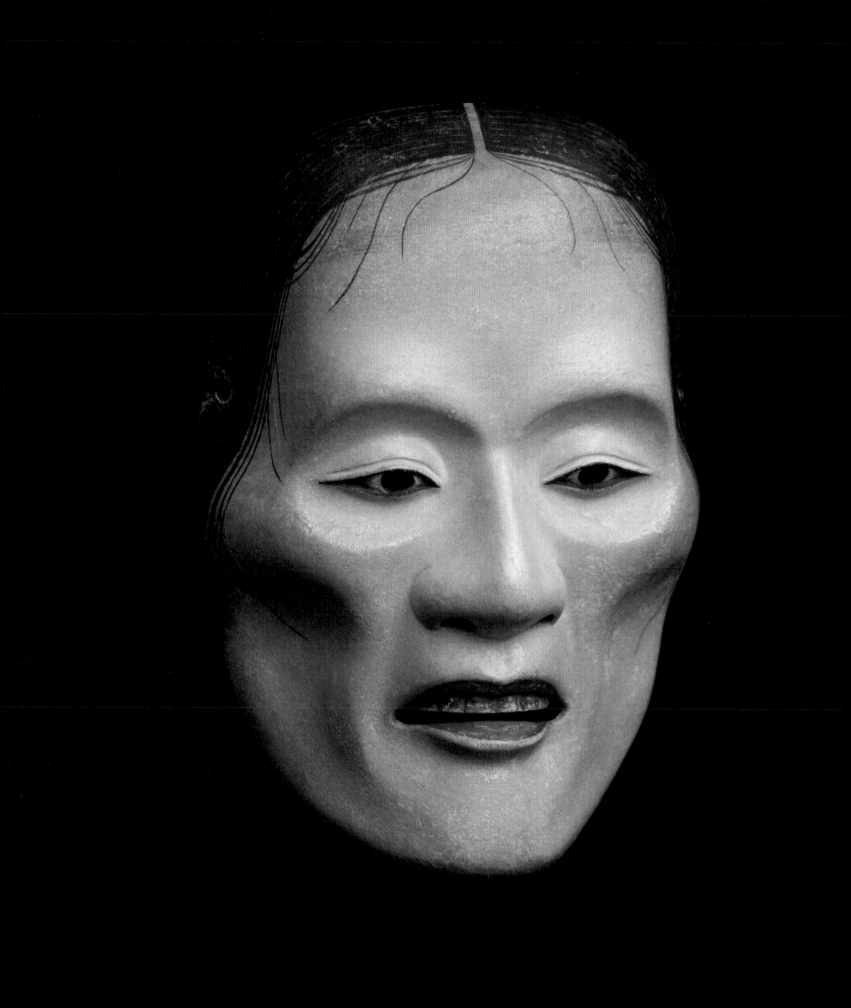

Meilin

Yase-onna (Emaciated Woman)

Chinese peasant woman in the first half of the English noh Pagoda.

In classical noh, a *yase-onna* mask is always used in roles portraying people that cannot attain Buddhahood. For *Pagoda*, although the situation is tragic, Kitazawa wanted the mask to have a static beauty as the tragic face of a once beautiful woman. Here the eyes are vacant, and the sunken cheeks are those of a woman who has been seeking the son she sent away more than 40 years ago, while she, and others in her village, died of starvation. *Yase-onna* embodies this sadness – a wretched sorrow that consumes the soul of this mother (see p. 5 for performance image).

Synopsis: A young traveller in search of her father's roots journeys to his birthplace in Southeast China. She meets a distraught woman and her daughter in front of an ancient pagoda, lamenting the departure of a young son. After the woman and daughter vanish, the traveller meets a fisherman who tells her the legend of the pagoda and of the Spirit of Meilin who visits it. The traveller realises that her father was the son of Meilin and that it was the Spirit of Meilin she encountered earlier. As night falls, the Spirit of Meilin appears once more and discovers that the traveller is her granddaughter and that her son had lived into adulthood and was thus spared the starvation of so many children from his village. The spirit of the son appears and mother and son are united in the spirit world. The young traveller is left alone to reflect on the ancient pagoda and the migrant's journey.

Commissioned by: The Oshima Noh Theatre/Theatre Nohgaku/Jannette Cheong for the English noh *Pagoda* written by Jannette Cheong, music and direction by Richard Emmert, choreography by Oshima Kinue and Oshima Teruhisa. Commission was for all four masks used in *Pagoda* (*yase-onna, waka-onna, waka-otoko* and *zō*).

Performance history: The *Meilin* mask was worn by Oshima Kinue in the December 2009 *Pagoda* tour of London (Southbank Centre), Oxford (Keble College, University of Oxford), Dublin (Samuel Beckett Theatre) and Paris (Maison de la Culture du Japon), and the June–July 2011 *Pagoda* tour of Tokyo (National Noh Theatre), Kyoto (Kongō Noh Theatre), Beijing (National Centre for the Performing Arts) and Hong Kong (Hong Kong Academy for Performing Arts), both by Oshima Noh Theatre/Theatre Nohgaku.

梅琳

痩女

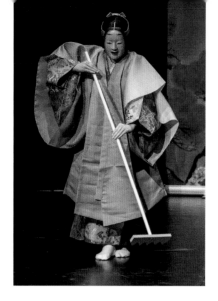

Mother Spirit

Zō-onna

Spirit of Meilin (nochishite, *Act Two main actor*) *in the English noh* Pagoda *and the Woman Gardener* (*representing Mother Nature,* maeshite, *Act One main actor*) *in the English noh* Between the Stones.

This mask is based on a famous *zō-onna* mask in the Hayashibara Museum of Art in Okayama. It has a warmer quality than the typical *zō* mask and Kitazawa felt it suited the humanity of the Mother character in *Pagoda*. Other *Pagoda* performance images of this mask can be seen on pages 2–3, 10–11.

Performance history: The Mother Spirit mask was worn by Oshima Kinue in the December 2009 *Pagoda* tour of London (Southbank Centre), Oxford (Keble College, University of Oxford), Dublin (Samuel Beckett Theatre) and Paris (Maison de la Culture du Japon), and the June–July 2011 *Pagoda* tour of Tokyo (National Noh Theatre), Kyoto (Kongō Noh Theatre), Beijing (National Centre for the Performing Arts) and Hong Kong (Hong Kong Academy for Performing Arts), both by Oshima Noh Theatre/Theatre Nohgaku. The Mother Spirit mask was also worn by Oshima Kinue in the January–February 2020 Oshima Noh Theatre/Theatre Nohgaku/ Unanico tour of *Between the Stones* in London (Southbank Centre), Kilkenny (Watergate Theatre), Wexford (National Opera House) and Paris (Musée Nationale des Arts Asiatique-Guimet).

母性
増女

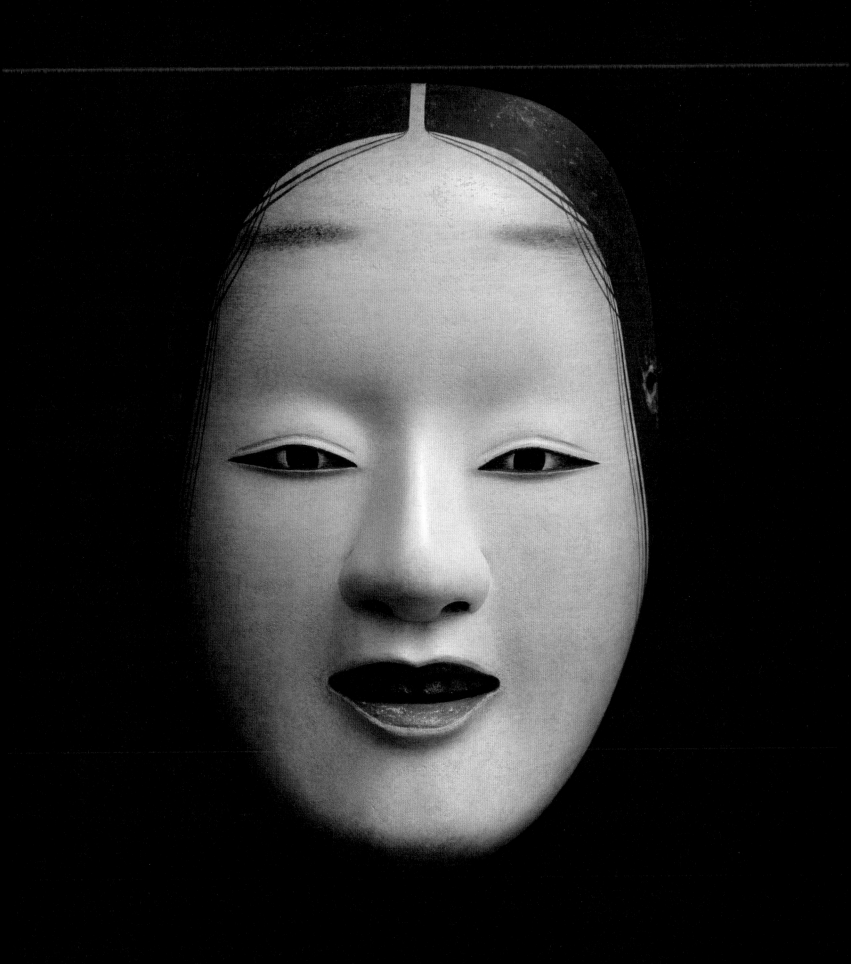

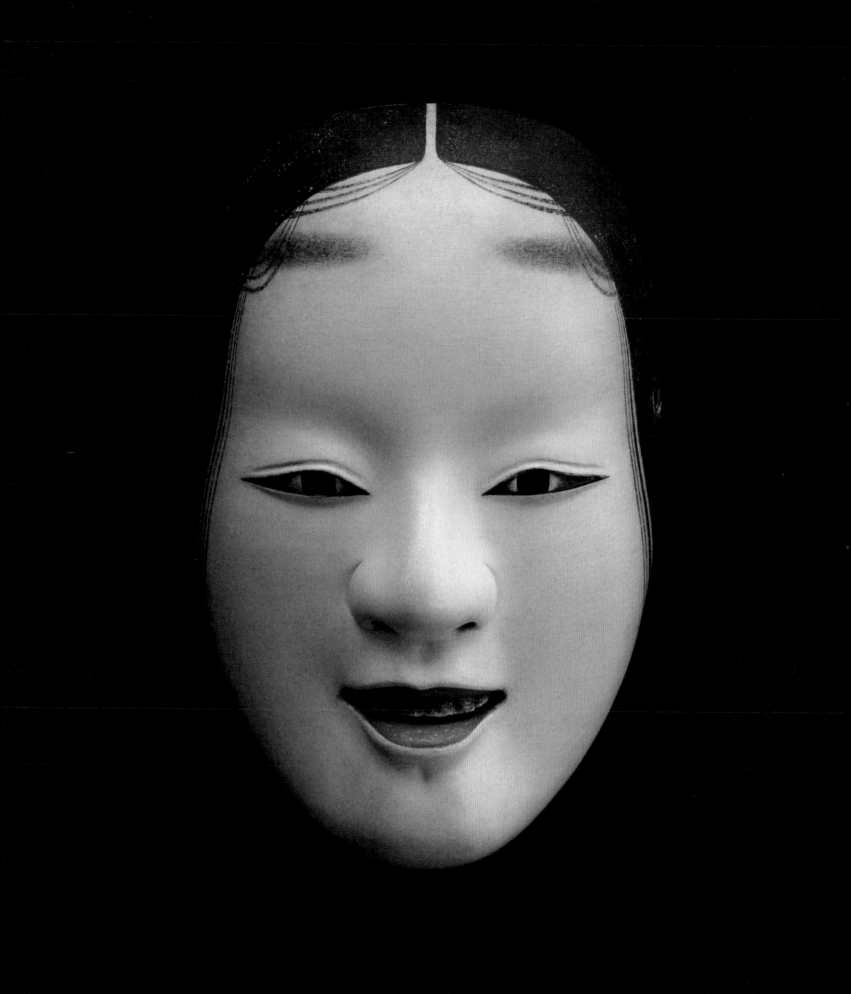

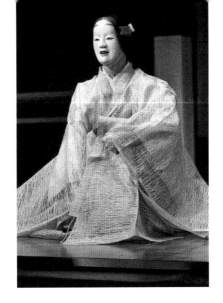

Daughter Spirit

Waka-onna

Spirit of the Chinese peasant woman's daughter in the English noh Pagoda.

The classical *waka-onna* is a young woman's mask which was developed after the *ko-omote*. While the *ko-omote* has a more stylistic representation of a young woman, *waka-onna* more closely resembles a human face.

Kitazawa developed this mask specifically for *Pagoda* with its distinctive hair detail to give it a more Chinese quality.

Performance history: The *Daughter Spirit* mask was worn by Elizabeth Dowd in the December 2009 Europe *Pagoda* tour and the June–July 2011 Asia *Pagoda* tour.

娘性

若女

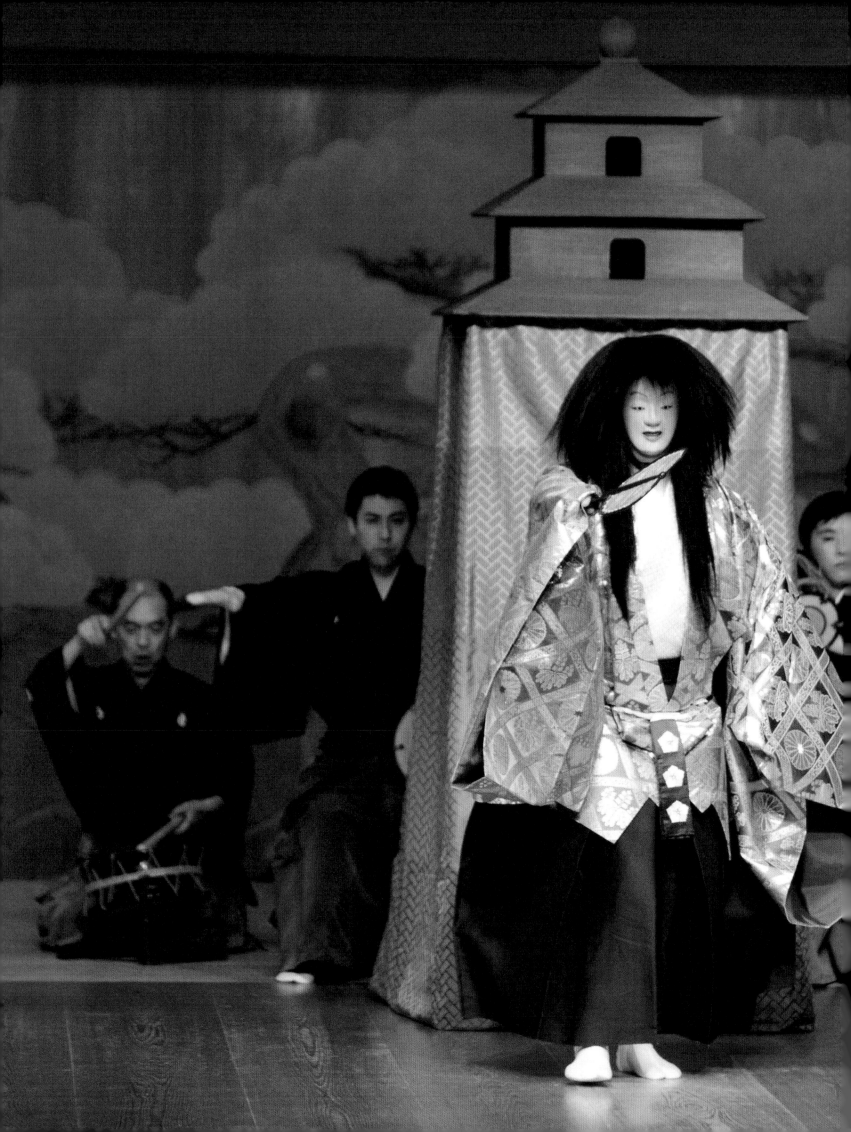

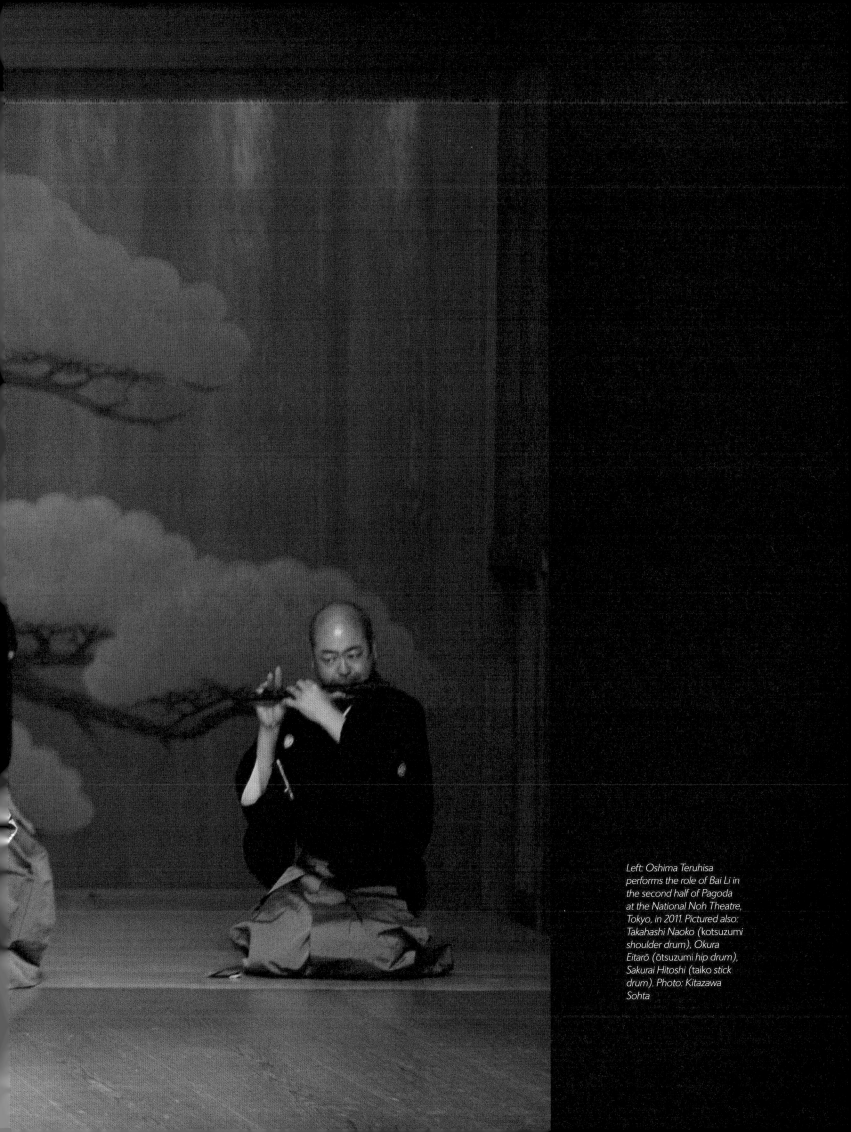

Left: Oshima Teruhisa
performs the role of Bai Li in
the second half of Pagoda
at the National Noh Theatre,
Tokyo, in 2011. Pictured also:
Takahashi Naoko (kotsuzumi
shoulder drum), Ōkura
Eitarō (ōtsuzumi hip drum),
Sakurai Hitoshi (taiko stick
drum). Photo: Kitazawa
Sohta

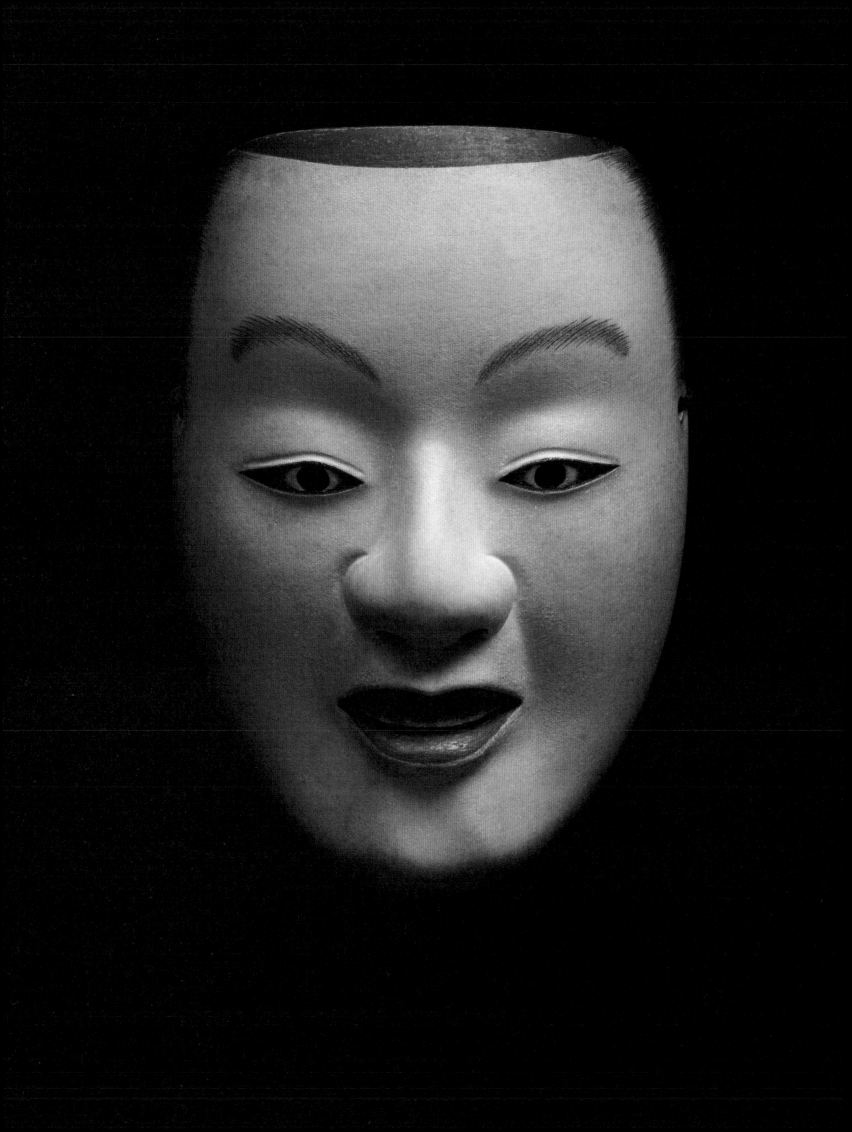

Bai Li

Waka-otoko

Spirit of the Chinese peasant woman's son Bai Li in the English noh Pagoda.

This is a replica of the *waka-otoko* mask in the Oshima family collection. *Waka-otoko*, meaning 'young man', is similar to the *Kantan-otoko* mask (pages 66–67), but gives the impression of a slightly younger man. In classical noh, it is used for the fortune-telling Shinto priest in the play *Utaura* or sometimes the ghost of Yorikaze who appears from out of his grave in the play *Ominameshi*. For *Pagoda*, Kitazawa wanted the mask to have an innocent and noble quality.

Performance history: The *Bai Li* mask was worn by Oshima Teruhisa or Matsui Akira in the December 2009 Europe *Pagoda* tour, and by Oshima Teruhisa in the June–July 2011 Asia *Pagoda* tour.

百
力

若
男

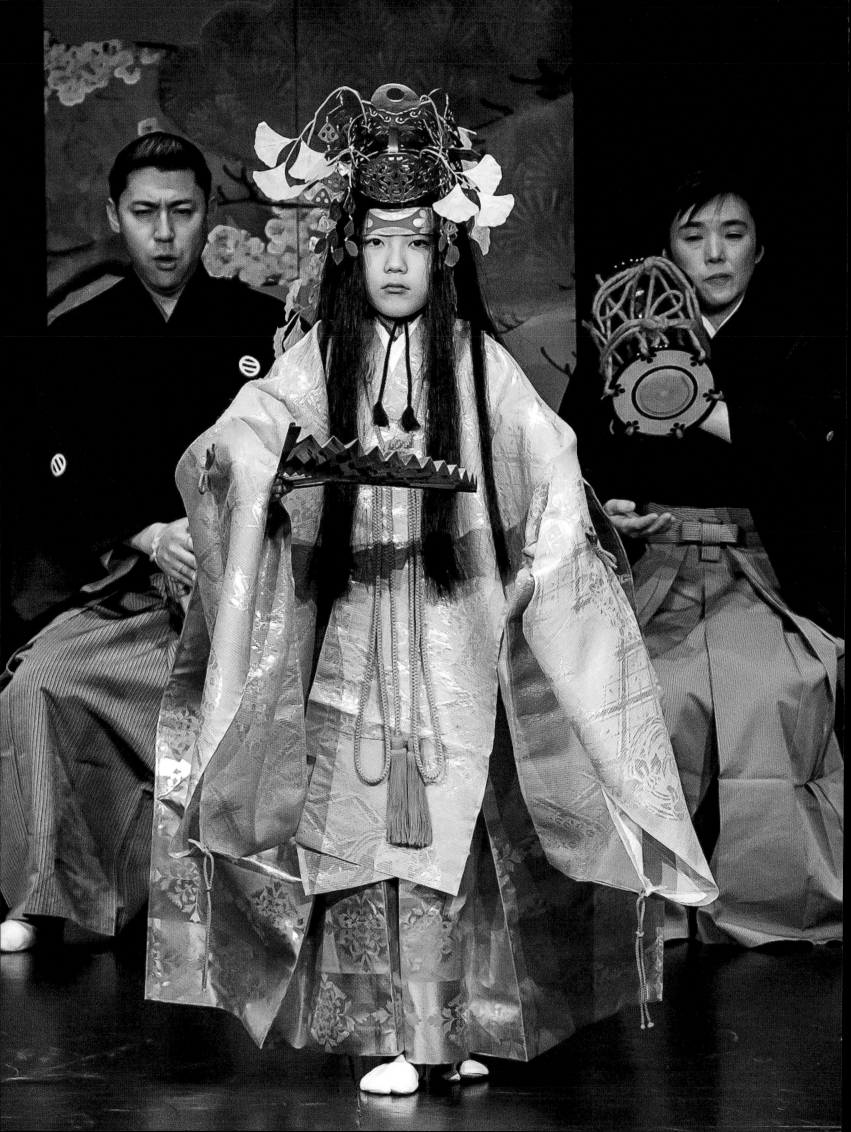

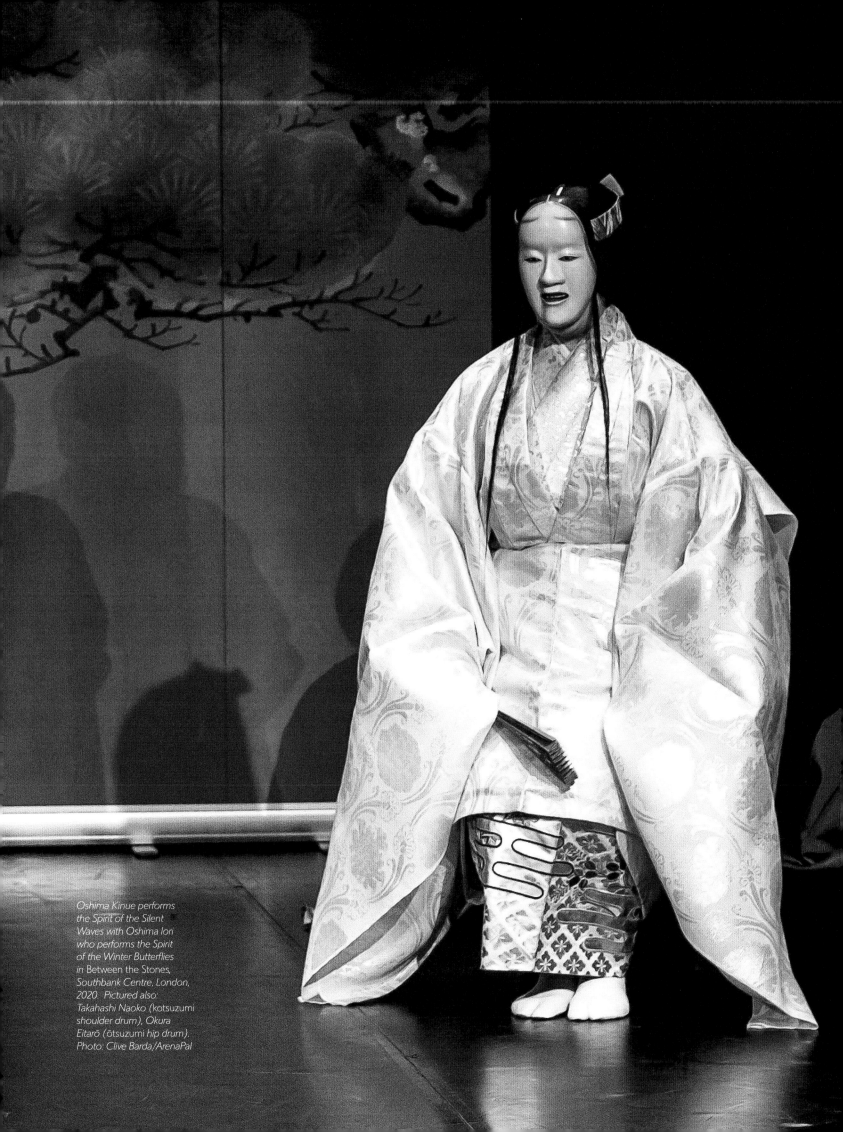

Oshima Kinue performs the Spirit of the Silent Waves with Oshima Iori who performs the Spirit of the Winter Butterflies in Between the Stones, Southbank Centre, London, 2020. Pictured also: Takahashi Naoko (kotsuzumi shoulder drum), Okura Eitarō (ōtsuzumi hip drum). Photo: Clive Barda/ArenaPal

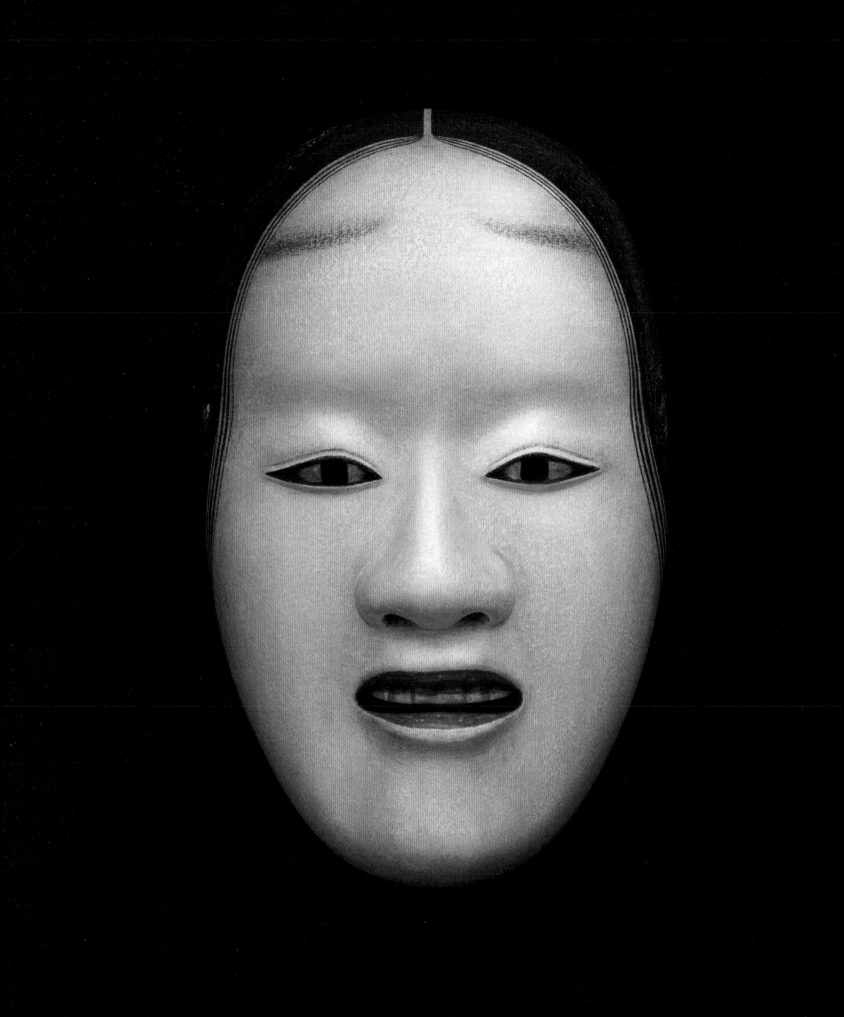

Silent Waves

Deigan

Spirit of the Silent Waves in the English noh Between the Stones.

The key characteristics of the *deigan* mask are the golden eyes and teeth, protruding forehead and a mouth in the shape of a silk-moth cocoon. There are many different facial expressions for *deigan* masks. While most used in noh today emphasise a jealous nature, for this particular mask Kitazawa returned it to the historically original bodhisattva nature and made it beautiful and elegant.

Synopsis: In the middle of a typhoon, a traveller grieving lost loved ones visits the stone garden of Ryōanji temple in Kyoto. A woman gardener, who understands the traveller's sadness, shows the traveller how the raking of the gravel enhances the garden's beauty and evokes a peaceful soul. After the gardener disappears, a priest announces the closing of the temple. When asked about the woman gardener, he remarks that only priests rake the stone garden and suggests the traveller might have experienced the spirit of the garden while meditating. Years later, the traveller completes the raking of her own stone garden in Europe and is visited again by the spirit of the garden – the Spirit of the Silent Waves. They discuss the courage of those who face death, and the spirit describes the final release before passing – 'like winter butterflies in a silent breeze'. The Spirit of Winter Butterflies then appears and dances in memory of departed loved ones.

Commissioned by: The Oshima Noh Theatre/Theatre Nohgaku/Jannette Cheong for *Between the Stones*, an English noh by Jannette Cheong, music and direction by Richard Emmert, choreography by Oshima Kinue and Oshima Teruhisa.

Performance history: The *Silent Waves* mask was worn by Oshima Kinue in the 2020 Oshima Noh Theatre/Theatre Nohgaku/Unanico European tour of *Between the Stones* in London (Southbank Centre), Kilkenny (Watergate Theatre), Wexford (National Opera House) and Paris (Musée Nationale des Arts Asiatique-Guimet).

静
波
泥
眼

Classical
Kyogen Masks

Kyogen is the comedic companion to the serious-themed noh. Kyogen plays are generally performed on the same programme as noh plays but should not be confused with the *ai-kyogen* interlude sections within noh plays.

Masks in kyogen are less common in comparison to noh. Of the approximately 263 classical kyogen plays in the current repertory, only about 75 use a mask. According to the *Nohgaku Daijiten* (Nohgaku Encyclopedia, Chikuma Shobō, Tokyo, 2012) there are 33 different types of kyogen masks. Masks of the same name may have different variations, for example, in terms of colours and shapes, and are not as strict in terms of design rules as noh masks. This allows the mask maker more opportunity to add their own ideas and creativity.

Similar to noh, the most important element for a kyogen mask maker is to have a good understanding of the story of the play. There is a considerable challenge in making masks that portray humorous faces and can also convey a high level of dignity, elegance and prestige, because kyogen is performed as part of a noh programme. Kyogen actors in the *ai-kyogen* interlude parts of noh also occasionally wear kyogen masks.

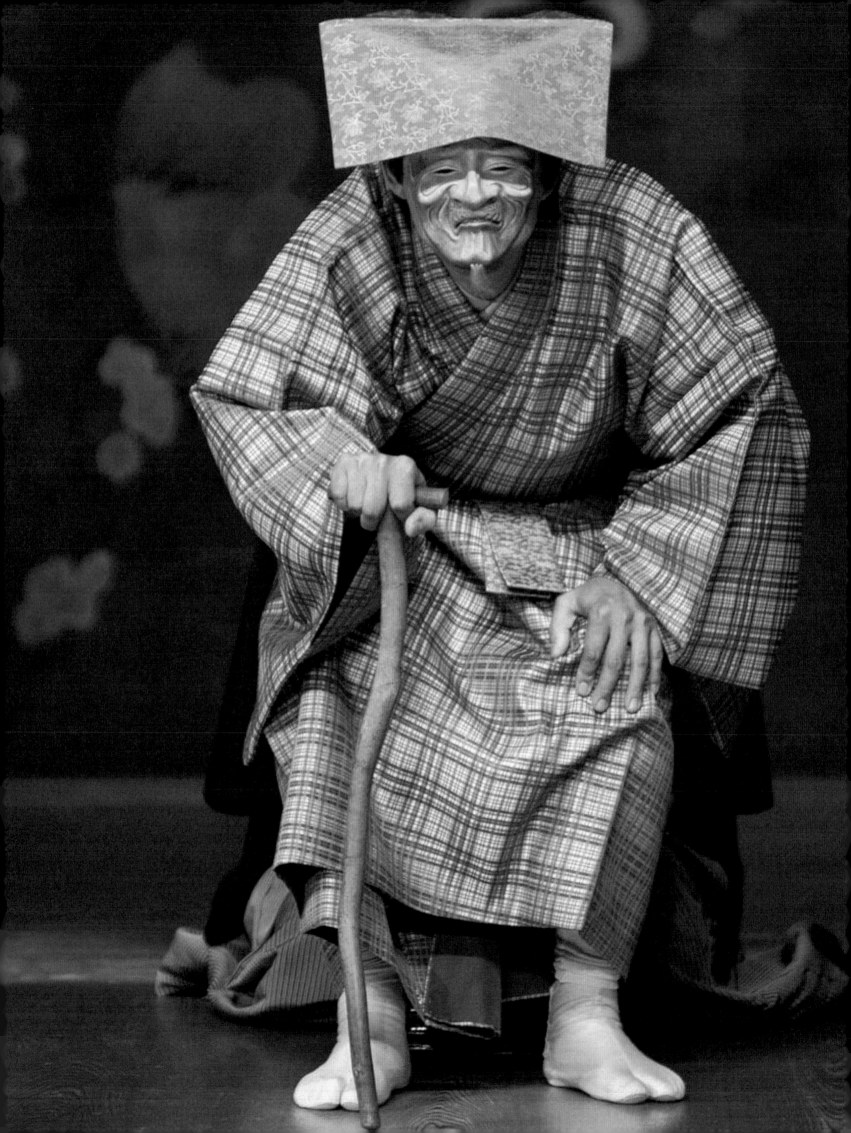

Koshi-Inori

Back-Straightening Prayer

Synopsis

A *yamabushi* mountain priest is returning home after completing rigorous ascetic training. He goes to visit his grandfather who is badly bent with age. The *yamabushi* feels sorry for him and tries to use his magical powers to heal him. His powerful prayers cause his grandfather to become bent in the opposite direction. He prays a second time and the grandfather becomes bent as before and screams in pain.

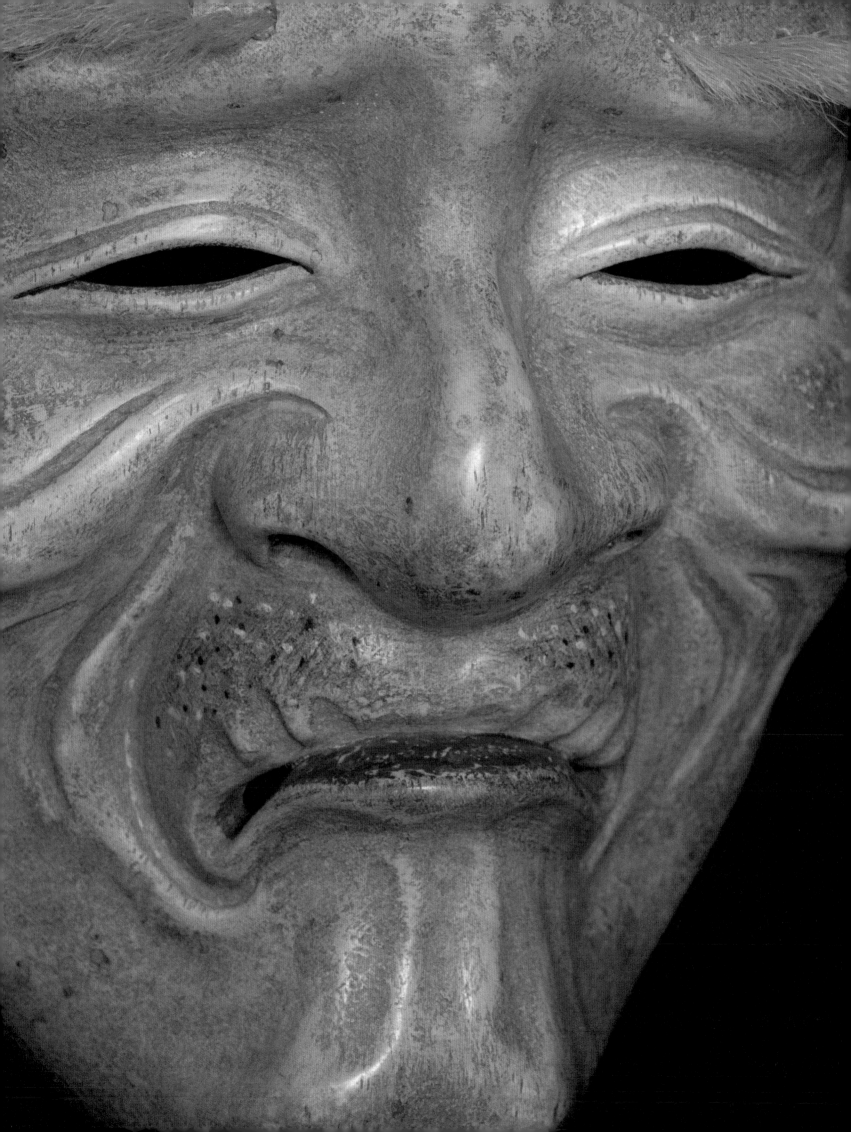

Oji
Grandfather

The *ōji* mask represents an old man. This variation of the mask was made based on a photo Kitazawa found of an old man who seemed to be living a good life. *Oji* is used for old men appearing in several kyogen plays, such as the old bent grandfather in *Koshi Inori,* the grandfather drinking with his three grandsons in *Saihō* and the old man wishing to exchange saké cups with a young aristocratic boy in *Rōmusha.*

Busshi

The Buddhist Sculptor

Synopsis

A man goes to the capital to buy a Buddhist statue and shouts out that he is looking for a sculptor. A con man approaches him claiming that he is a sculptor and that he can make a statue in either three years, or by the next day. When the man visits him the next day, the con man tells him the statue is in the next room. As the man goes to the next room, the con man goes around the back way, puts on a mask (such as *oto*) and pretends to be the statue. The man worships but then asks for slight changes. The con man goes back and forth humorously changing his position, before the man finally realises he is being duped and chases him off.

Kitazawa Hideta performs
the con man in Busshi at
the Tessenkai Noh Theatre,
Tokyo, 2006.
Photo: Kitazawa Sohta

仏
師

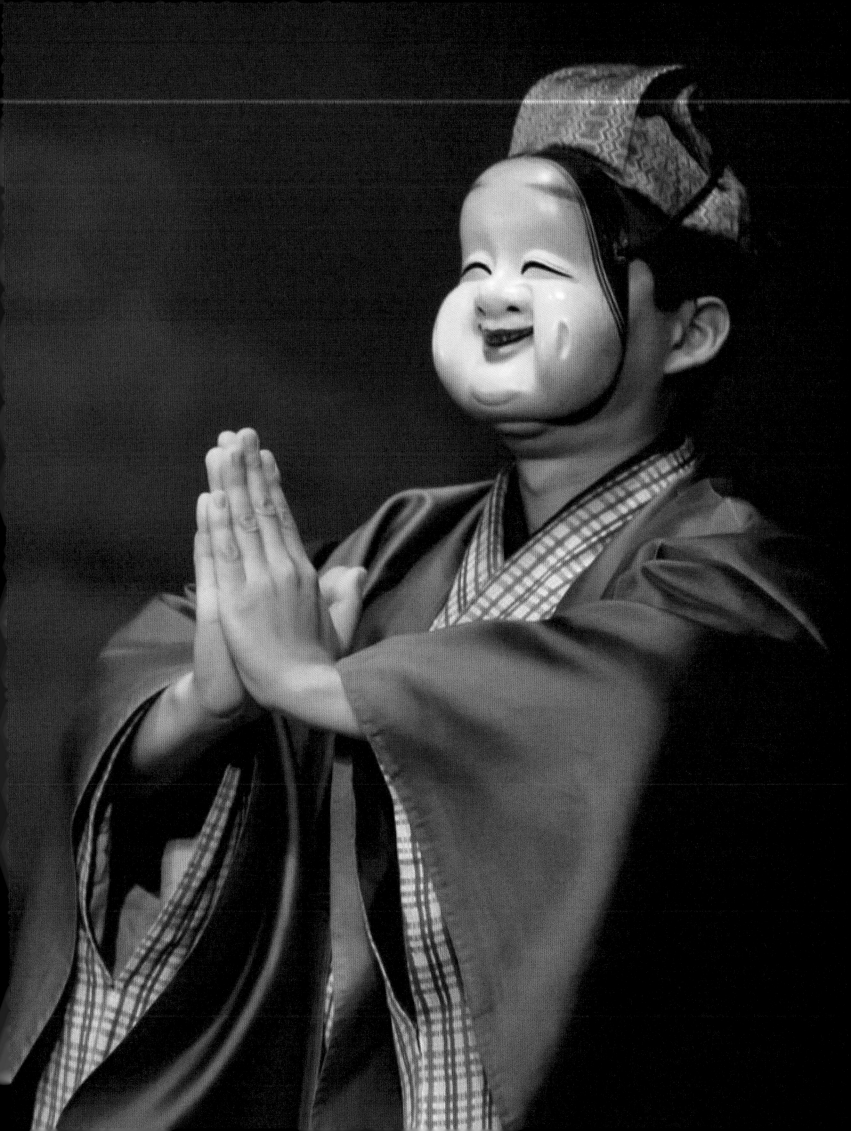

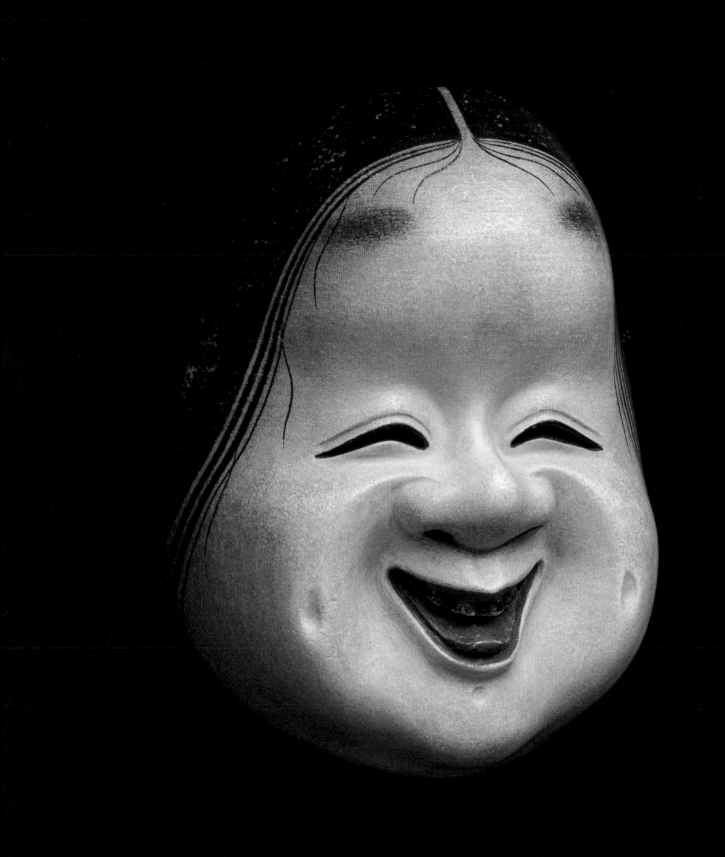

Oto

Young Girl

This humorous mask represents an unattractive young girl, although some variations might be slightly more attractive. It is used in roles such as the ever-changing Buddhist statue in *Busshi,* the object of an old man's affections in *Makura Monogurui* and the young inexperienced demon princess in *Kubihiki.*

The first time Kitazawa made an *oto* mask, he modelled it on his two-year-old son. Kitazawa often mentions that if you compare *oto* with the young woman's *ko-omote* noh mask (pages 44–45), you can understand the conceptual difference between noh and kyogen.

Shimizu

Demon at Shimizu (wearing the *oni-buaku* mask)

Synopsis

A master orders his servant Tarō Kaja to fetch the delicious water from the Shimizu spring. Tired of doing such work, Tarō Kaja returns from the spring without the water saying he was attacked by a demon. The master is suspicious and decides to go to the spring himself. Tarō Kaja takes a *buaku* mask and, arriving at the spring before his master, puts on the mask and threatens him, but agrees to spare his life if the master treats Tarō Kaja better. The master is fooled at first but later realises the similarity of the voice of the demon and the voice of Tarō Kaja. The master goes again to the spring, as does the masked Tarō Kaja. This time the master unmasks him and chases him off.

Kitazawa Hideta performs the kyogen Shimizu *using the* oni-buaku *mask at the Yorozu Stage, Tokyo, 2017. Photo: Kitazawa Sohta*

清水

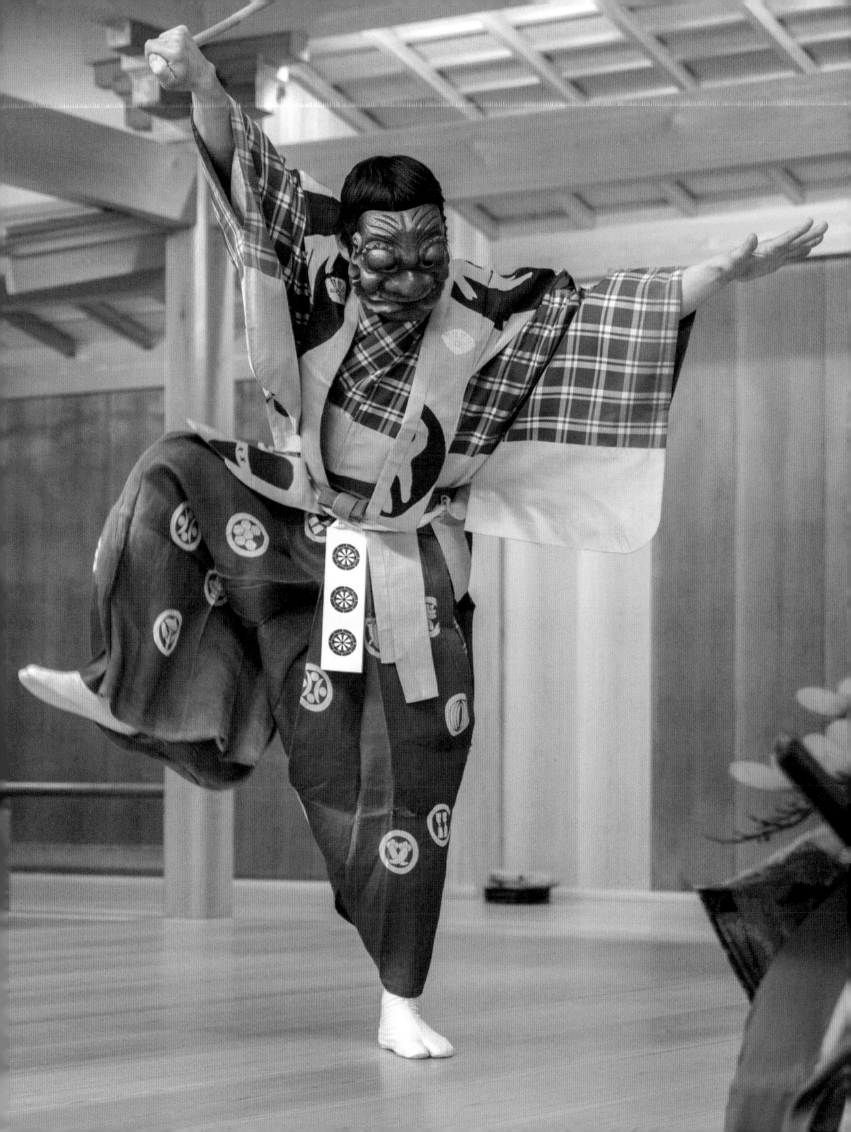

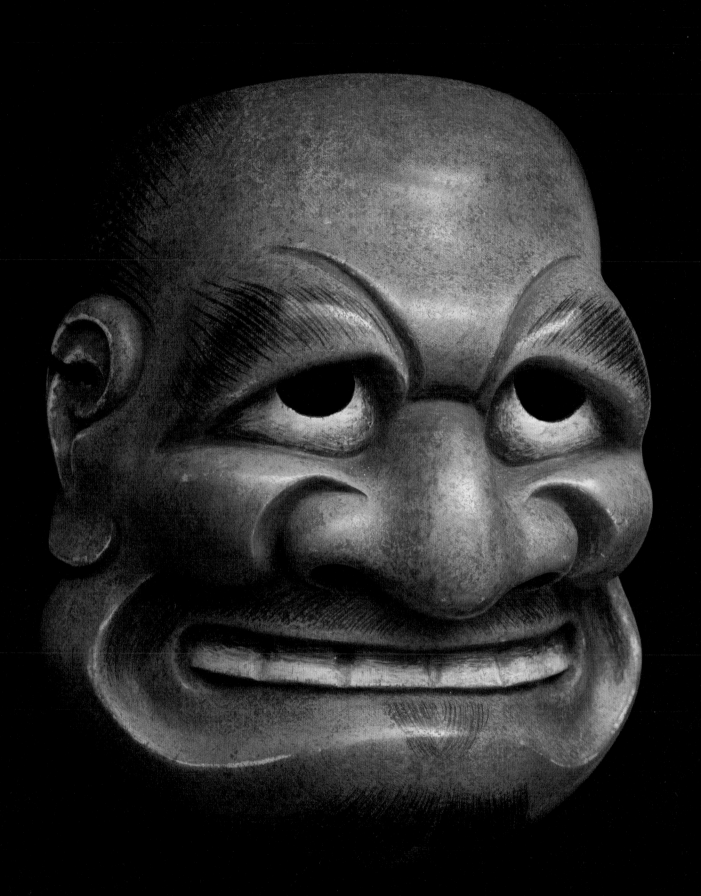

Buaku

Buaku is used to portray Enma, the king of hell, or a demon that is more inept than evil. As with other kyogen masks, it is meant to represent characters with changing emotions. It is thought to be based on the *ōbeshimi* (pages 98–99) noh mask though it displays a more humorous mien. The great kyogen actor Nomura Manzō VI wrote that the *buaku* mask 'must be able to display anger, to cry, or to laugh'. It is used in *Kaminari* for the injured thunder god, in *Shimizu* by a servant wishing to scare his master, and in *Kubihiki* for the demon father who tries to teach his shy daughter to eat human flesh for the first time. The *oni-buaku* mask which Kitazawa created and is wearing on the photograph on the previous page, represents an even more humorous demon.

Kazumō

Mosquito Wrestling

Synopsis

A lord orders his servant Tarō Kaja to find a new servant. He hires a man who says he is good at *sumō* wrestling. The lord has the new servant fight another wrestler whom the new servant easily defeats. However, the lord recognises that the new servant is the spirit of a mosquito so he challenges him to a *sumō* match and uses a large fan to create a breeze against the mosquito. But eventually the lord loses the fight anyway.

Side view of the *usofuki* mask (also on following page) worn by the mosquito character in *Kazumō*.

蚊相撲

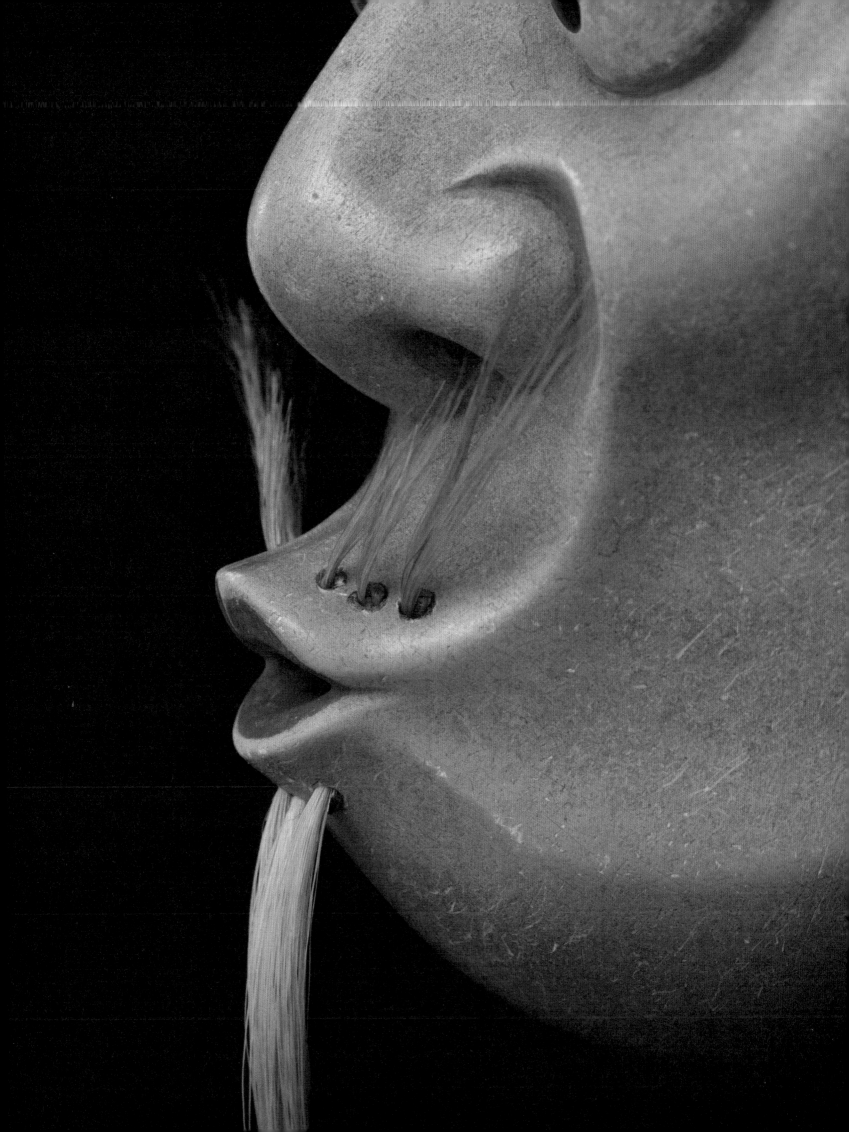

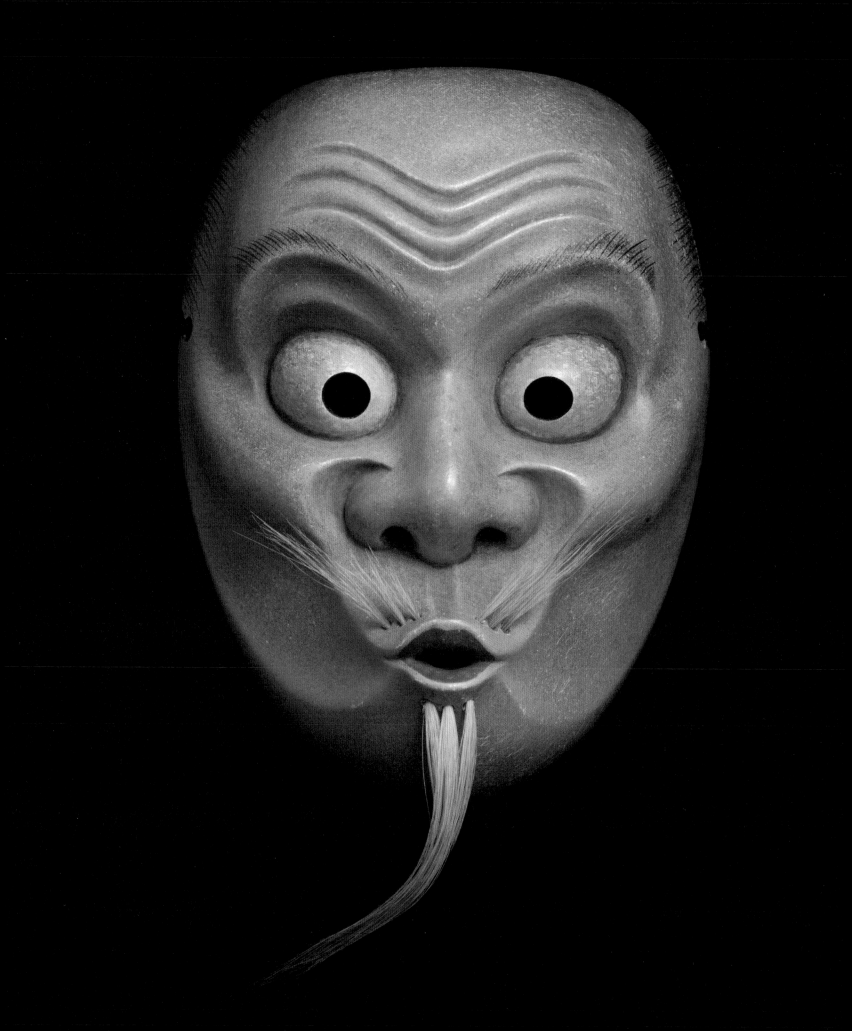

Usofuki

Whistling Lies

This mask with its distinctive whistling lips can be made in a variety of ways. It usually has whiskers sticking out above the lips and often has them below the lips as well. The mask is used in different plays to portray the spirits of various animals and plants including a mosquito, a cicada, a mountain potato, a mushroom and a scarecrow. In *Yao* it is the ghost of a dead man meeting Enma, the king of Hell. In *Ishigami* it is worn by the disguised husband whose wife wants to divorce him. The orange *usofuki* was used as the spirit of an octopus in the classical kyogen play *Tako* (Octopus). Kitazawa made this particular *usofuki* mask for the new kyogen project *Derailed* at the University of Hawai'i (see page 197).

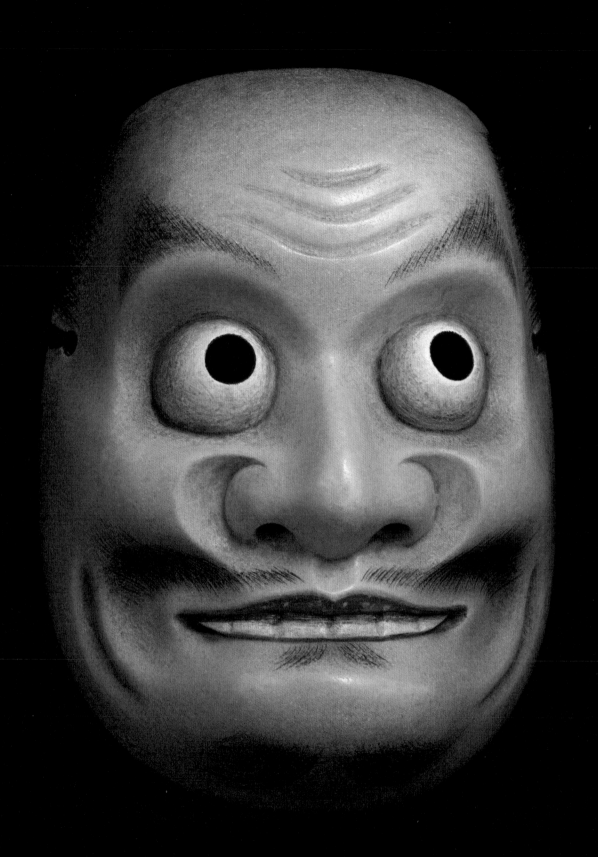

Kentoku

Wise Man

This mask is thought to be modelled after a man called Kentoku. Although its origins are unknown, it is believed to be quite old. A *kentoku* mask can be used to portray a variety of animal roles which may vary in colour such as a horse, a cow, a crab (usually red), a dog (brown) and even the spirit of a crucian carp. Such roles might seem strange but that is part of the humour of the use of this mask in kyogen. This yellow *kentoku* portrayed the spirit of a sea tortoise in the English kyogen play *Derailed* at the University of Hawai'i and is now the property of the university (see page 197).

Kaminari

Thunder

This is the both the name of a mask and the name of a kyogen play. Of the two kyogen schools, Okura and Izumi, the former uses a dedicated *Kaminari* mask while the latter does not, but uses a *buaku* mask. Kitazawa is an Izumi school practitioner, yet decided to make this dedicated mask and use it when he performed *Kaminari*. It is similar to the *ōbeshimi* (pages 98–99) noh mask although it reflects a kyogen perspective.

The story of *Kaminari* is about a quack doctor who is travelling in the countryside when the god of thunder suddenly falls down from the sky. Thunder has not been feeling well and when he finds out that the man is a doctor, he demands that he treat him. The doctor at first refuses but Thunder becomes angry. The doctor agrees and gets out his large acupuncture needles. He warns Thunder that the treatment will be painful. Thunder cries out in pain but when the treatment is done he feels much better. The doctor then asks for payment but since Thunder doesn't have money with him, he blesses the doctor and his descendants for 800 years.

This is the acupuncture needle (32 cm long) and hammer also made by Kitazawa for use in Kaminari.

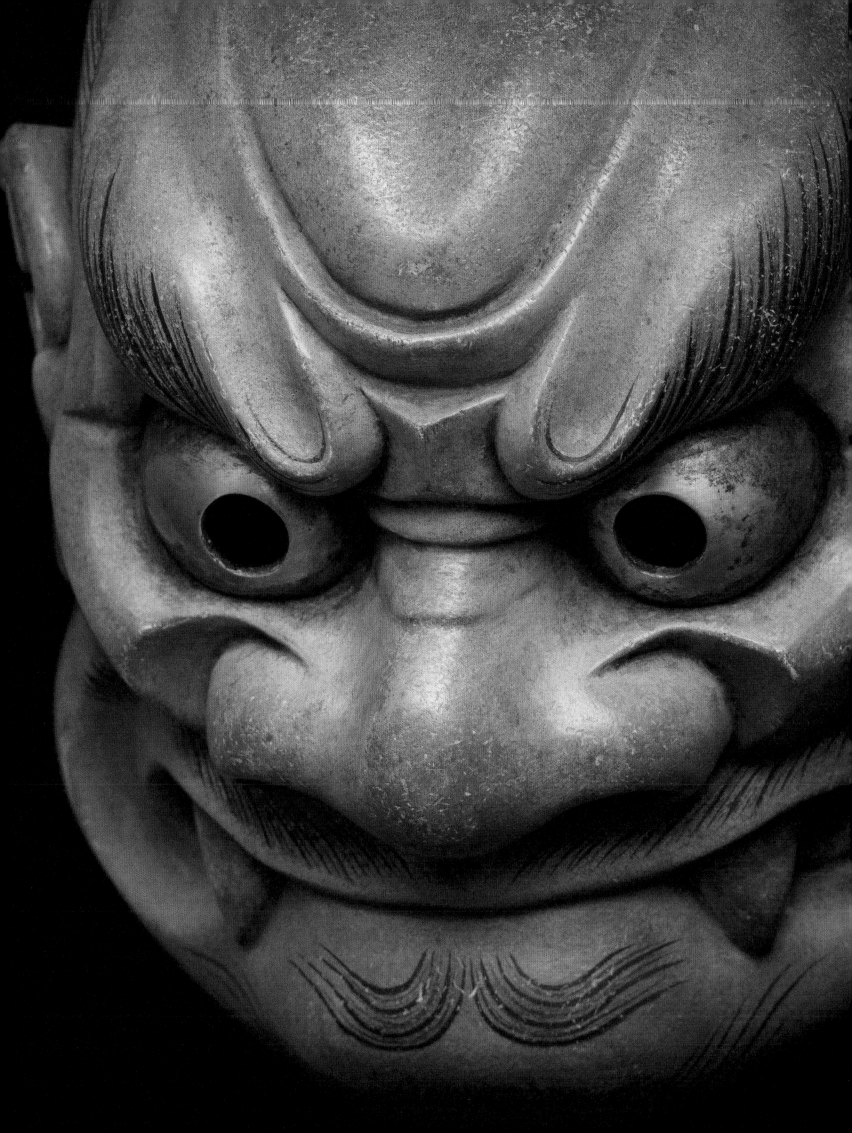

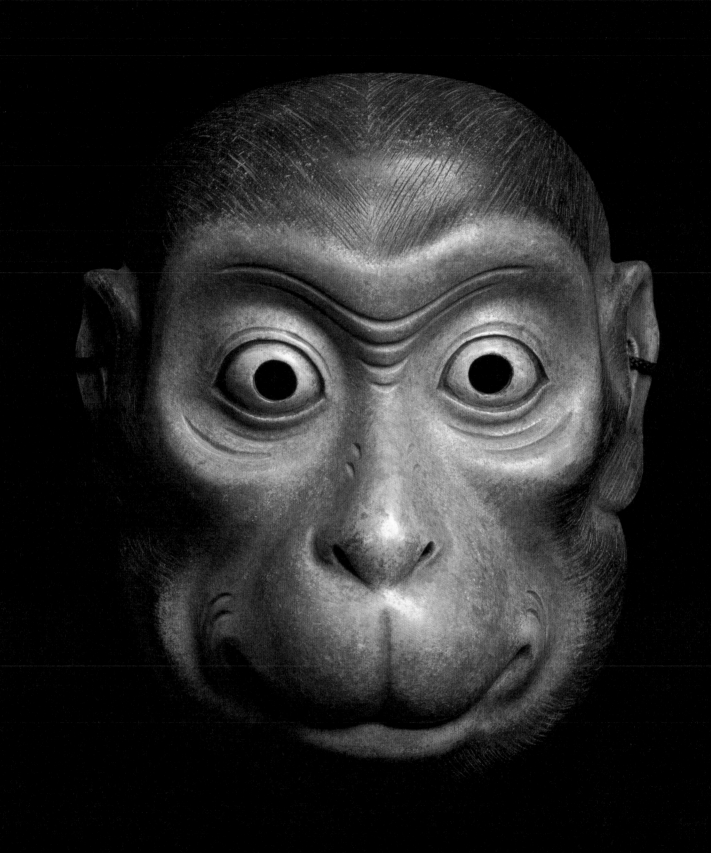

Saru

Monkey

This *saru* mask is used only in the play *Saru Muko* when each of the characters wear a *saru* mask. Kitazawa has made several masks of this type. When he first made this mask he went to a zoo to research monkey faces. He has made several monkey masks which have different characteristics.

The play *Saru Muko* (The Monkey Bridegroom) recreates a monkey wedding with many monkey characters on stage all wearing these masks including the bridegroom, the bride, the father-in-law, servant monkeys and others. They sing and speak in monkey chatter.

In another kyogen, *Utsubozaru,* a child actor wears a small child-size *saru* mask. This is a popular play in which a monkey trainer and his small monkey, played by the child actor, perform for a feudal lord who becomes completely engrossed in the antics of the monkey and begins to imitate them. This is usually one of the first kyogen that an actor, when still a child, will perform in their career.

Contemporary
Noh Masks

These non-classical masks were all created for contemporary work including English noh and noh-influenced pieces.

When Kitazawa receives a commission for a contemporary noh mask, he generally works closely with one or more members of the creative team to gain an understanding of the character and how that character should be portrayed. They also discuss costuming, including the wig, in order to consider the entire balance of the character. Kitazawa usually tries to study the text of the play. When the character is someone who was a real person, such as Elvis Presley, Frida Kahlo or Robert Oppenheimer, Kitazawa researches photographs, as well as the life and work of the person, in order to develop the expression of the mask.

Kitazawa believes that it is important to create a new mask using the same techniques as those used to make a classical mask. Though the face of a contemporary mask may be different from that of a classical noh mask, it is still important to make a lightweight mask that fits comfortably on the actor.

The first step in the actual creation of the new mask is for Kitazawa to make a drawing which is discussed with the creative team. Then he makes a clay model of the mask to invite further discussion and any necessary adjustments. It is only then that Kitazawa begins the actual carving. A mask, by definition, will never look exactly like the person it represents. It is important to make a mask which allows the actor to give life to the character. The mask, text, music, movement and costumes work together to create that atmosphere. The mask maker's role is to allow the mask to be a part of that process.

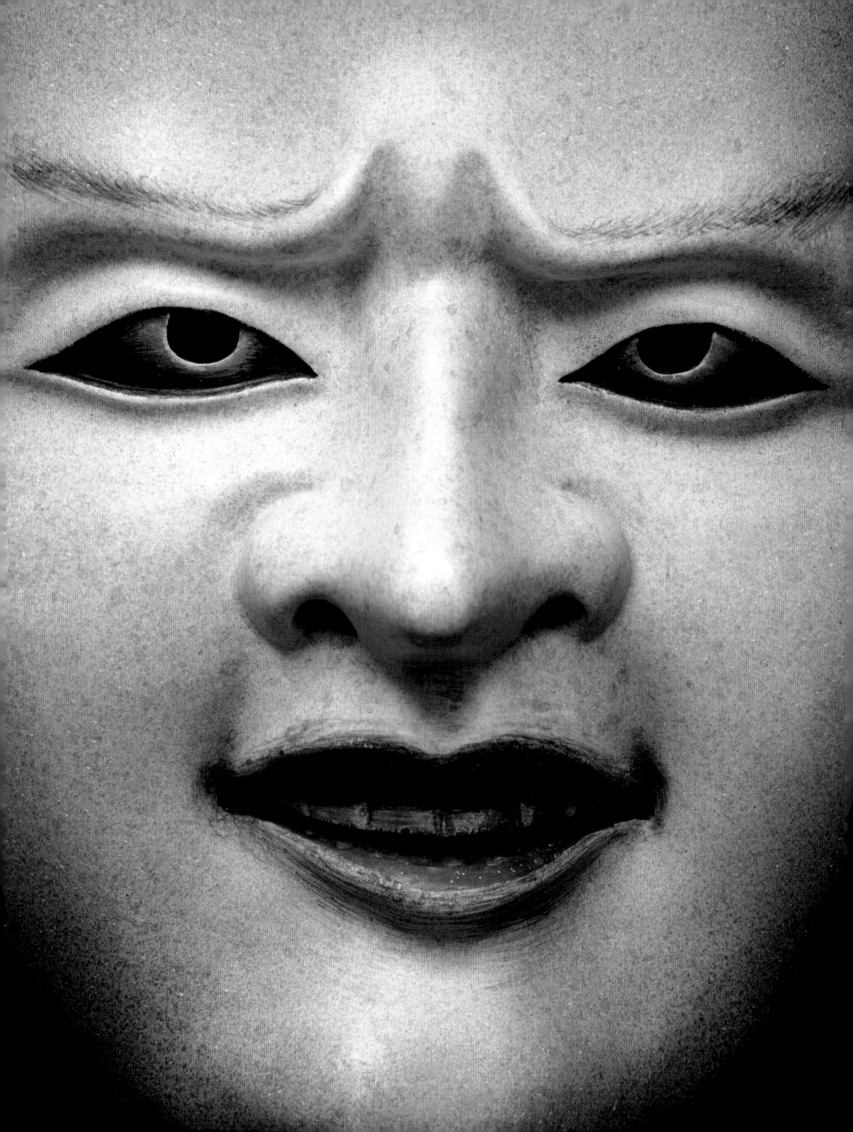

Richard Emmert performs the Young Boy in Pine Barrens *(2006) and on pages 156–157 also performs the Jersey Devil.*
Photos: David Surtasky

Evil Boy
2006

Young boy (maeshite, *Act One main actor*) *in the English noh* Pine Barrens.

Pine Barrens was the first Theatre Nohgaku play for which Kitazawa made masks. The inspiration for the *Evil Boy* mask came from the 1970s movie *The Omen* which portrayed an evil boy. Kitazawa was also influenced, particularly in the sharp sculpting of the nose, by Javanese masks. The mask is white with a bluish tinge, which suggests a non-living person.

Synopsis: Two witches travel to New Jersey's desolate pine barrens to hunt for a comrade who disappeared while practising their sacred art. A young boy appears from out of the swamp, warns the witches of the evil that lurks there and tells of a 13th child who was promised to the devil in a fit of desperation by his mother. The boy disappears. In the second half, the demon known as the Jersey Devil appears and fights with the two witches, who fend him off with their protective amulets until he flies off, promising to return to hunt his prey.

Commissioned by: Theatre Nohgaku for *Pine Barrens*, an English noh by Greg Giovanni, music and direction by Richard Emmert.

Performance history: The *Evil Boy* mask worn in Act One and the *Jersey Devil* mask (see pages 156–157) worn in Act Two of *Pine Barrens* were both worn by Richard Emmert in Theatre Nohgaku's *Pine Barrens* production in the September 2006 tour in the United States to the North Carolina School of the Arts and Duke University, North Carolina, and Hampden-Sydney College, Virginia.

Jersey Devil
2006

Jersey Devil (nochishite, Act Two main actor) in the English noh Pine Barrens.

This mask is based on various drawings online that exist of the Jersey Devil. Kitazawa created a mask that suggests a less refined animal-like character, such as one that might be found in kyogen, or one similar to the rather weird *yakan* mask of a fox which is used in some variant performances of the noh *Sesshōseki.* The costume uses the large red *akagashira* wig found in various noh and kyogen to portray strong, other-worldly or demonic characters. Thus, Kitazawa gave the mask a reddish quality which works well with both the wig and costume.

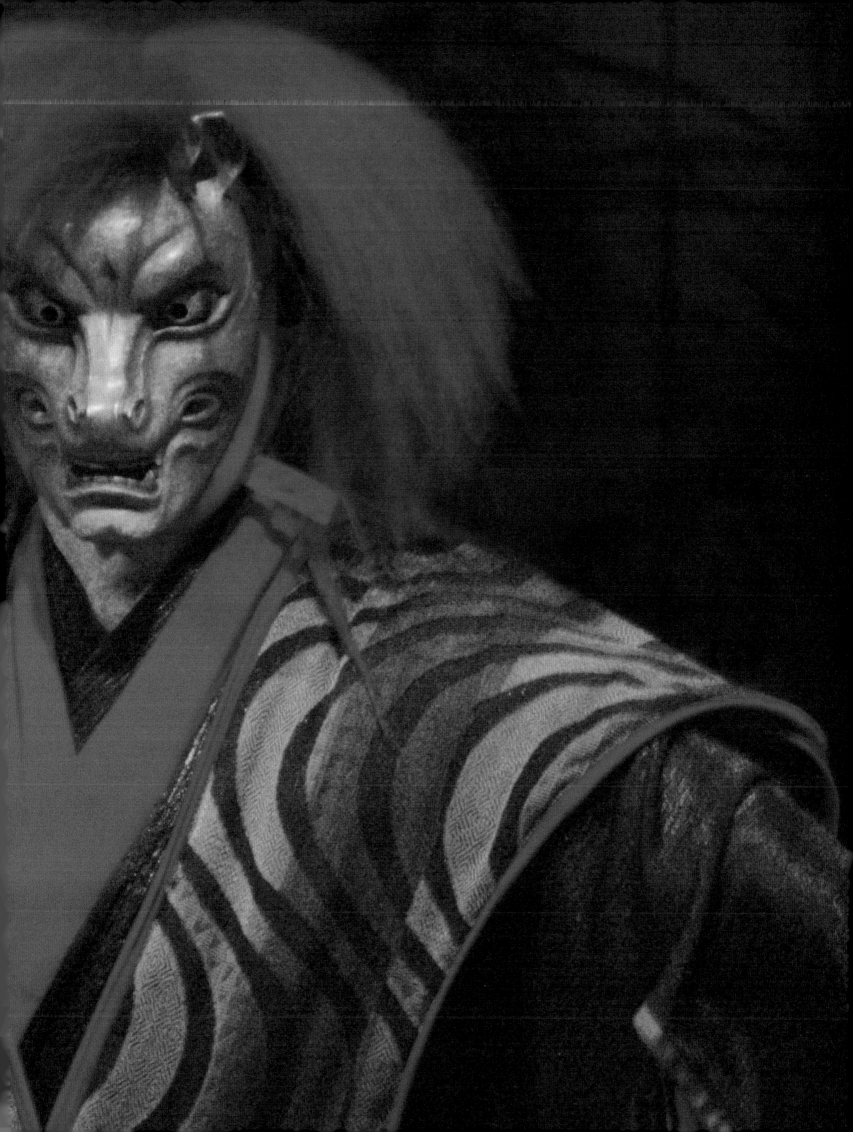

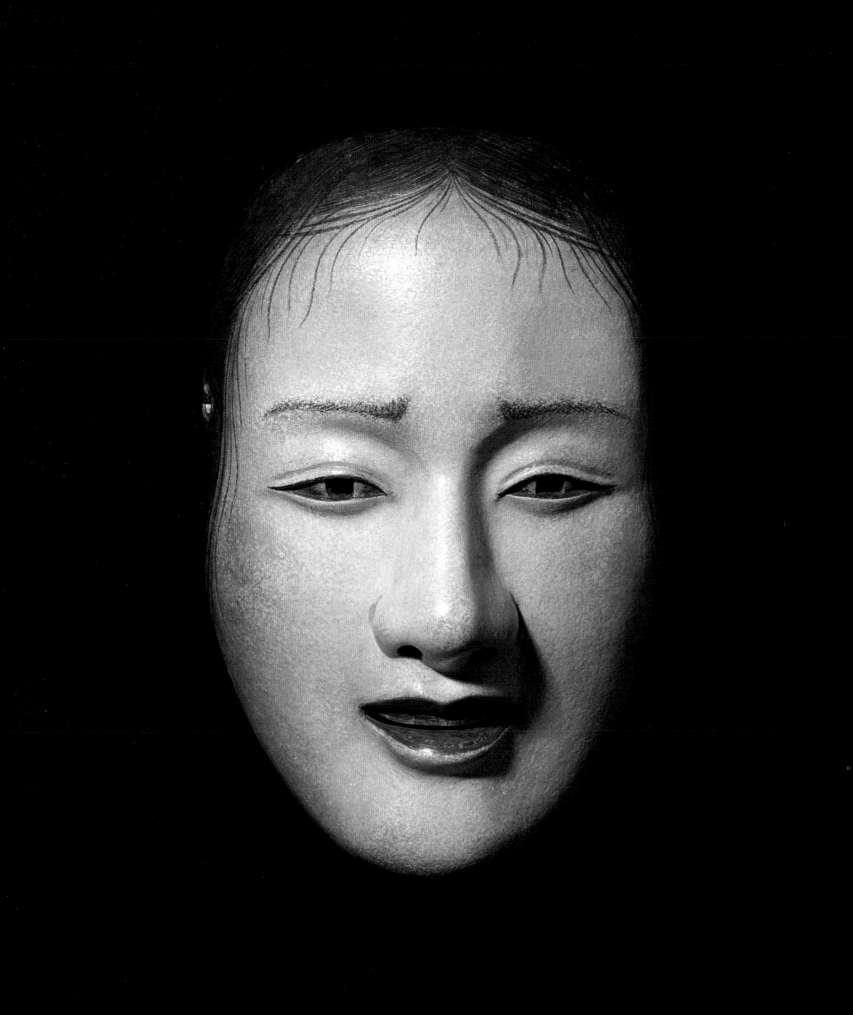

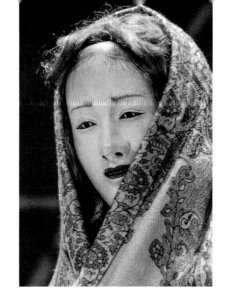

Crazy Jane

2007, 2010

Young woman (Jane) shite (main actor) in the English noh Crazy Jane *and Cordelia (young woman) in Act One of the noh-infused musical drama* Cordelia.

This represents a young Caucasian woman's face. The size of the mask is the same as a *ko-omote* and it has a similar wide nose. But the eyes are deeper and require deeper carving. The hair is brown, not black, and disheveled, suggesting somewhat crazed emotions. Kitazawa found the eyebrows particularly difficult to make. In comparison the classical *ko-omote* is a more subtle mask and Kitazawa felt that this mask needed a clearer expression.

Synopsis: In *Crazy Jane* a travelling young man takes shelter in a church for the night. He meets Jane, an ageing woman who was driven mad when her lover Tom left her years ago. Recalling how Tom and she once danced on the village green, she begins to move to imaginary music, drawing the young man in. As dawn breaks, Jane vanishes, leaving the young man bereft.

Commissioned by: Theatre Nohgaku/David Crandall for *Crazy Jane*. Initially written, composed and directed in 1983 by David Crandall for an ensemble of flute, clarinet, cello, marimba and percussion, with choreography by Monica Bethe. In 2006, Crandall finished a noh version of the play for Theatre Nohgaku and the mask was commissioned at this time.

Performance history: *Crazy Jane* toured in the USA in March–April 2007 to the University of Puget Sound, University of Washington, and South Puget Sound Community College, Washington. Worn by Colleen Lanki for one performance in Theatre Nohgaku's *Crazy Jane* production in August 2010 at the Alvina Krause Theater, Bloomsburg, Pennsylvania. Also worn by Jubilith Moore in Theatre of Yugen's *Cordelia* in April–May 2011 and again in September 2012 (see full performance history page 161).

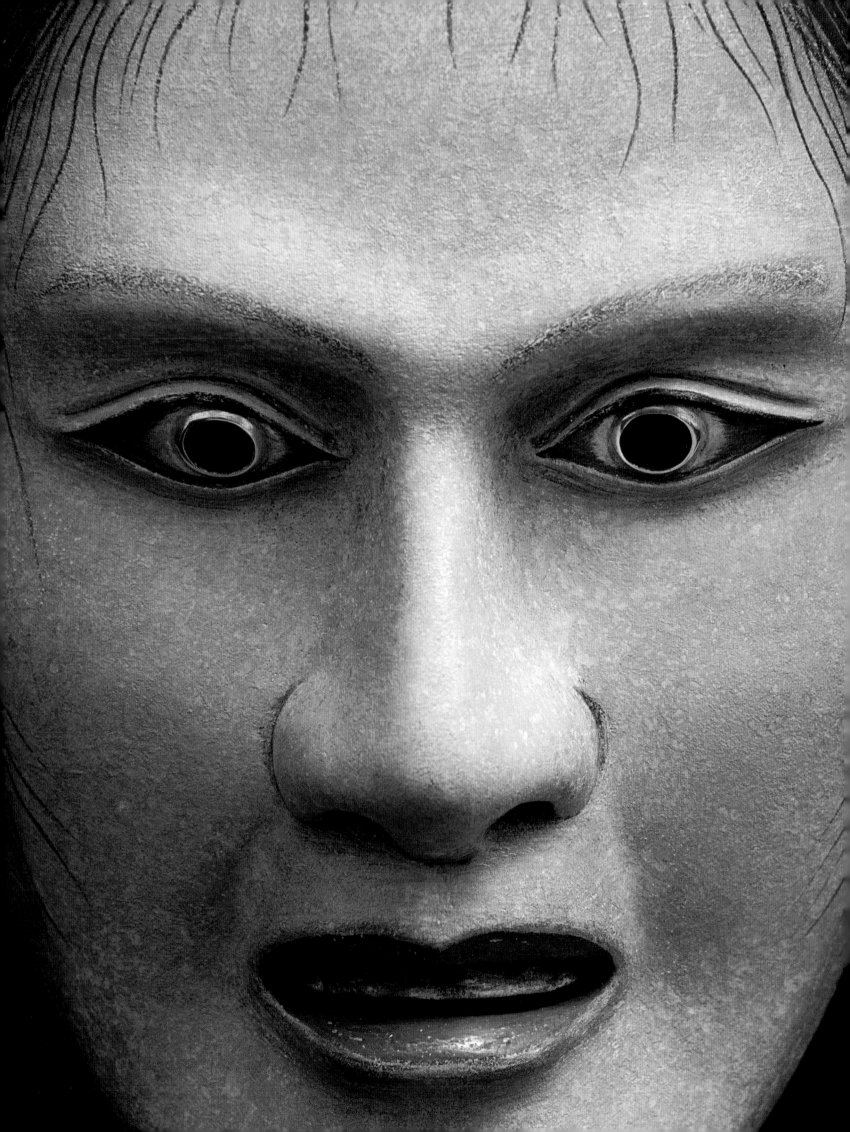

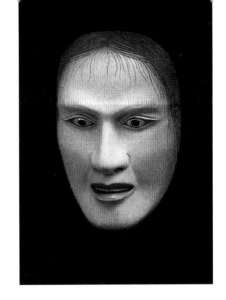

Cordelia

2011

Cordelia as warrior princess (nochishite, *Act Two main actor*) in the *noh-infused musical drama* Cordelia.

This mask was made to be used on a stage that has changing lighting effects. The eyes have gold-plated metal in order to catch and reflect light. The mask is based on the 'dragon woman' *ryūjo* mask used in the noh *Ama*. It has an angry or passionate feel, but its white forehead gives it a sense of nobility as she tries to contain her high emotion.

Synopsis: *Cordelia* is rooted in Shakespeare's *King Lear*. It is an uncharacteristic interpretation of Cordelia, Lear's youngest daughter. In the first act, *Cordelia*, forthrightly advocating for basic human interaction, reveals herself to be out of step with the court's new sophisticated sensibilities and, devalued, is erased. In the second act, she responds to her sister's political machinations by returning to rescue her father with sword in hand.

Commissioned by: Theatre of Yugen for *Cordelia*, a noh-based dance-drama by Eric Ehn, music by Suki O'Kane. Directed and choreographed by Jubilith Moore.

Performance history: Worn by Jubilith Moore in Theatre of Yugen's *Cordelia* for a season of performances in the USA at NOHSpace, San Francisco, California, April–May 2011, and again in a remounted production of *Cordelia* by Theatre of Yugen at the La MaMa Experimental Theatre Club, New York, September 2012.

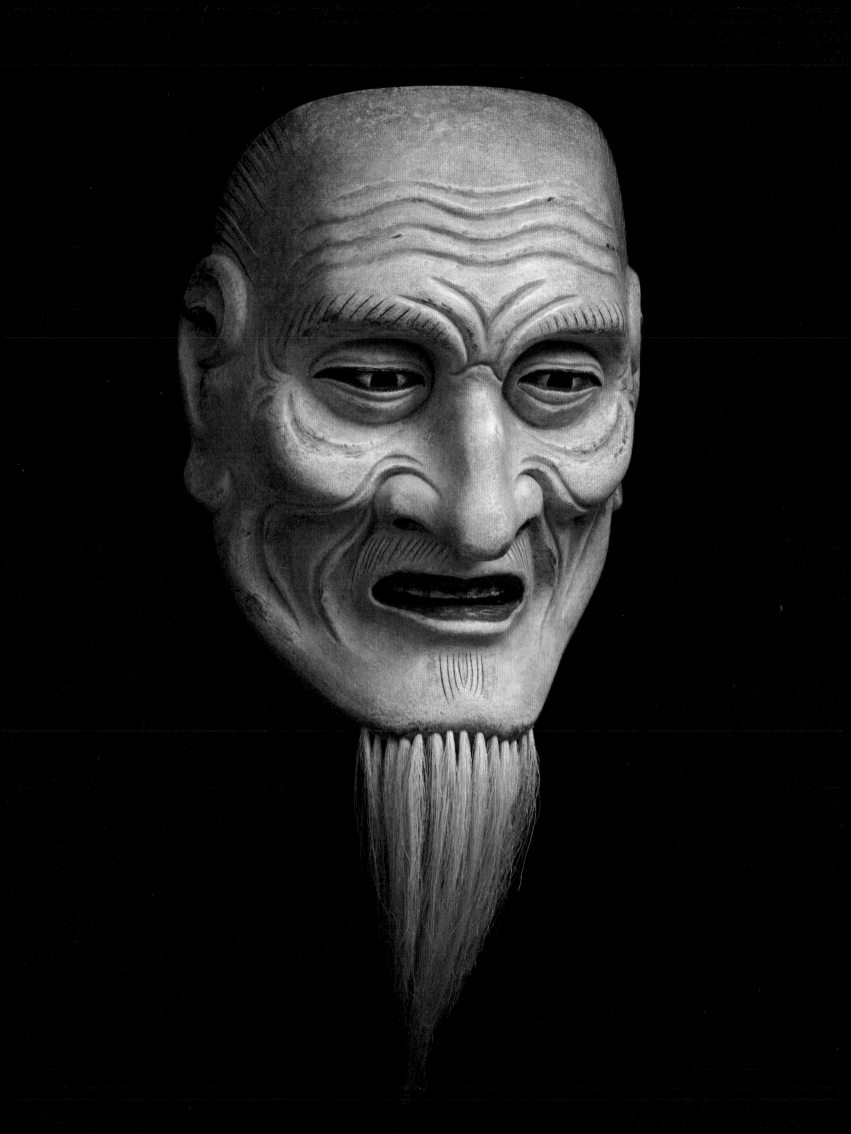

Dartmoor

2014

Old man, originally for The Linden Tree, *now to be used for the* maeshite, *Act One main actor, in the noh-based dance-drama* The Rowan Tree.

This mask is based on the *ishiō-jō* old man mask used for tree spirits appearing as old men such as in *Saigyōzakura* and *Yugyō Yanagi.* Kitazawa made the face to be Caucasian, especially the eyes and nose. He discussed this at length with David Crandall in order to give the mask a subtle ability to change expression like many classical masks.

Synopsis: An American woman in search of her roots travels to Dartmoor, England, and finds a rowan tree blooming in midwinter. She encounters an old man who tells her of a couple who planted the tree long ago to mark their love. Refusing to leave despite an approaching plague, the wife dies. Her devotion is celebrated by the spirit of the rowan tree, which performs a dance.

Commissioned by: David Crandall, originally for *The Linden Tree*, to be used for the noh-based dance-drama *The Rowan Tree,* along with the *Rowan* mask (see pages 164–165).

Performance history: Crandall's earlier noh-based dance-drama, *The Linden Tree,* was performed in Tokyo in 1986. *The Rowan Tree* masks have been used in various performance workshops and lecture-demonstrations by David Crandall.

Rowan

2014

Young man (spirit of a rowan tree), originally for The Linden Tree,
to be used for the nochishite, *Act Two main actor, in the noh-based
dance-drama* The Rowan Tree.

This is based on the classical young boy mask *dōji* who dances in
celebration. Kitazawa based this mask on a photograph of a young
movie star that David Crandall sent him, as well as his own research
into European religious carvings. On a trip to Germany, Kitazawa
had purchased a number of books about carved wooden Christian
iconography and was particularly taken by the work of 16th-century
sculptor Tilman Riemenschneider.

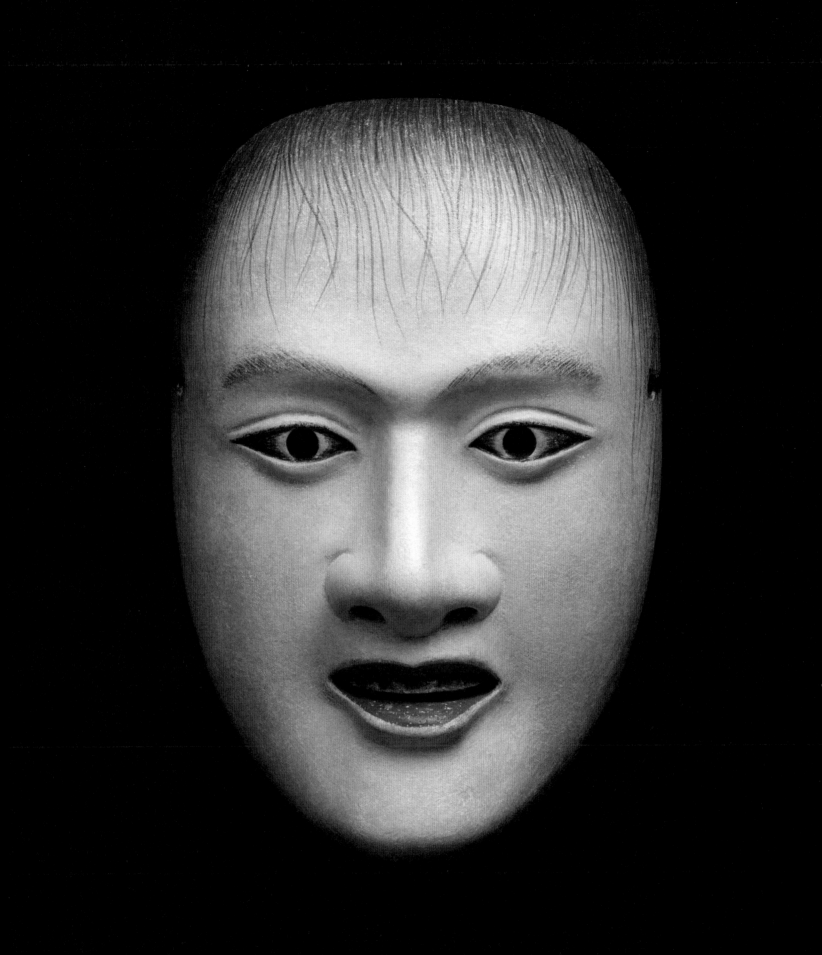

Anguished old man (Robert Oppenheimer, nochishite, Act Two main actor) in the English noh Oppenheimer.

Kitazawa made this mask at Allan Marett's home in Sydney, Australia, based on photographs of Robert Oppenheimer. It became quite similar to the classical mask *myōga-akujō*, the 'ginger-shaped evil old man', which has a very sad feel to it.

Synopsis: A pilgrim visits the ruins of an old temple in Hiroshima and there meets a priest who tells of the priest Hyakujō, who was condemned to live 500 lives as a fox because of his denial of the karmic laws of cause and effect. In the second half, the ghost of Robert Oppenheimer, the creator of the atomic bomb, appears and tells of his suffering in a fiery hell due to his denial of the karmic laws.

Commissioned by: Allan Marett for *Oppenheimer*, an English noh by Marett, music by Richard Emmert, choreography by Matsui Akira, direction by Matsui and Emmert.

Performance history: Worn by John Oglevee in an Allan Marett production at the Sydney Conservatorium of Music, Sydney, Australia, for performances on 30 September and 1 October 2015.

John Oglevee (left) performs the Ghost of Oppenheimer and Matsui Akira (right) Fudō Myōō in the English noh Oppenheimer *at the University of Sydney in 2015. Photo: Lee Nutter*

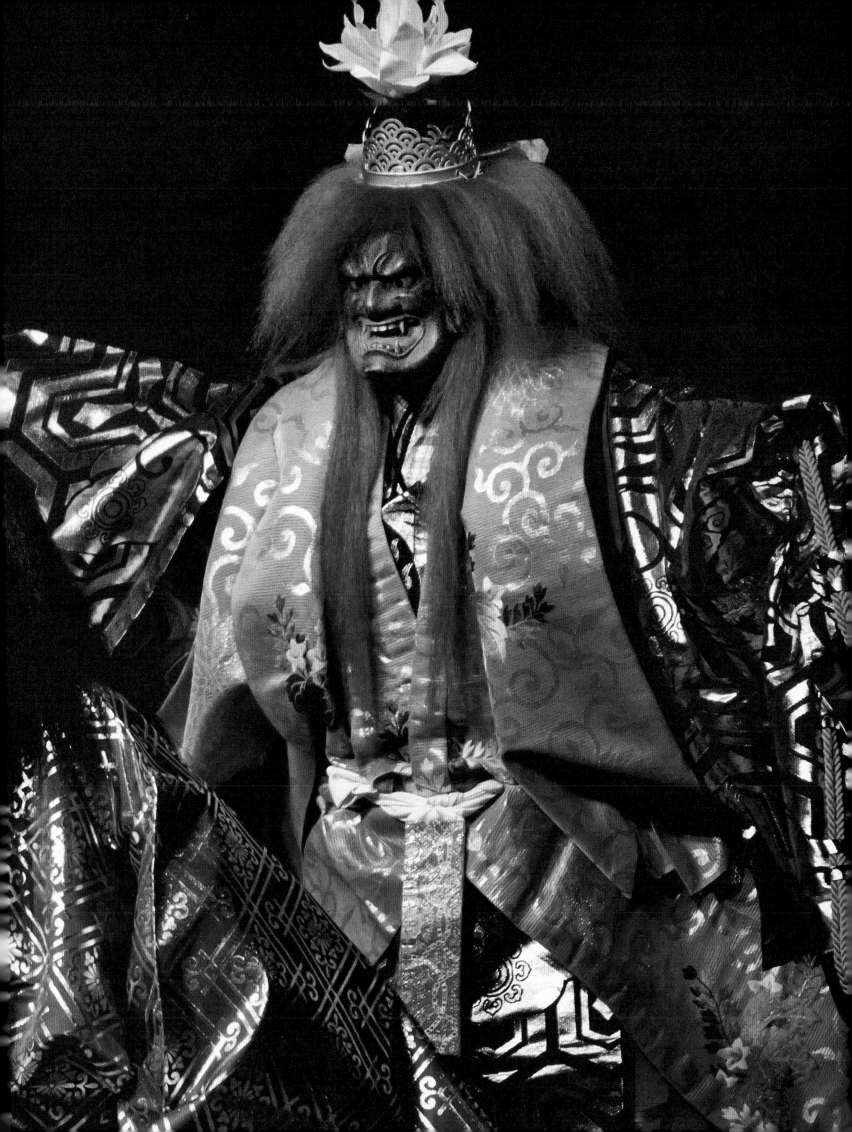

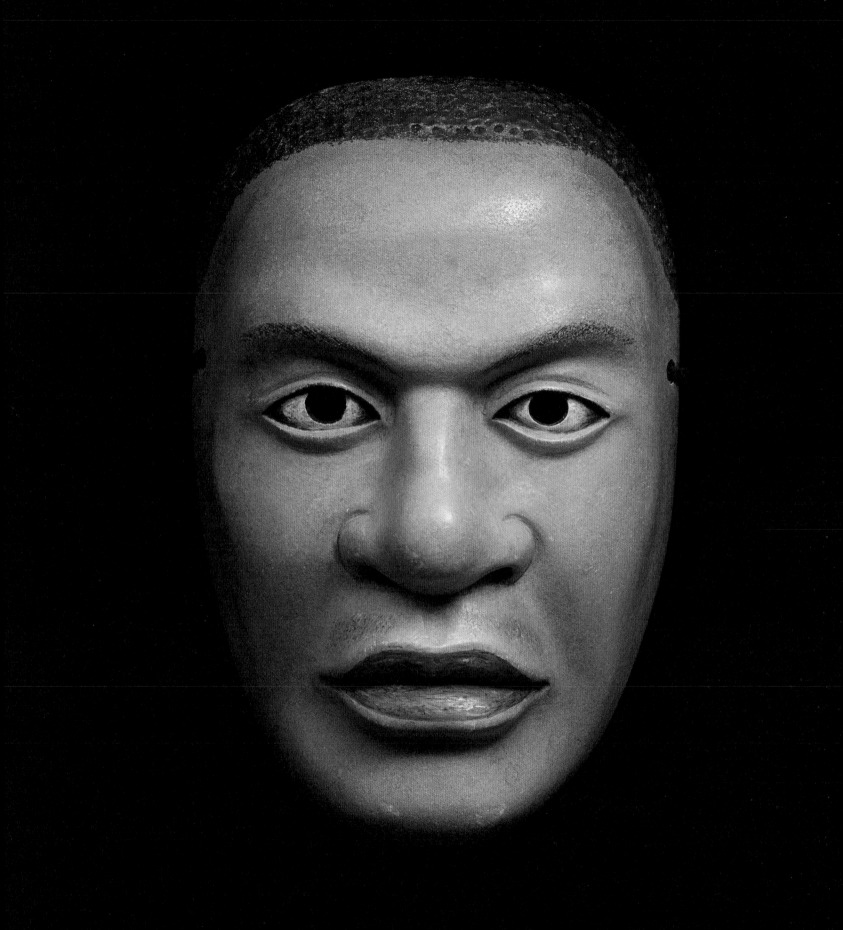

Robert Johnson

2016

Blues Man (maeshite, *Act One main actor*) *in the English noh* Blue Moon Over Memphis.

John Oglevee found several photos of blues musician Robert Johnson from the 1930s and in discussion with Kitazawa decided that these would be an appropriate model for the character, so they became the basis for the mask. During his extensive research Kitazawa read a biography of Robert Johnson. It is interesting to note that the mouth looks closed but actually there is a very thin slit between the lips.

Synopsis: *Blue Moon Over Memphis* is a stark yet beautiful meditation on loneliness, with numerous textual and musical allusions to 20th-century popular song. Judy is a lonely middle-aged woman and devout Elvis fan. She makes a pilgrimage to Graceland on the anniversary of Elvis' death, but is forced to wait outside due to the overwhelming crowds. She is left to reflect on her life through the verbal imagery of popular song. But during the candlelight vigil, a mysterious man lets her into the Meditation Garden where Elvis is buried, and there, under the light of a blue moon, she encounters the spirit of Elvis.

Commissioned by: Theatre Nohgaku for *Blue Moon Over Memphis,* an English noh by Deborah Brevoort, music by Richard Emmert, directed by Emmert and John Oglevee.

Performance history: Brevoort wrote her original noh-structured version at Brown University in 1993 and its production several years later used popular music. Later she condensed her original play in order to make it work with a new noh version. The *Robert Johnson* mask used in Act One, and the *Elvis* mask for Act Two, were both worn by John Oglevee in Theatre Nohgaku's USA performances of *Blue Moon Over Memphis* at NACL Theatre, Highland Lake, New York (August 2016), Williams College, Massachusetts, and Earlham College, Indiana (March 2017), and by Jubilith Moore/John Oglevee for two performances at the University of Michigan, Ann Arbor, Michigan, and the University of California at Los Angeles (October 2018).

*Right: John Oglevee
performs Elvis in* Blue Moon
Over Memphis, *2016.
Photo: David Surtasky*

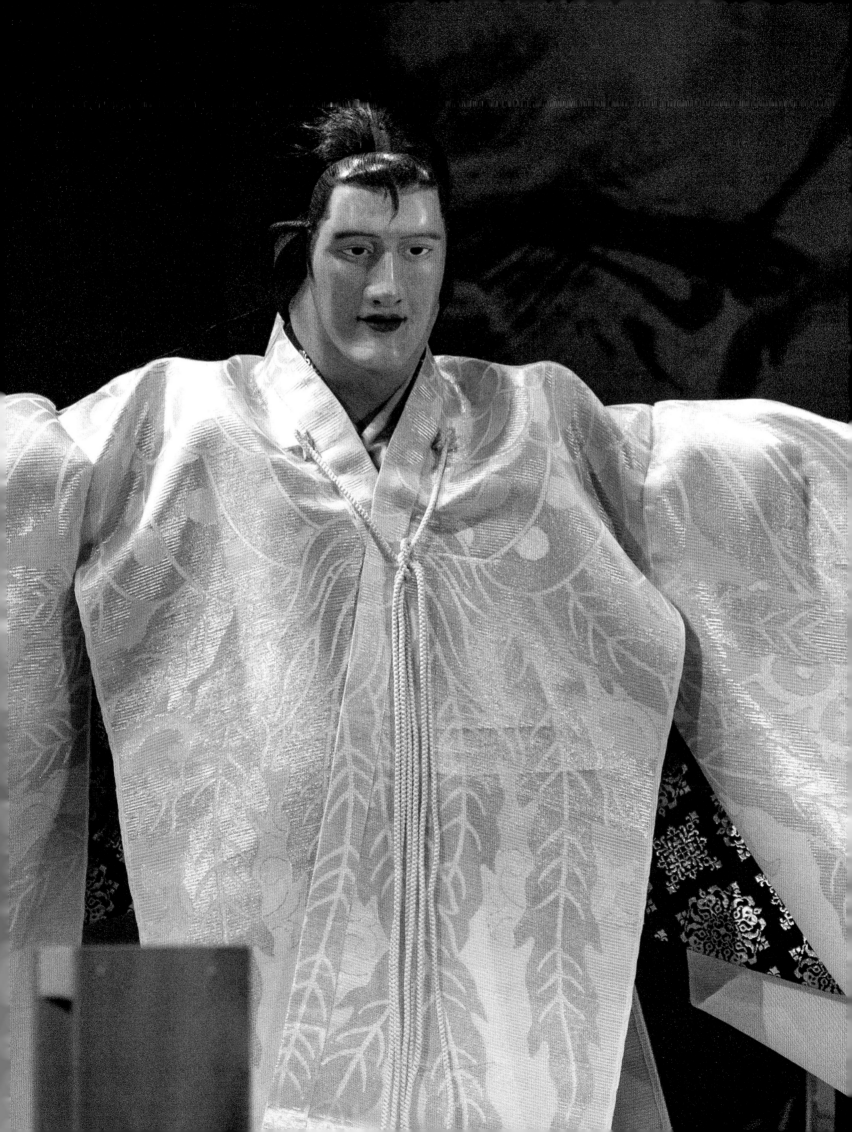

Elvis
2015

Young man (Spirit of Elvis Presley, nochishite, *Act Two main actor) in the English noh* Blue Moon Over Memphis.

There are many photos of Elvis, and Kitazawa had a number of discussions with John Oglevee about this and how Elvis should be portrayed. Although Elvis is very well known, it was important that this mask was a noh mask and not necessarily a realistic portrayal of Elvis. If people immediately recognise this as Elvis it might be more comedic than serious. In that sense, Kitazawa felt that it was a very difficult mask to make.

The *Elvis* mask was Theatre Nohgaku's first commission where they asked Kitazawa for a mask of an actual person. After much dialogue regarding the *Elvis* mask, it was decided that the mask should use the cheeks from Elvis' later years, the eyes of his thirties, the mouth of his late twenties and the hair of his early thirties. Add some poetic licence and the result is an uncanny figure that suggests 'Elvis the myth' rather than 'Elvis the man'. It displays Kitazawa's mastery of employing tradition to embrace modernity.

'Every mask should contain every emotion carved into it and the work of the shite *is to coax those emotions out for the audience to receive.'*

John Oglevee
Actor, Director

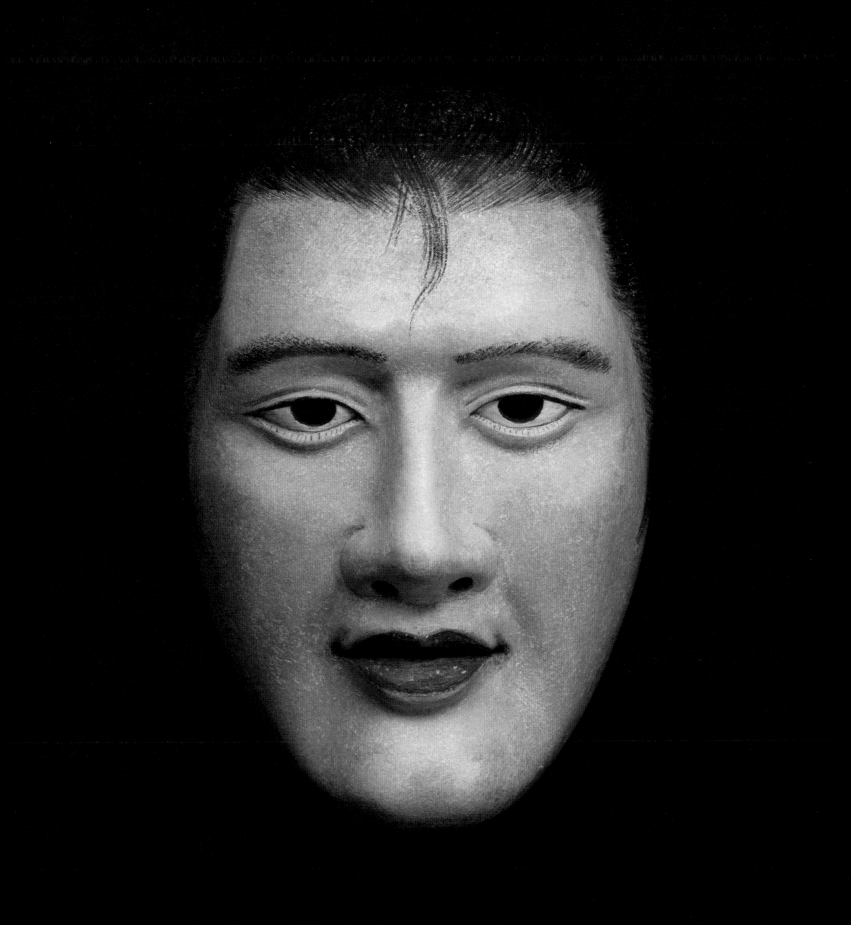

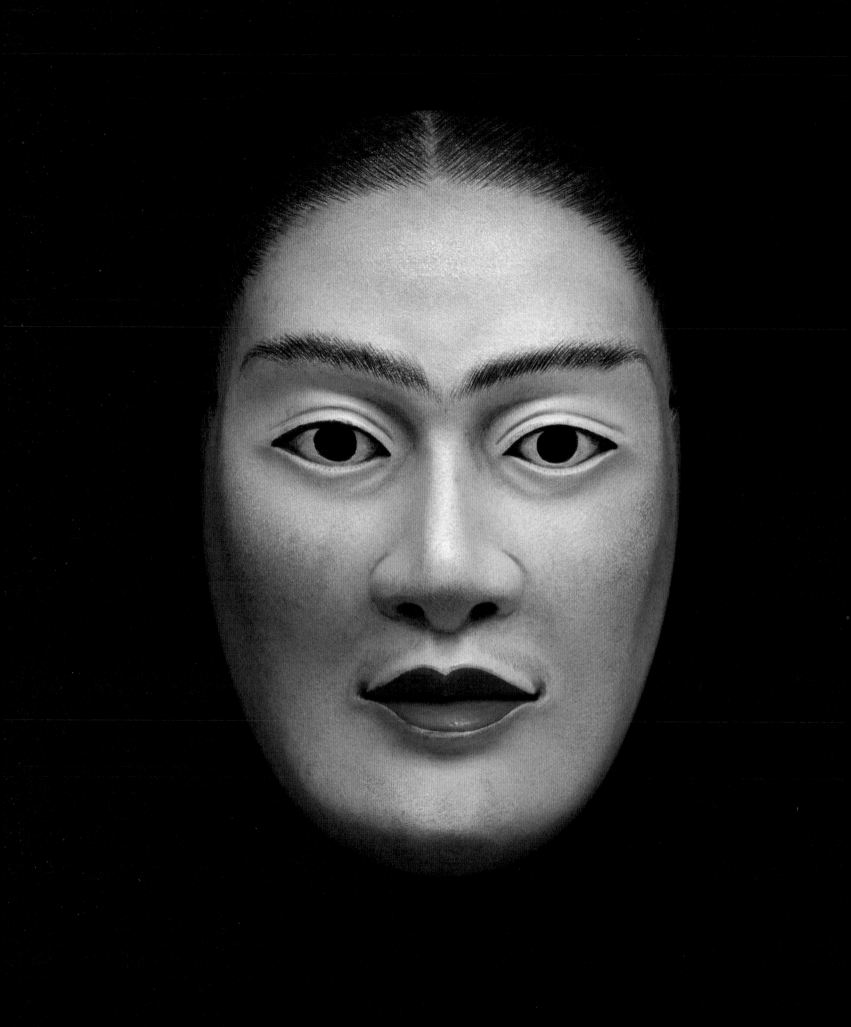

Frida Kahlo
2016

Middle-aged woman (Frida Kahlo) in the noh-infused musical drama
The Weaver and the Dress.

The main characteristics of this mask are the connected eyebrows and the large lips. Since the mask was made to be used by a student actor, Kitazawa made the openings for the eyes rather large to make it easier to use. Round eyes generally give a crazed effect which is related to the classical mask *shakumi*. The lips look closed but there is a thin slit between them, making it easier to breathe and speak. When making masks of well-known people, Kitazawa's aim is not to produce a photo-realistic image but something of the inner soul of the character.

Synopsis: Living remotely outside Mexico City, an old wheelchair-bound weaver is visited by the widower Diego. He wishes to commission the Weaver to recreate a simple dress his wife once wore. Quixotically, the Weaver passionately refuses and disappears. Alone, Diego, feeling haunted and nostalgic, is visited by dreams, even at one point inserting himself into them. Through his vision, we see members of his wife's family, and we see his wife, stunning in her true form as Frida. She appears before Diego to help him – and perhaps herself – confront his loss, let go of the past and move on.

Commissioned by: Willamette University Theatre for *The Weaver and the Dress* by Judy Halebsky, music by James Miley, music direction and sound design by Zachary Ward, direction and choreography by Jubilith Moore.

Performance history: Student production of *The Weaver and the Dress* in April 2016 at the M. Lee Pelton Theatre, Willamette University, Oregon.

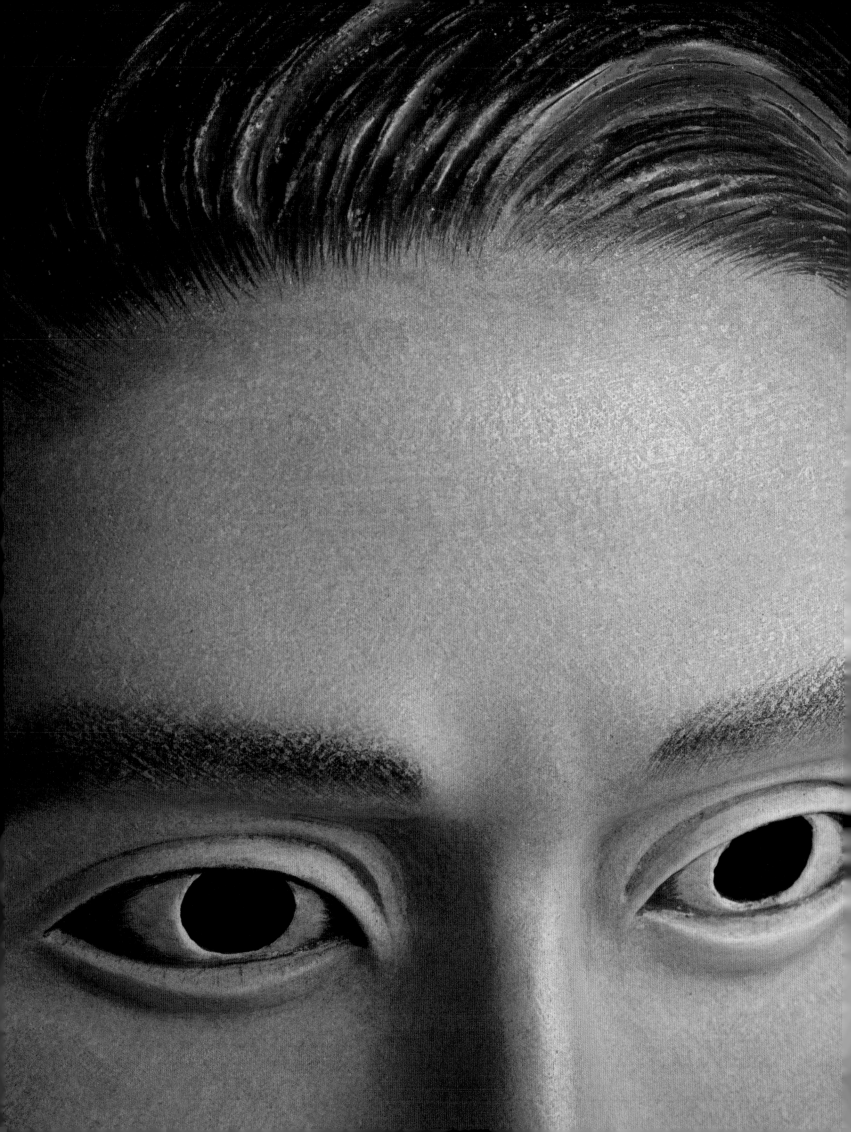

'It is the symbolic
use of the masks
that portray the
central theme.
The final Peter
mask is removed
and placed on
the stage – the
physical "self"
disappears and
only the memory
of the character
remains.'

Jannette Cheong
Author, Producer

Peter
2017

Young man (dancer, Act Three main character) in the noh-opera-ballet collaboration Opposites-InVerse.

Based on photos of the dancer Peter Leung, Kitazawa thought this mask would be a difficult challenge. Most classical masks are meant to be used with wigs and the mask itself only has traces of hair painted on it. But this mask has the hairstyle carved on it, without which it would be difficult to recognise the character. Therefore, Kitazawa was hoping that Peter Leung would not change his hairstyle for the performance.

Synopsis: The text and music are in noh style with noh instruments, yet sung by opera singers and danced by a noh actor and a ballet dancer. This conceptual piece reflects some of the opposites and differences in life that may affect us all. It is in three parts reflecting: 1) opposites in opposition, presented by a father and son unable to reconcile; 2) opposites that attract, presented as young lovers; and 3) opposites in balance, presented as an acceptance of one another, oneself and the passing of life.

Commissioned by: Jannette Cheong, Richard Emmert and Unanico Group for noh-opera-ballet collaboration *Opposites-InVerse*. A collaboration conceived and written by Jannette Cheong, music by Richard Emmert, choreography by Matsui Akira and Peter Leung. Matsui Akira also wears two other masks in this piece (*sanko-jō* in part one, and *zō* in part two: see pages 68 and 117 respectively).

Performance history: The *Peter* mask was worn by Matsui Akira in the noh-opera-ballet collaboration *Opposites-InVerse* for two performances at LSO St Luke's, London, in February 2017 as part of the *Noh Time Like the Present* tribute programme for Matsui Akira for his seventieth-year celebration.

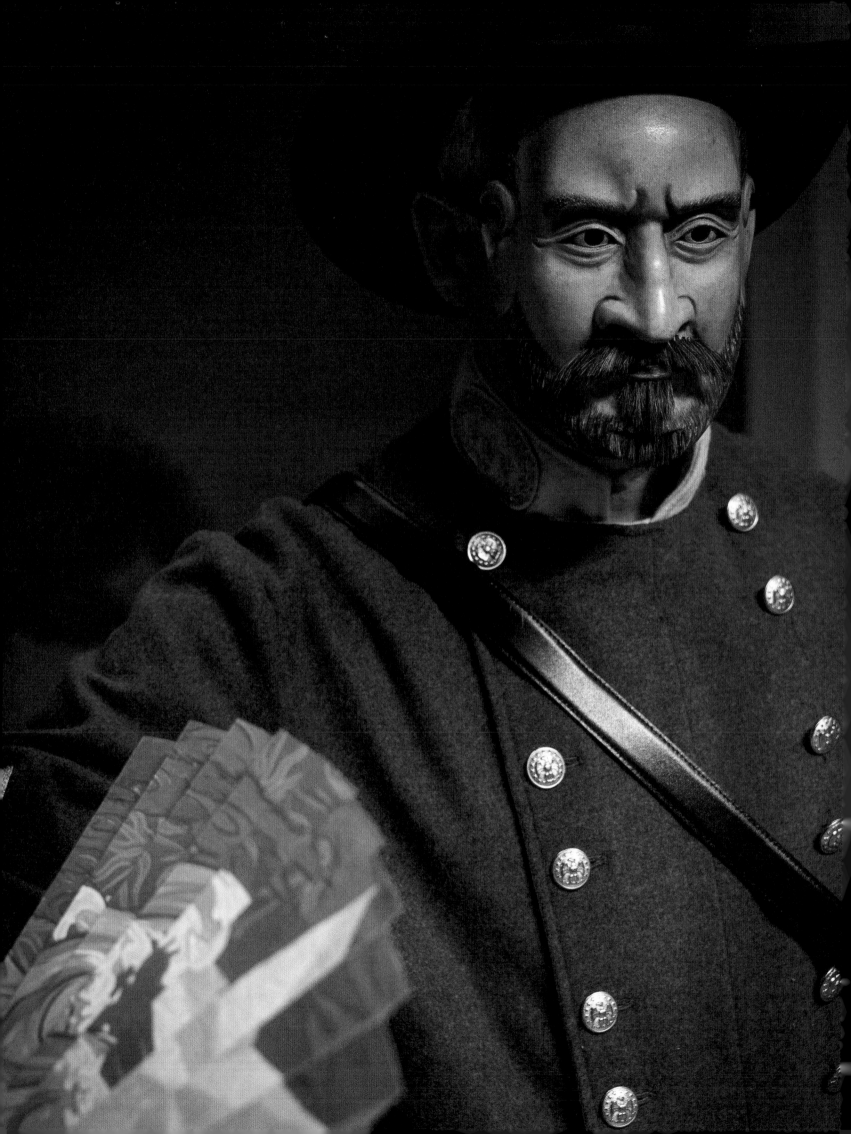

'Hideta asked me to give him a single word to encapsulate the character. I replied, "regret" ... he understood the fierce and haunted spirit that would inhabit this mask.'

Elizabeth Dowd
Actor, Director

Armistead
2017

Warrior (ghost of Confederate Brigadier General Lewis Armistead) in the noh-based dance-drama Gettysburg.

Kitazawa enjoyed having long discussions with both David Crandall and Elizabeth Dowd about this mask. They both visited his home early on in the development of the design. It has a very neutral face and in that sense is noh-like in that it allows the performer to create the character's emotions rather than having a mask which already expresses a strong emotion. Noh masks that portray strong emotions are generally used for characters that are only on stage briefly.

Synopsis: A veteran of the war in Afghanistan and descendant of Civil War Union General Winfield Hancock travels to the battlefield at Gettysburg, where he encounters the ghost of Confederate Brigadier General Lewis Armistead. *Gettysburg* recounts the pre-Civil War friendship between Armistead and Hancock, who were fated to fight each other in the battle of Pickett's Charge. The play is a meditation on the cost of war to those who fight it.

Commissioned by: Elizabeth Dowd for Theatre Nohgaku's production of *Gettysburg*, a noh-based dance-drama by Elizabeth Dowd, music by David Crandall, direction by Dowd and John Oglevee, music direction by Kevin Salfen.

Performance history: Worn by David Crandall in *Gettysburg* for Theatre Nohgaku's August 2017 work-in-progress performance, Alvina Krause Theatre, Bloomsburg, Pennsylvania; again in April 2018 for a second work-in-progress performance at Hampden-Sydney College, Virginia; then in September 2019 USA tour performances at Charity Randall Theatre-University of Pittsburgh, Harvey Powers Theatre-Bucknell University, Sutherland Theatre-Penn State Abington campus, Pennsylvania, The Sharp Theatre-Ramapo College, New Jersey.

Left: David Crandall performs the Ghost of Armistead in Gettysburg, 2017.
Photo: David Surtasky

> 'Both designs sought a balance that was almost akin to yin-yang – the masks mapping the same emotional tensions, but from opposing points of view.'

Ashley Thorpe
Author of Emily

Old Groundsman

2019

Old Groundsman (maeshite, Act One main actor) in the English noh Emily.

This mask is based primarily on one photo that Ashley Thorpe provided to Kitazawa of an old man that he had found on the internet. The mask depicts a highly focused Caucasian face. Up close, this mask is very lifelike. Discussions about the two masks used in *Emily* explored the contrary emotional states between them. The old groundsman mask required a heavy weariness, a sense of toil under the sun, but also suppressed energy – a glimpse of sporting prowess still lurking underneath.

Synopsis: *Emily* explores the legacy of Emily Wilding Davison, a British suffragette who was killed by the king's horse at the Epsom Derby in 1913 while protesting for the right of women to vote. A layperson travels to Royal Holloway College to visit its beautiful chapel. A groundsman tells him of a new library named after a graduate of Royal Holloway, Emily Davison, and explains why Davison is remembered. The layperson arrives at the chapel as the night draws in. While offering prayers, the spirit of the king's jockey, Herbert Jones, appears and explains how he suffers in purgatory for taking his own life. His penance is to re-live Emily's death under his horse. The layperson witnesses Jones' reliving of the 1913 Epsom Derby and the death of Davison.

Commissioned by: Ashley Thorpe and the Department of Theatre, Royal Holloway, University of London, for *Emily,* an English noh by Ashley Thorpe, music by Richard Emmert, choreography by Matsui Akira, direction by Matsui and Emmert.

Performance history: The *Old Groundsman* mask was worn by John Oglevee in the remounted Theatre Nohgaku production, 4–6 September 2019, Tara Theatre, London.

Herbert Jones

2018

Young man (Spirit of Herbert Jones, nochishite, Act Two main actor) in the English noh Emily.

Ashley Thorpe provided several photos of the jockey Herbert Jones, on which Kitazawa based this mask, but it is also very similar to the *chūjō* 'lieutenant' mask used in several noh such as *Kiyotsune* and *Tadanori*. This has a longer nose and other Caucasian features. It was based on photos of Jones but is the opposite of the *Old Groundsman* mask. The *Herbert Jones* mask exudes the pride of a jockey doing the thing he loves, but also captures the horror of death that he inflicts every night while reliving the race. The eyebrows in both masks are powerfully expressive, communicating an almost religious focus and determination, but also the horror and regret of a soul in purgatory.

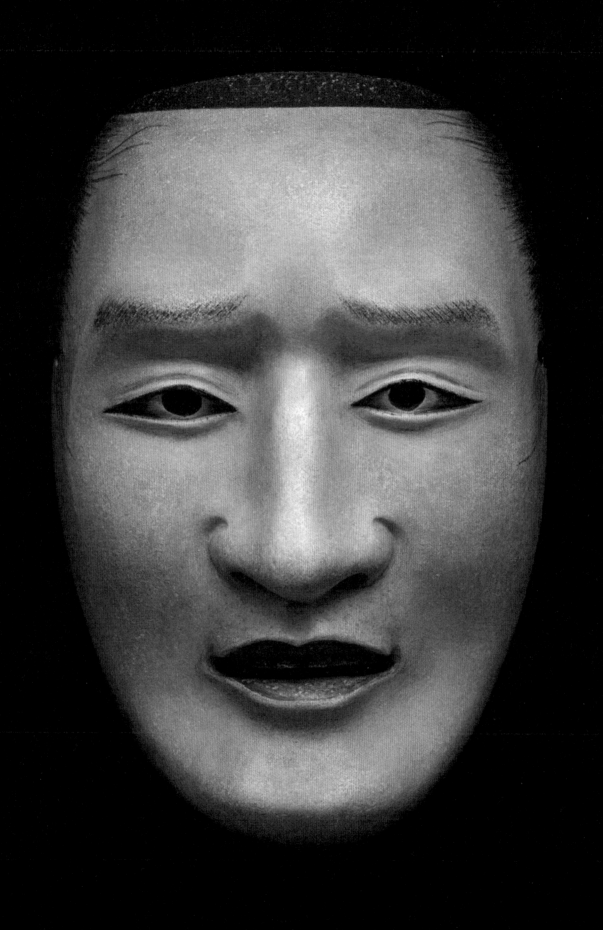

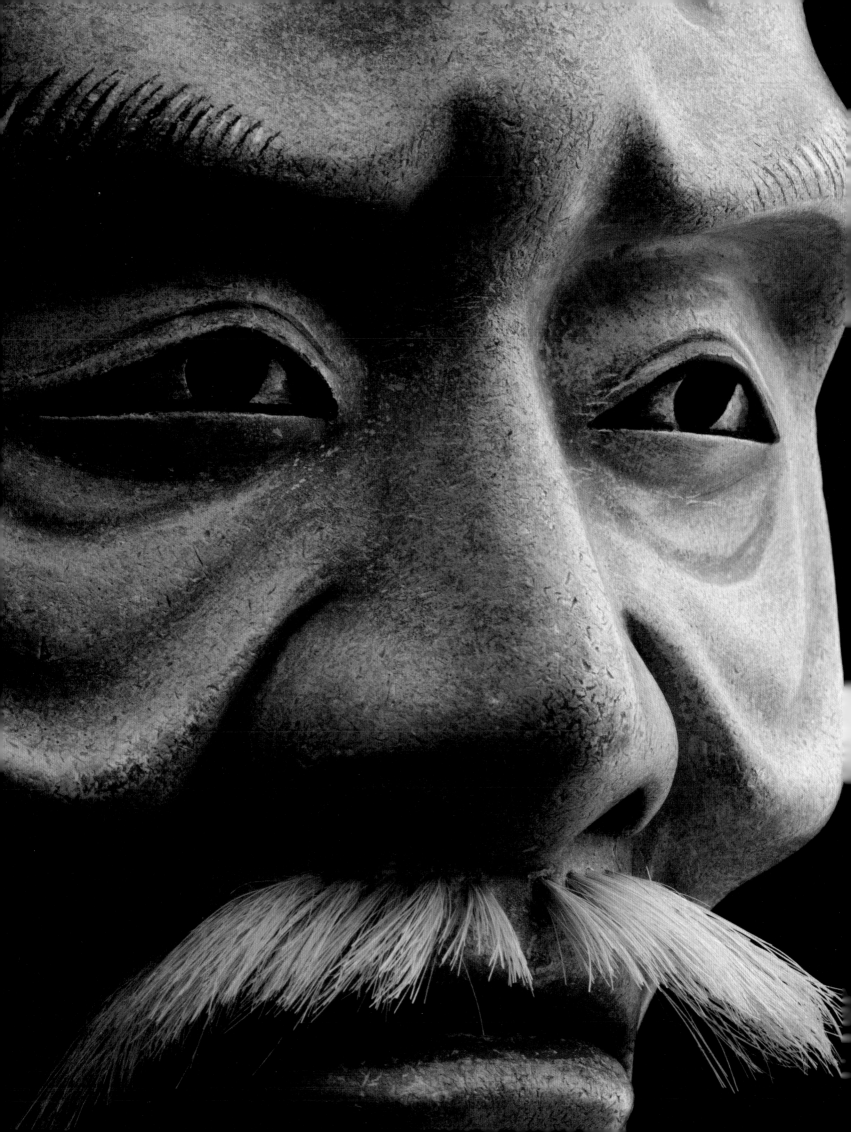

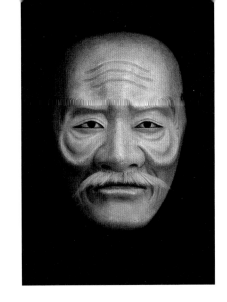

'The mask for Kanō, founder of judō, is strong, filled with resolve; and sad, no stranger to pain and disappointment; but with a tinge of something else, a glimmer of hope that will not die.'

Kevin Salfen
Author of Phoenix Fire

Kanō Jigorō

2020

Middle-aged man (Kanō Jigorō, maeshite, Act One main actor) in the noh-infused musical drama Phoenix Fire.

Based on photos of Kanō Jigorō (1860–1938), the father of modern *judō*. As *judō* is taught in most schools his photo is widely displayed and his face is well known to most Japanese. It is a contemporary Japanese face, quite similar to the *sankō-jō* old man mask with a moustache, but does have a small beard.

Synopsis: *Phoenix Fire* imagines a meeting of filmmaker Ichikawa Kon, maker of *Tokyo Olympiad*, the documentary about the 1964 Games, and the spirit of Kanō Jigorō, the founder of *judō*, who tried to bring the 1940 Olympics to Japan. Kanō describes how his plans for the 1940 Games fell apart, which reminds Ichikawa of the great suffering of the war years. Later, a phoenix arrives to preside over the 1964 Games as the chorus describes events and the triumphant closing ceremonies.

Commissioned by: Kevin Salfen and Theatre Nohgaku for *Phoenix Fire*, a noh-based dance-drama with text and music by Kevin Salfen, direction and choreography by Matsui Akira. Due to the Covid-19 pandemic, the 2020 *Phoenix Fire* scheduled tour to Tokyo and Kumamoto in Japan and San Antonio in the USA was postponed, as were the 2020 Tokyo Olympics.

Performance history: Richard Emmert wears the *Kanō Jigorō* mask in Kevin Salfen's film of *Phoenix Fire*, which is in production.

Miscellaneous Masks

These miscellaneous masks were commissioned for pieces that required masks that were made in a variety of styles different from any of the masks in the previous categories. In some cases movement and/or vocal techniques were also different from noh or kyogen pieces.

For example, *Mystical Abyss* (*Izanagi, Susano-o*) used dancers, so Kitazawa tried to make these new masks in a way that would not interfere with the actor-dancers' performance. He made half masks inspired by *commedia dell'arte* and Japanese warrior-style samurai face protectors, although the original idea is from an old Native American Iroquois tribe mask.

The *white fox* mask is based on a traditional Japanese *kagura* mask. *Kagura* masks are generally used in folk festivals at local shrines. The white fox is a servant of the Inari god who is responsible for a good rice harvest. *Kamapua'a* represents a Hawai'ian native god. In preparation, Kitazawa researched Hawai'ian and Polynesian traditional woodcarving. The three horns of the mask indicate heaven, earth and mankind.

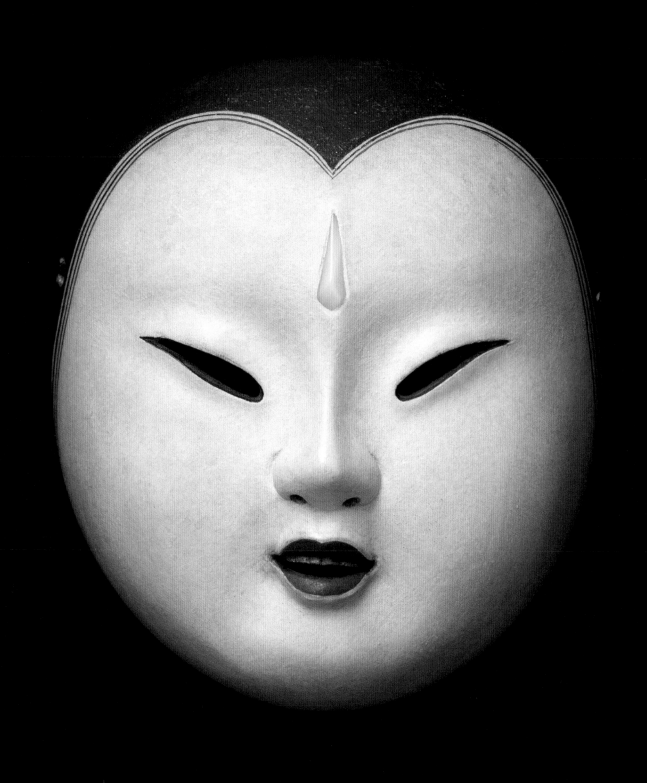

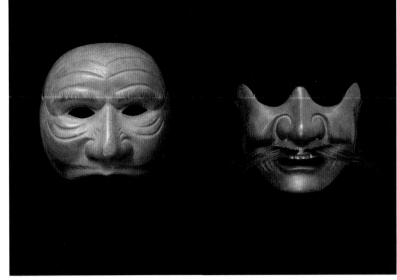

Izanagi Susano-o

Gentle Izanami, Angry Izanami, Izanagi, Amaterasu, Susano-o
2012

Five masks created for Theatre of Yugen's production *Mystical Abyss*. Yuriko Doi suggested the *Gentle Izanami* mask be based on several famous Jōmon period clay figurines of Izanami. Kitazawa added the power stone above the nose. This mask is round like a ball, so is a bit difficult to use. The shape and its mouth, eyes, nose and hair are similar to those of the clay figurines. The mouth is quite small and Kitazawa added teeth and strands of hair similar to the *ko-omote* mask.

Both the *Izanagi* and *Susano-o* masks were to be worn by dancers so the eyes were made large in order that they can see through them easily.

Synopsis: A fusion of Japanese and Iroquois mythology, a cyclical story of death and rebirth. 'Sky Woman', from Iroquois mythology, falls into an abyss toward the sea. As she falls, she meets 'Fire Dragon', who gives her seeds, and then she meets various Japanese gods, goddesses and other symbolic characters of nature. 'Sky Woman' witnesses scenes from Japanese mythology, and is then killed by Susano-o, the god of storms. When she is buried the seeds are scattered and a small white pine tree appears. All assembled are filled with joy.

Commissioned by: Theatre of Yugen. A contemporary dance-drama by John O'Keefe, music by Takizawa Narumi and Kenny Perkins, direction by Yuriko Doi, choreography by Jesus Jacoh Cortes, Nomura Shiro, Jairo Heli Garcia, computer graphic animation by Kobayashi Taketo, Takahashi Koya.

Performance history: *Izanami (Gentle, Angry)* and *Amaterasu* masks worn by Nomura Masashi; *Izanagi* and *Susano-o* worn by Jesus Jacoh Cortes in Theatre of Yugen's *Mystical Abyss* performances at ODC Theatre, San Francisco, California, September 2012, and again by Nomura Masashi with *Izanagi* and *Susano-o* worn by Jairo Heli Garcia in a remounting of the piece in association with Cleo Parker Robinson Dance Company, Denver, Colorado, September 2015.

Left: Gentle Izanami, a beautiful Japanese goddess whose decomposed body turns into Angry Izanani (see page 190).

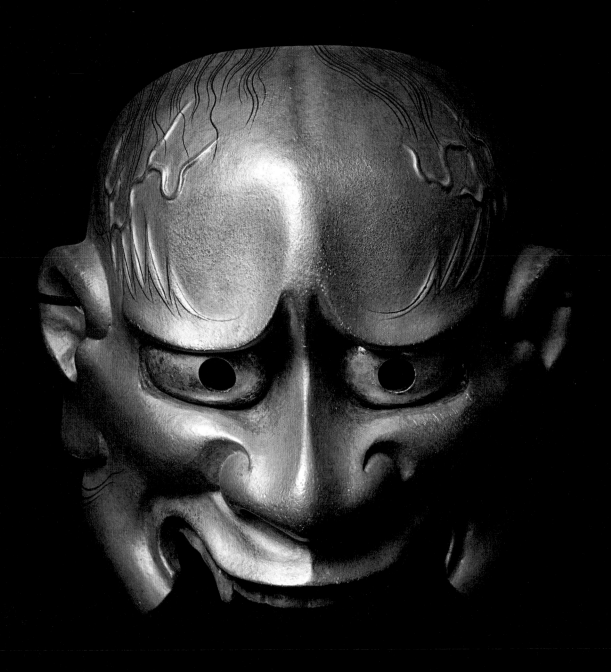

Angry Izanami

This mask is based on a *hannya* mask without the lower chin. It is painted gold and has some extra forehead decoration.

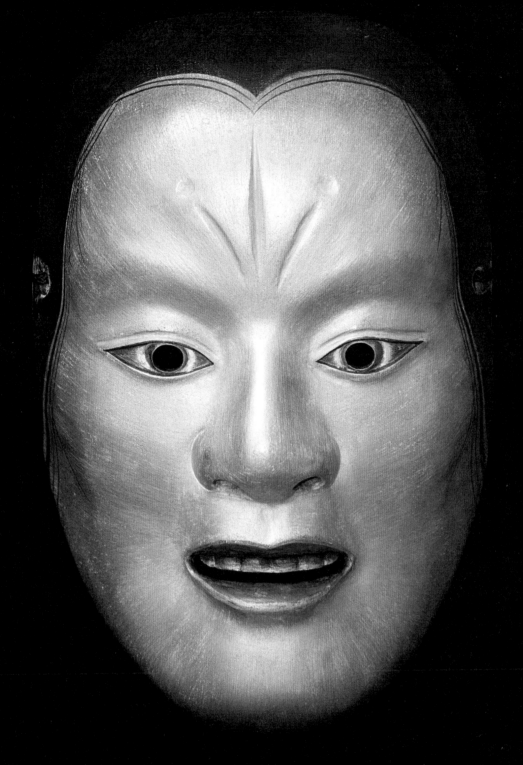

Amaterasu

This mask represents the sun goddess of Japanese mythology who has an intense divine power which is reflected in the use of gold metal in the eyes. It is based on the *masukami* mask.

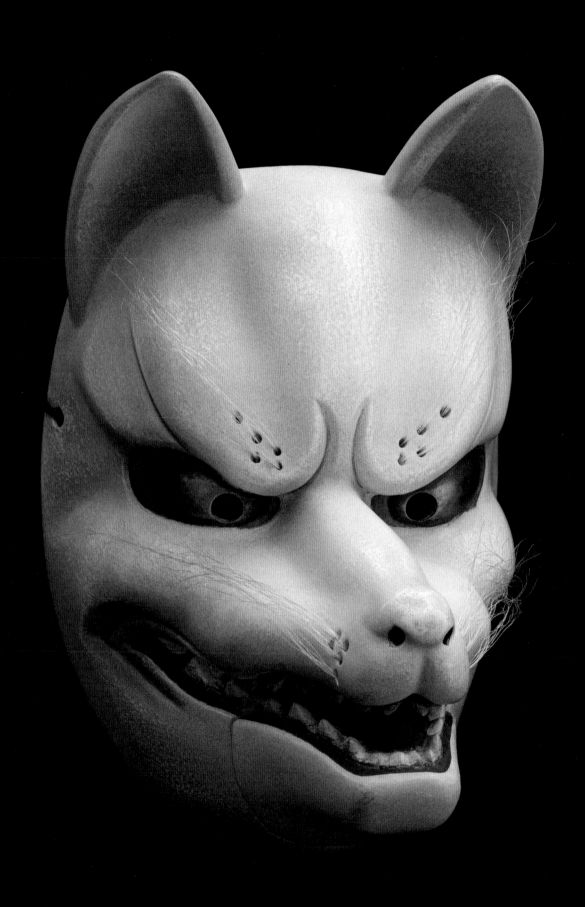

White Fox (Tenko)
2015

A 'heavenly fox' (tenko) *mask originally for use in various types of kagura shrine performances in Japan. Used to portray the interlude fox role in the English noh* Oppenheimer (*see also pages 166–167*).

This is a *kagura* mask which Kitazawa made originally for his own study. He wanted to make a *kagura* fox mask with a more refined, professional look compared to the fox masks often used for *kagura* festival performances. It is not a normal fox, but has a divine god-like mien.

Commissioned by: Used in the English noh *Oppenheimer.* Purchased in 2019 by Art Gallery of New South Wales, Sydney, Australia.

Performance history: Worn by Yoke Chin in the Allan Marett production of the English noh *Oppenheimer* at Sydney Conservatorium of Music, Australia, for two performances on 30 September and 1 October 2015.

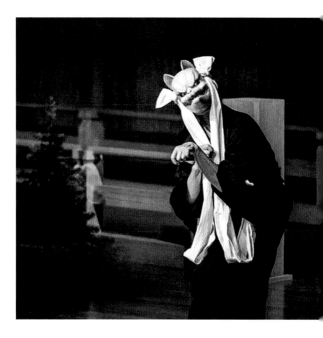

Right: Yoke Chin performing the interlude fox role in Oppenheimer, *Sydney, 2015. Photo: Lee Nutter*

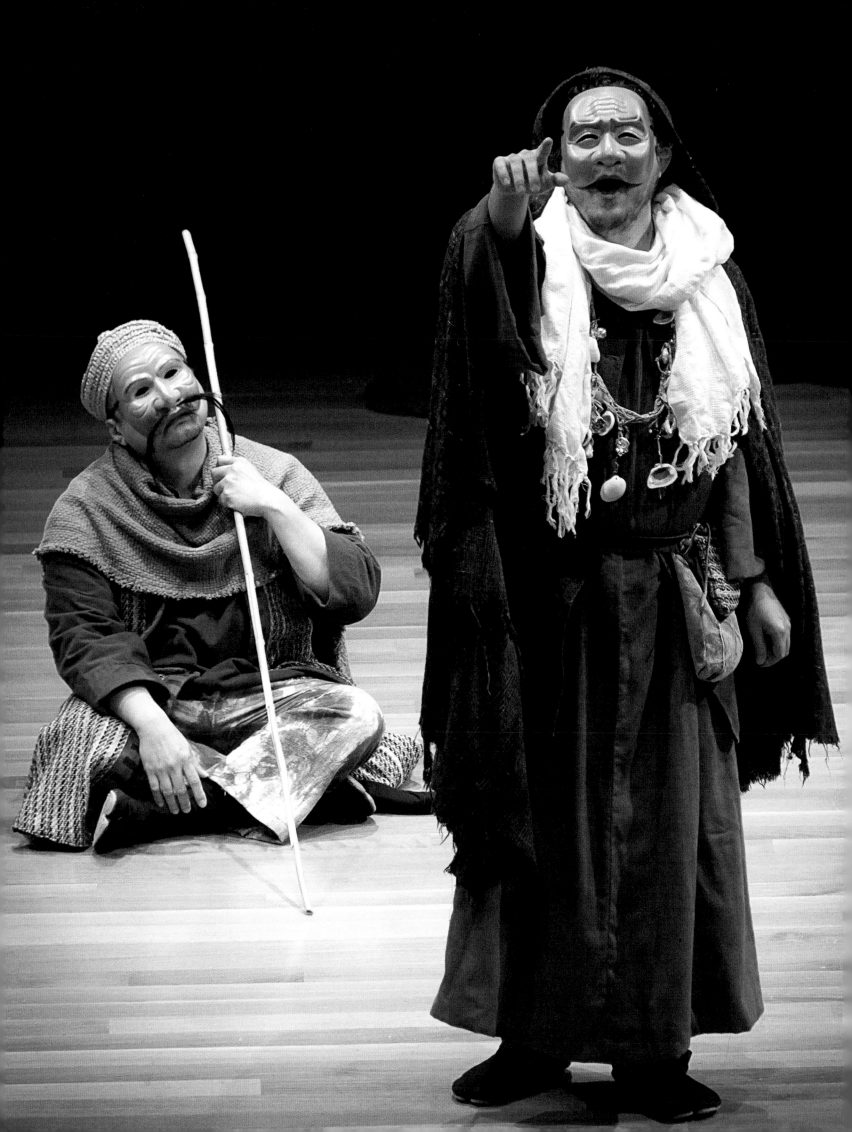

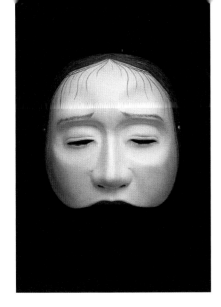

Ferryman, Traveller, 'Madwoman'
2015

The three main characters in the English music-drama Curlew River.

In speaking with Kevin Salfen, it was decided that it would be easier for the opera singers if these were all half-masks, and for the audience to understand if they were different colours. The ferryman is orange, the traveller is yellow and based on the well-known Japanese comic actor Issey Ogata, and the 'madwoman' is white and is based on a *deigan* mask.

Synopsis: A 'madwoman' and a traveller cross the Curlew River on a ferryman's boat. The 'madwoman' is searching for her missing child. The ferryman gives her passage, during which time he tells of a boy who one year earlier had arrived with a cruel master who had kidnapped him. Finding the boy sick, the master had left him here to die. Hearing details of the boy, the 'madwoman' reveals that the boy is her child and goes to pray at the boy's gravesite. Joined by the chorus as they all chant together, the boy's spirit voice is heard reassuring his mother that they will meet again in heaven.

Commissioned by: Kevin Salfen for a production of Benjamin Britten's *Curlew River* church parable. *Curlew River* is an English music-drama written in 1964 with music by Britten and libretto by William Plomer, based on the Japanese classical noh play *Sumidagawa*.

Performance history: The *'Madwoman'* mask was worn by Steven Brennfleck, the *Ferryman* mask by Chia-Wei Lee, and the *Traveller* mask by Scott Flanagan in *Curlew River* for USA performances in the November 2015 *Where Rivers Meet* Texas tour, at the University of the Incarnate Word and St Luke's Episcopal Church (San Antonio), and the Asia Society (Houston).

'The ferryman's half-mask conveys bold muscularity, and resonates with the ritual origins of Japanese theatre.'

Kevin Salfen
Producer of Curlew River

Left: Chia-Wei Lee performing the Ferryman and Scott Flanagan performing the Traveller in Curlew River, *San Antonio, 2015. Photo: David Surtasky*

Above: The 'Madwoman' mask. Photo: Kitazawa Sohta

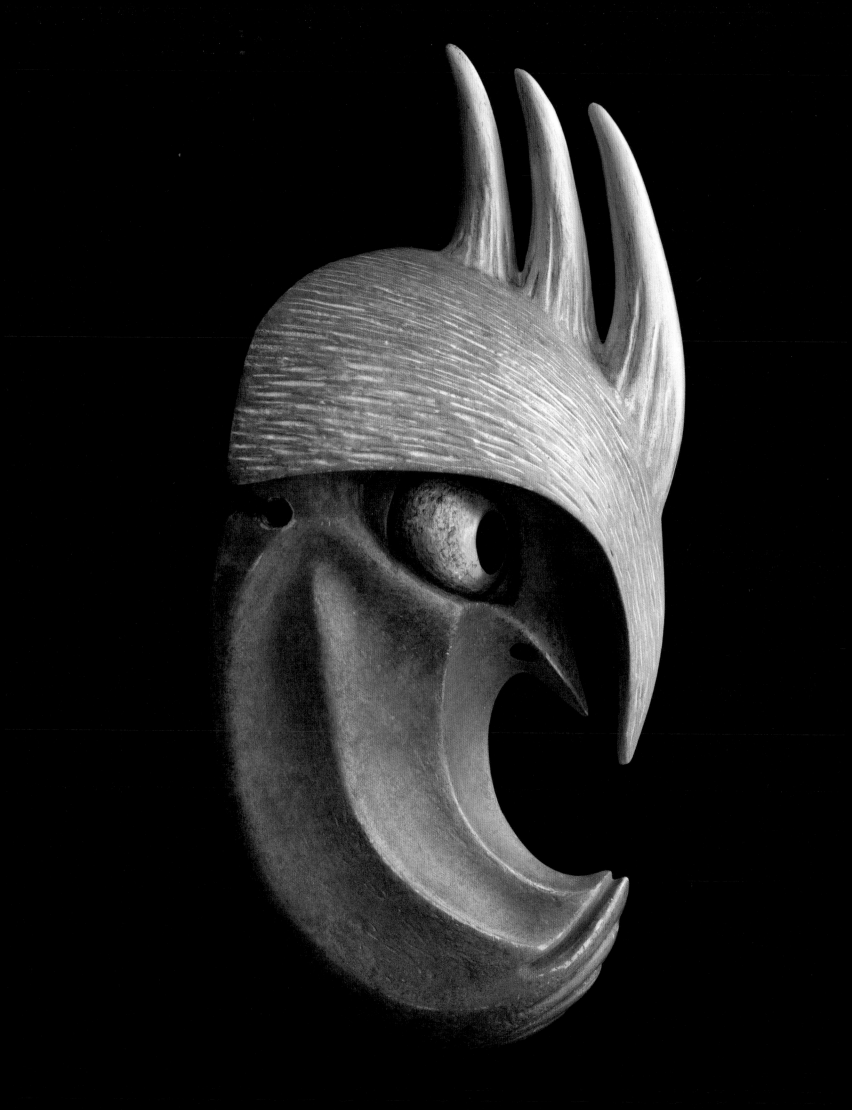

Julie A. Iezzi
Theatre Professor

Kamapua'a
2016

The Hawai'ian demigod, known as a mischief-making shapeshifter, whose physical form is part man and part pig, in the English kyogen-style play Derailed.

In Honolulu, Kitazawa went with Julie Iezzi to the Bishop Museum, the cultural history museum of Hawai'i, and found a Kamapua'a *ki'i* (image) statue on which this mask is based. The statue has numerous horns, some of which are broken. They decided that the mask should have three horns, which stand for *ten-chi-jin* ('heaven-earth-man'), which is at the centre of Japanese cosmology and is also referred to in noh and kyogen, notably in the ritual piece *Okina*.

Synopsis: A play set in contemporary Hawai'i, *Derailed* blends kyogen form and spirit with 21st-century socio-political reality in Hawai'i. Harkening back to the early satirical roots of kyogen, clever local construction workers outwit a clueless consultant and his ill-advised ideas about moving the planned rail line into sacred forbidden lands, demonstrating the power of Hawaiian beliefs and the importance of protecting the land.

Commissioned by: Julie A. Iezzi and the Department of Theatre and Dance, University of Hawai'i at Manoa. *Derailed* was written by Matthew Kelty and developed with the cast, director, and master kyogen artists Shigeyama Akira and Shigeyama Dōji (Sennojō III), directed by Julie A. Iezzi. *Derailed* also featured two classical kyogen masks, *usofuki* and *kentoku,* made by Kitazawa. *Kentoku* was used to represent a sea turtle (*umigame*) and *usofuki* to represent an octopus (*tako*). These masks (see pages 143, 145, 147) are now the property of the University of Hawai'i.

Performance history: The *Kamapua'a* mask was worn by Michael Donato in the April 2017 production of *Derailed* for the Department of Theatre and Dance, University of Hawai'i at Manoa at the Bakken Auditorium, Mid-Pacific Institute, in May 2017 at Kamehameha High School on Mau'i, and in June 2017 at Hilo and Kona Public Libraries.

面の裏

Behind the Mask

Hinoki

Hinoki is the Japanese name for the type of wood most typically used for the making of noh masks. Known commonly in English as Japanese cypress (scientific name: *Chamaecyparis obtusa*), it is a species of cypress native to central Japan that is now widely cultivated in the temperate northern hemisphere for its high-quality timber. *Hinoki* is said to last around 1,000 years.

Since ancient times, *hinoki* has been used in Japan to build temples and shrines. Over 1,300 years ago *hinoki* was used to construct the Hōryūji temple in Nara Prefecture, whose main hall is considered the world's oldest wooden structure. In addition, most notably, the sacred reconstruction of the Ise Grand Shrine in Mie Prefecture uses *hinoki* from the Kiso region of Nagano Prefecture, and hence these giant trees, which often grow 40 metres tall, are considered 'divine trees'. (The old shrines are dismantled and new ones built on an adjacent site to exacting specifications every 20 years, so that the buildings will be forever new and original. The present buildings, dating from 2013, are the 62nd iteration to date and are scheduled for rebuilding in 2033.)

Hinoki has an aromatic quality, sometimes described as lemon-scented, and is highly rot-resistant. Its beautiful grain, and its lightness and durability, make it an ideal material for the sculpting of noh masks. The wood from straight grain trees that are 200–300 years old are typically used for making masks. Meanwhile, noh stages also generally use *hinoki* in their construction. The wood is perhaps most well known in contemporary Japan for its use in the construction of traditional Japanese baths.

Kitazawa, as a mask maker, speaks of his love of carving *hinoki* because of the scent that is released. In giving demonstrations he often gives wood chips to audience members so they too can experience its delicate fragrance.

Making

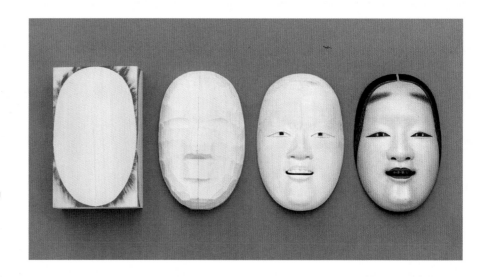

These photographs by Kitazawa Sohta illustrate the making of noh masks. They were produced for an exhibition at the Pitt Rivers Museum, Oxford, in 2015.

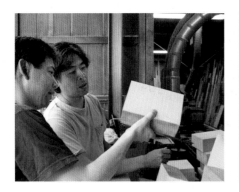

1. Choosing blocks of *hinoki*

Kitazawa visits his *hinoki* supplier to select the desired grain and size of wood for the masks to be carved.

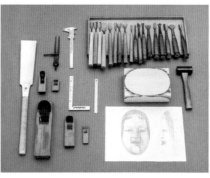

2. Creating a design

This picture shows the outline pattern on the block of *hinoki*, a drawing of the mask and a range of mask-making tools.

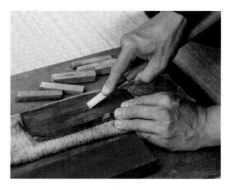

3. Sharpening chisels

Natural whetstones, soaked in water, are used to sharpen chisels. A rougher red whetstone is first used, then a darker stone for smoother finishing.

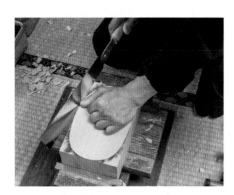

4. Sawing the block

The larger areas of excess wood are removed using a Japanese pull saw to create the outline of the mask.

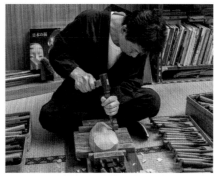

5. Beginning the carving

Kitazawa begins rough carving from the nose, then moves to the eyes and mouth, bearing in mind the overall balance of the mask.

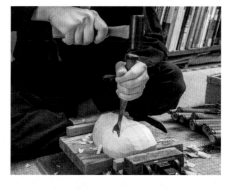

6. Rough carving

Rough carving chisels have metal caps as they are hit with a hammer.

7. Delicate carving

The finishing chisels are used for fine, delicate hand carving.

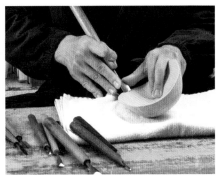

8. Carving the back

The back of the mask is carved carefully until it is smooth. This is important to make it comfortable for the noh performer.

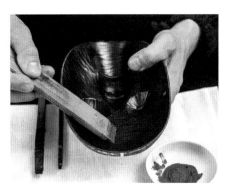

9. Lacquering the back

The back is painted with multiple coats of *urushi* (lacquer). It strengthens the wood and protects it from the performer's perspiration.

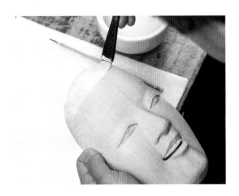

10. Applying the white base

This is a basic white pigment of *gofun* (gesso, fine ground oyster shells) mixed with *nikawa* (natural glue of rendered cow skin and bones).

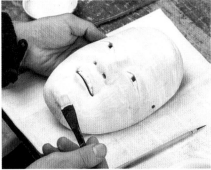

11. Layering and sanding

Ten coats of white pigment (*gofun*) are applied and gently sanded with fine-grain sandpaper to make a perfectly smooth surface.

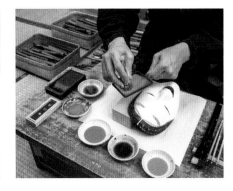

12. Creating an antique look

A thin, dark water-based ink is used to create the antique finish.

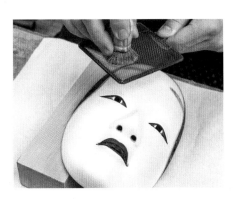

13. Sprinkling the ink

The ink is delicately sprinkled onto the face of the mask using a fine mesh and a brush.

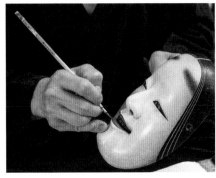

14. Painting facial features

The detailed parts of the mask – the hair, eyebrows, eyes and teeth – are painted using black Chinese ink. The lips are painted with red pigment.

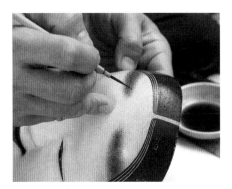

15. Painting eyebrows and teeth

Placing eyebrows high on the forehead, and using black for the teeth, are old Japanese makeup customs.

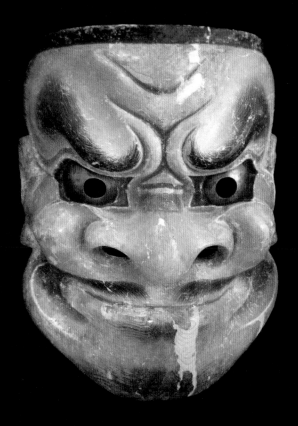
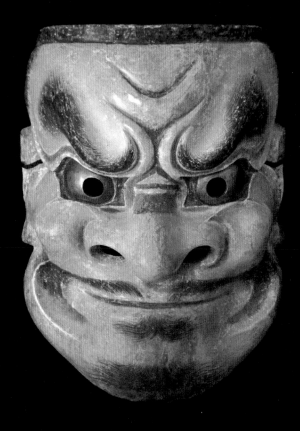
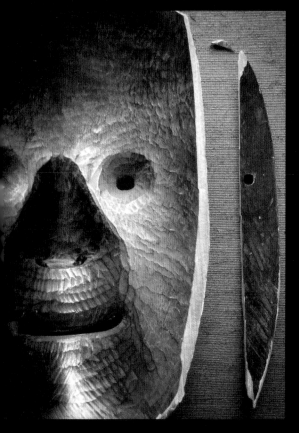

Stage 1 Stage 2 Stage 3

Restoring

Restoration is an important part of Kitazawa's work. When he receives a commission to restore a mask he discusses this in detail with the client until he understands exactly what is required. Generally, he tries to return the mask to its original condition, and not add anything. He often goes to museums and exhibitions to research masks from certain periods. This is essential preparation work for restoration. Initially he carries out research and records any broken or damaged parts carefully, and then makes a restoration plan. Then, he begins the restoration work, taking his time to understand the condition of both the wood and the painting. Restoration work is difficult, but Kitazawa believes he learns a lot from old masks. He feels that it is as if the ancient craftsmen are teaching him their techniques and ways of thinking, and he uses these techniques for his own creative work. He believes that restoration and creative work are intrinsically connected.

Repairing

Stage 1: A broken mask is repaired by using *nikawa* (glue made from animal skin and bones boiled down to extract the gelatin) to glue the two pieces together. Then, *gofun* (white gesso made from fine oyster shell powder) is painted on as a foundation and on top of this layers of thin water-based ink are painted until the surface looks natural. This is painstaking work and requires a lot of patience.

Stage 2: This photo shows the typical completed restoration. However, if the mask is to be used in performance, Kitazawa adds extra reinforcement. This can be seen in the third photo.

Stage 3: In this photo, a thin layer of hemp cloth has been glued to the mask using *nori-urushi* (*nori* is glue made of rice powder and water, and mixed with *urushi* lacquer). The *urushi* needs to be kept at a temperature of 20°C, and at a 60 per cent humidity level for drying. The restored mask is put in an airtight box for a week (a process called an *urushi* bath), then painted 3–4 times with *urushi,* after which it is smoothed with fine sandpaper. This process makes the mask very strong.

Photos: Kitazawa Sohta

Wearing

The photographs on this page are from the January 2020 presentation at the British Library, London. This included a demonstration of the process of costuming and the putting on of the mask, plus a short performance of *Takasago* by Matsui Akira. Photos: Paul Laikin

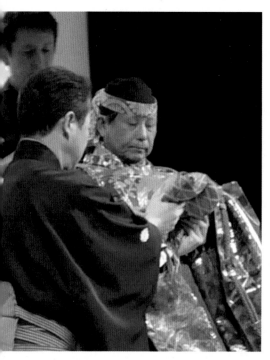 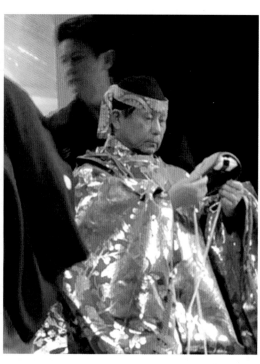 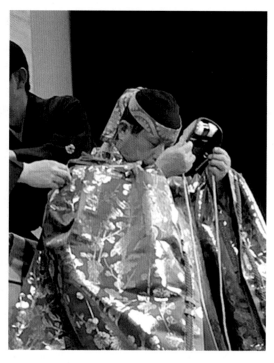

*The actor receives the mask
from a kōken (stage assistant),*

reflects on the mask,

bows to pay respect to the mask,

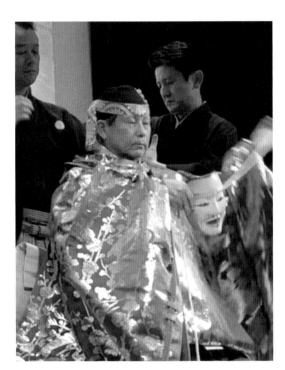

turns the mask over and throws the mask cords to the kōken,

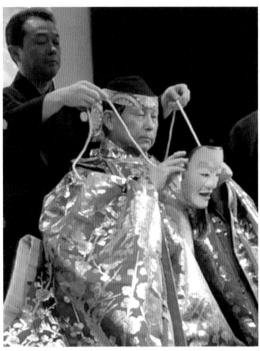

the kōken takes the cords from behind,

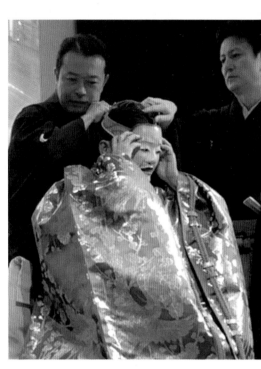

and ties the mask firmly at the back of the actor's head.

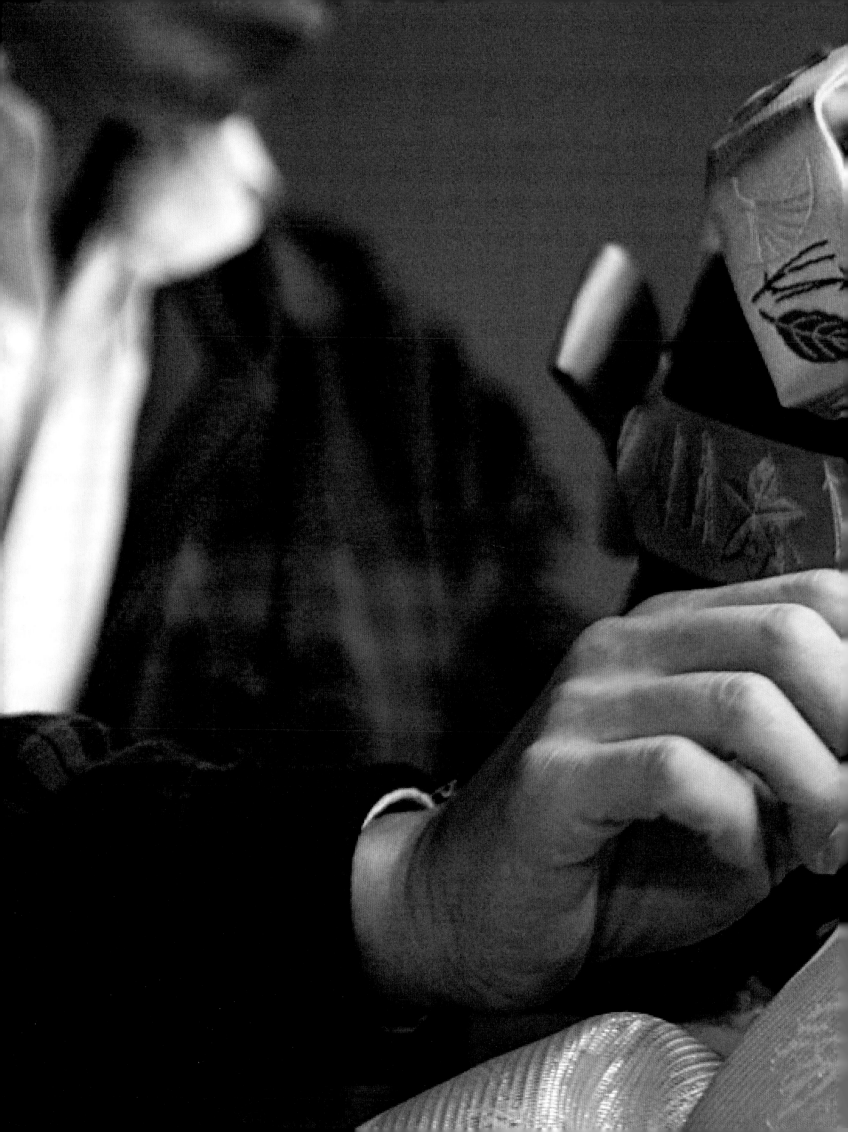

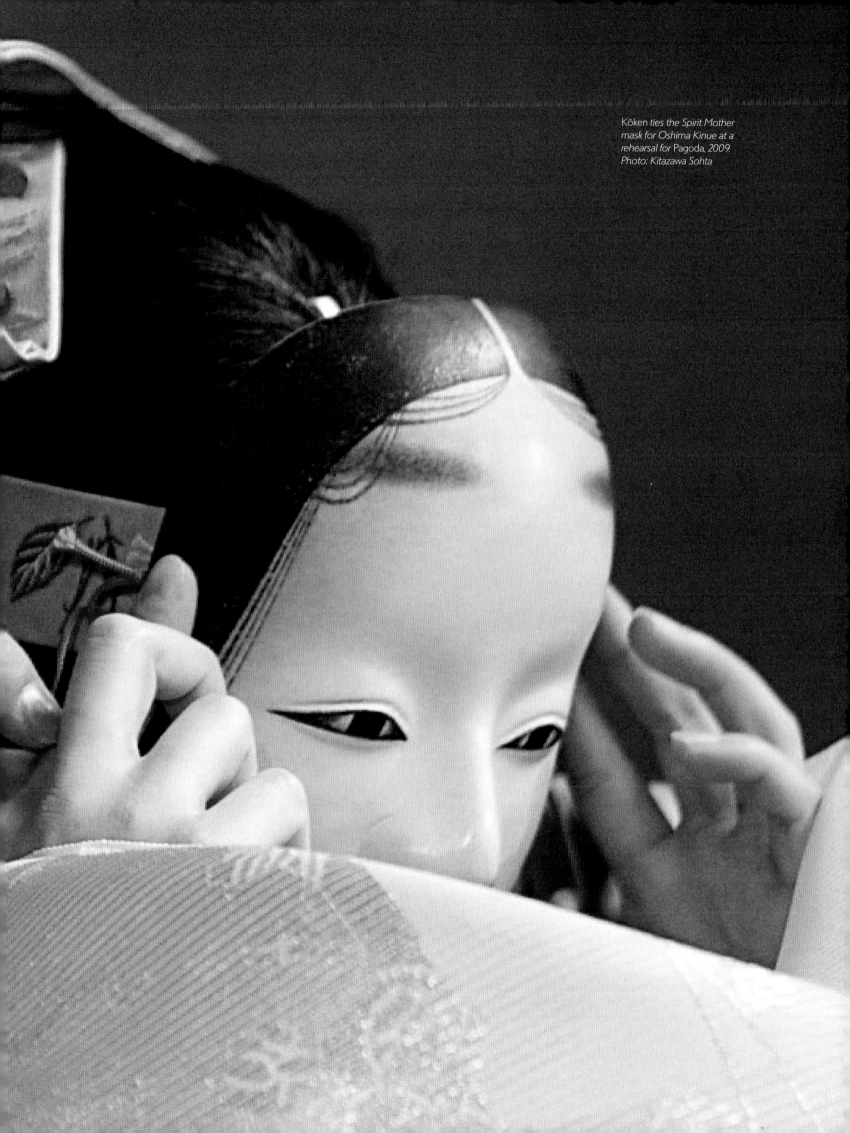

Understanding Nohgaku

History

Noh is a 650-year-old highly aesthetic Japanese classical performance art which features stylised movements and dance, poetic texts chanted by actors and a chorus, instrumental music played by drums and flute, and elaborate masks and costumes. Noh pieces present the appearance of gods and demons, and, most strikingly, the ghosts of warriors or women who died maintaining a strong attachment to their lives (*mugen* noh). Other pieces feature people living in the present time of the piece (*genzai* noh). Shinto and Buddhist elements often inform the art.

Kyogen, featuring short dialogue pieces with two to four characters, is the humorous partner that balances the complex themes of noh. Noh and kyogen have been performed in tandem on the noh stage since the 14th century. While noh is the senior partner, together they are referred to as *nohgaku*. Specialised noh theatres are found throughout Japan, mainly in major cities. This includes the National Noh Theatre (Kokuritsu Nohgakudō) in Tokyo, which opened in 1983.

According to the Noh Performers' Association, in 2020 there were about 1,100 professional nohgaku performers. Traditionally, noh was performed by men only although now about 20 per cent of professional performers are women. The large number of amateur performers is made up of perhaps 80 per cent women. Historically, the tradition has been passed down along patrilineal lines. For example, in 2024, the Komparu family records their lineage as 81 generations, the Umewaka family 56, the Kanze and Kongō families 27, the Okura family 16 and the Oshima family 6 generations. Other families have lineages of varying lengths.

The roots of noh go back to the Nara period (eighth century) when largely acrobatic arts known as *sangaku*

were brought to Japan from China. With the addition of humorous skits, song and dance, the art came to be known as *sarugaku* during the Heian and Kamakura periods (9th–13th centuries), and later *sarugaku* noh, troupes of which began performing at Shinto shrines and Buddhist temples. In the 14th and 15th centuries under the leadership of performer-playwrights Kan'ami (1333–1384) and his son Zeami (1363–1443), performances which feature the complex themes of today's noh developed, although it wasn't until the Meiji period (1868–1912) that the term *sarugaku* was dropped and the art became known as nohgaku, indicating both noh and kyogen.

In recent years scholars have attributed approximately 50 noh to Zeami, many of which are performed as part of today's classical repertory comprising some 250 pieces from the more than 2,500 said to exist. Zeami also wrote significant treatises explaining aesthetic principles of composition, acting and teaching. Noh flourished during Zeami's time under the patronage of the shogun Ashikaga Yoshimitsu (1358–1408).

During the Edo period (1603–1868), noh became the official performing art (*shikigaku*) of the military court and the warrior class. Feudal lords supported their own troupes, and studied and performed the art themselves. With the societal reforms of the Meiji period, noh lost its patronage and nearly died out. But enough performers regrouped and found private sponsors and audiences for it to begin to thrive again. Noh navigated the upheaval of World War II and its aftermath, notably flourishing in the 1970s and 1980s. Amateur students became an important source of income for professionals. In recent years there is an increased awareness that noh will have to continue to evolve to survive.

Above: The Kita (North) Noh Stage at Nishi Honganji Temple, Kyoto. Built in 1581, it is the oldest noh stage in Japan. Photo: Jannette Cheong

In the 20th century, international interest in noh grew. W.B. Yeats wrote so-called 'noh plays', and academics such as Arthur Waley produced translations. Other acclaimed international artists such as Barba, Britten, Brecht, Brook, Lecoq and Stockhausen have taken inspiration from noh. In the post-war era, Japanese troupes began performing internationally; individual performers and mask makers have given workshops and lecture demonstrations; foreign academics have written about the art and translated much of the repertory. Playwrights in several countries have written original pieces in native languages. In 2001, UNESCO proclaimed nohgaku an Intangible Cultural Heritage of the World in its first such listing.

Theatre Nohgaku, a group of international performers, creates original noh in English with traditional music and movement. Theatre of Yugen in San Francisco performs kyogen in English. The former Polish ambassador to Japan, Jadwiga Rodowicz, a scholar of noh, created noh in Polish which was translated and performed by the Tessenkai group in Japan. This is just some of the current international activity which heralds support for the future of noh.

Types of Classical Noh

There are five categories of noh: 'god', 'warrior', 'women', 'miscellaneous' – notably 'madwomen' or present-time – and 'demon' and 'supernatural animal'. During the Edo period, a full day's programme consisted of the ritual piece *Okina* followed by one noh from each of the five categories with a kyogen performed between each noh.

Noh Stage

A traditional noh stage (*noh butai*) consists of a square with a bridgeway (*hashigakari*) leading in from stage right. At the end of the bridgeway is a multi-coloured hanging curtain (*maku*) from which the characters enter and exit. Stages were traditionally outside and covered with a long sloping roof. From the late 19th century, many stages were brought indoors. Inside stages (*nohgakudō*) maintain the prominent sloping roof under the theatre ceiling. The stage is open on two sides. A pine tree is painted on the back wall (*kagami ita*) and remains the same for all performances. Instead of realistic stage sets, symbolic stage properties (*tsukurimono*) are often used and are light enough to easily be brought on stage.

Language and Text

Classical texts generally follow a narrow set of parameters. Noh pieces have one or two acts, plus usually an interlude (*ai*). Scenes (*dan*) within these acts have a number of smaller segments (*shōdan*), and are the building blocks of noh texts. These *shōdan* have textual, musical and often movement characteristics. Some *shōdan* have a regular poetic syllable metre (7 and 5), others irregular poetic metre, yet others non-metred phrases and prose. The important concepts of *jo-ha-kyū* and 'less is more' support the entire structure

of noh. Another important concept is *yūgen*, an aesthetic term suggesting quiet elegance and grace, and subtle fleeting beauty most often found in third-category noh.

Characters

The main character of a noh play is called the *shite* (pronounced *sh'tay*) who sometimes appears with one or two companion characters called *tsure*. Typically, the *shite* appears in the first act as an ordinary person, then reappears in the second act in its true form as an incarnation of a god or demon, or the ghost of a famous person of long ago. A secondary character is called the *waki* with accompanying *wakitsure*. The *waki* is typically a travelling priest or perhaps some other traveller and their questioning of the *shite* develops the storyline. An interlude character known as the *ai* or *ai-kyogen* is played by a kyogen actor who typically appears as a local person and narrates background information on the main character to the *waki*.

Costumes and Accessories

Noh costumes are elaborate, with dyed silks and intricate embroidery. The costumes reveal the type of character being portrayed and follow prescribed conventions. There is much variety. The design, the colour combinations, the richness of texture and the strength of form give noh its visual impact. All characters are beautifully costumed. The costuming process is complex and multilayered. Rather than the actor putting on his own costume, two or three costumers are needed to sculpt the costume and wigs on the actor. Other accessories important to the piece are either worn or carried by the actors. A fan (*ōgi*) is an important accessory in noh. They are carried by all the instrumentalists and chorus members and usually by all the actors. For the latter, the fan is an essential multipurpose object used as a catalyst for movement and draws the attention of the audience.

Movement

Noh is not realistic theatre. Rather, its movements are highly stylised and prescribed. Noh is often referred to as the 'art of walking'. The gliding style of walk is called *suriashi* (sliding feet). While some movement forms (*kata*) have specific meaning, many serve as an abstract aesthetic expression to convey the emotions of the character. The combining of *kata* creates the choreography. All of noh movement can be described as dance. At times there is very little movement as dramatic tension is built through the narration, while at other times there is strong vigorous movement. Movement takes place to the chant of the chorus, or sometimes to purely instrumental music. In general, deliberateness, brevity, suppression and abstraction are important features of noh movement.

Instrumentalists (*Hayashi*)

The three drummers (*kotsuzumi* shoulder drum, *ōtsuzumi* hip drum, *taiko* stick drum), and one flautist

(*nohkan*) – the only instrumentalists – sit at the back of the stage. The complex rhythms of the drums and the distinctive melody of the flute follow prescribed systems. A unique feature are the vocal calls (*kakegoe*) by the drummers which serve as signals among the instrumentalists as well as between the drummers and chanters. These vocal calls add an important element to the aural texture of the performance, helping to create the mood and establish the tempo.

Chant

Characters chant in three styles: melodic (*yowagin* or *wagin*), dynamic (*tsuyogin* or *gōgin*) and stylised speech (*kotoba*). The chorus (usually eight persons who sit at the side of the stage) also chant in melodic and dynamic styles. They narrate the background, story and mood of the play, often describe a character's thoughts and emotions, and sometimes chant lines for a character.

Schools in Nohgaku

There are five main stylistic schools (known as *ryū*) in noh which are responsible for producing most performances. They are each made up of *shite* main role actors who not only take acting roles but also sing in the chorus and are the primary stage attendants (*kōken*). Of the five noh schools, Kanze, Hōshō, Komparu and Kongō were established in the 14th century. The fifth, Kita, developed in the 17th century. The other roles in noh – *waki*, kyogen and the four instrumentalists – each have schools as well. All told, there are 24 schools in *nohgaku*, including the two kyogen schools (Izumi and Okura).

Kyogen

Kyogen, which literally means 'crazed speech', are independent plays performed between noh. These are predominantly humorous dialogue plays though sometimes with chant and dance. They present the foibles of the common man, including stories of servants tricking their masters, hen-pecked husbands and their wives, or weak-kneed demons interacting with humans. Sometimes they parody noh pieces. Kyogen plays developed in the 14th century with roots from comedic skits going back centuries earlier. Due to these ancient roots, the dialogue was often improvised and consequently the plays developed texts over time rather than being authored. Scripts of plays were written down and codified during the Edo period. There are approximately 260 plays in today's repertory of the two kyogen schools. Masks do not appear in kyogen plays as often as in noh pieces, but when they are used their humorous characteristics are evident. Kyogen actors also take the interlude *ai-kyogen* roles within noh pieces – roles that are generally narrative and rarely humorous.

The Mask in Noh

The use of the mask in classical noh is at the essence of how noh is described as a requiem for the dead. Noh is often referred to as a 'masked stage art'. However, the chorus in noh never wear masks. The *waki*, who is always living in the present time of the play, also never wears a mask. The instrumentalists never wear masks. There are also noh in which all roles represent male characters living in the present, in which case not a single performer wears a mask.

Given that even these performers tend not to show emotion on their faces, their unmasked 'mask-like' faces, known as *hitamen* (direct mask), indicate that this is still a 'masked stage art'. Indeed, the strong images of noh masks are so distinctive in representing noh that their importance in noh is indisputable. In many pieces, there might only be the *shite* wearing a mask, generally a mask of a ghost, a god, a demon or a plant or animal spirit. These masks represent the most unique aspect of noh pieces where often other-worldly beings come in contact with those living in the present time. There are uses of noh masks which do not represent other-worldly beings. Many of the beautiful women masks are used for characters living in the present time of the piece. But as the actors were traditionally all men, such present-time female roles all wore masks. Other unique male characters, such as old men, young boys, grizzled former warriors or blind young and old men, also wore masks because of their distinctive presence.

Remarkably, noh masks are quite realistic. This is an interesting contrast to the stylistic quality of the movements of all characters in noh, so unlike realistic theatre in the West. While the mask itself is a stylistic object as it cannot change in any realistic fashion, the delicacy of the carving and painting itself is often like a realistic portrait painting. Looking at it from a different angle often gives it a different expression. Indeed, noh performers learn to use delicate movements to change the mask's expression to joy, sorrow or anger just by tilting the mask. The realism of the masks and the stylism of the performers' movements creates an intriguing juxtaposition.

Noh masks are among the most beautifully made masks in the world. Along with the elaborate costuming and the beauty of the noh stage, the masks give a stunning elegance not only to beautiful women, goddesses or handsome men and powerful gods young and old, but also to those suffering in this life or the next, or to angry demons or fierce dragons.

The role of the mask in many noh serves as a bridge between the living and other-worldly beings of our human beliefs and imaginations. The importance of that role goes to the very heart of noh – giving us, the living, an opportunity for dialogue with the dead in a kind of requiem. These masks, whether created in centuries past or made today with the anticipation of their continued use in centuries future, serve to convey that powerful purpose of the noh theatre.

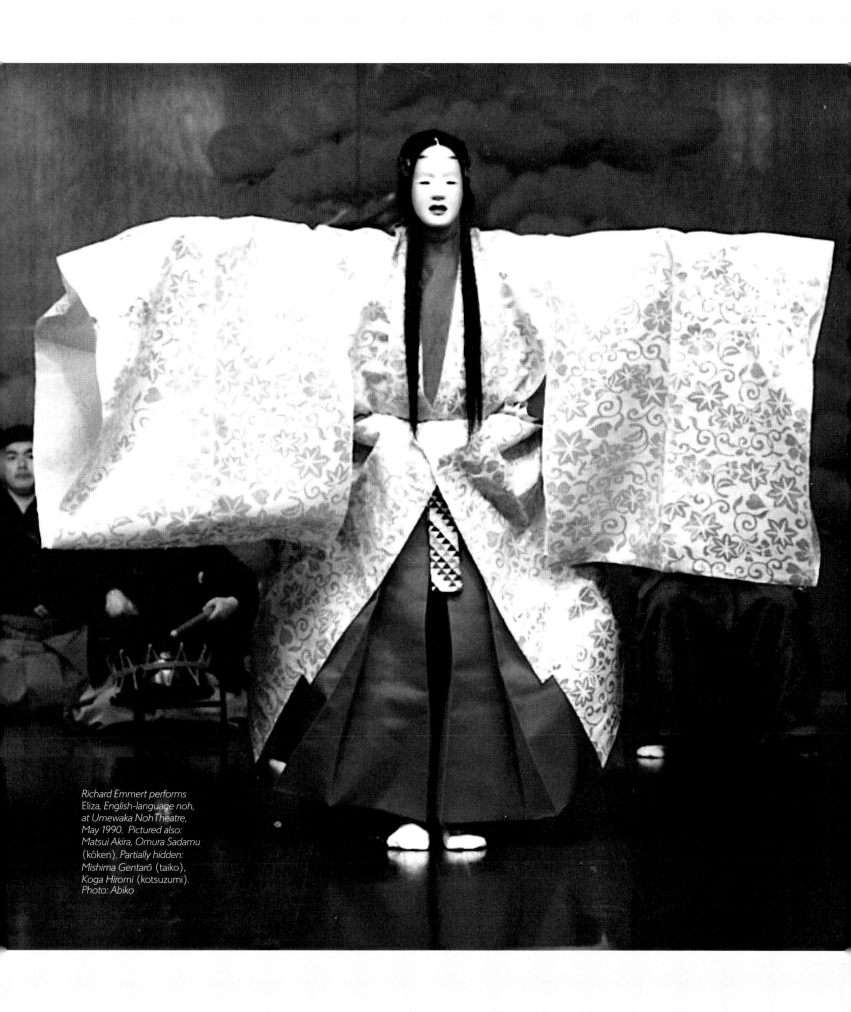

Richard Emmert performs
Eliza, *English-language noh,*
at Umewaka Noh Theatre,
May 1990. Pictured also:
Matsui Akira, Omura Sadamu
(kōken). Partially hidden:
Mishima Gentarō (taiko),
Koga Hiromi (kotsuzumi).
Photo: Abiko

Curating the Mask

Reflections from Museum Representatives

Julia Nicholson, Curator, and Andrew McLellan, Head of Public Engagement, Pitt Rivers Museum, University of Oxford, UK

In 2009 Kitazawa Hideta visited the Pitt Rivers Museum to demonstrate his skills to the public. Over 900 visitors were able to watch Kitazawa working in the museum galleries, and 78 children and 80 adults participated in the 'Family Friendly' workshop. On day two a further mask-making demonstration and informal introductions to noh masks were made to over 700 gallery visitors in the museum over a four-hour period. We were so impressed that in 2015 we commissioned Kitazawa to carve three masks to show the processes that he uses to take a block of wood to the finished performance mask. The results are on permanent display in the museum.

In 2017, when Kitazawa was visiting the UK to deliver a mask that he had recently carved for a noh theatre performance in London, he came back to Oxford to run a range of workshops and demonstrations as part of a trip funded by The Japan Foundation. For three days Kitazawa sat in the midst of the Pitt Rivers Museum carving, talking and laughing, and was able to demonstrate his art to the public. Kitazawa is a natural performer and communicator and the public were mesmerised by his work. On one occasion a student was so inspired she said that she would raise funds to 'go to Japan to train in noh mask making as an apprentice'. Some people sat and watched for most of the day.

A highlight for me was when Kitazawa ran an informal workshop with wood-working students from Rycotewood Furniture Centre. The two-way discussion of tools, materials and processes was truly inspiring, and undoubtedly influenced the development of their practice. I feel very privileged to have worked with Kitazawa on these occasions, and for my children to have watched and talked with a master craftsman working at his best.

Craig Barclay, Head of Museums, Galleries and Exhibitions, Durham University, UK

The Oriental Museum, Durham University, houses outstanding collections from across Asia and North Africa. It is home to an extensive collection of Japanese art and cultural objects, ranging in date from the Heian period (794–1185 CE) to the 21st century. The collection is unparalleled in Northern England, and the museum promotes the understanding of Japanese art and culture through a formal collaboration with the National Museum of Japanese History, as well as through displays, exhibitions, formal and informal learning activities, and programmes of community workshops and talks.

In February 2017, we were fortunate to be able to invite Kitazawa to visit us in Durham, where he delivered a master-class in the art of noh mask carving to an audience drawn from across North East England. The event proved to be a sell-out, with rapt onlookers gathering round as Kitazawa miraculously brought life to the block of wood gripped between his feet. The workshop made a lasting impression on all who attended and, as a direct result of Kitazawa's visit, the university authorities agreed to commission the artist to create three new noh masks on behalf of the Oriental Museum. These wonderful works of art – ko-omote, sankō-jō and shishiguchi – were delivered to us a few months later and have since become firm favourites with our many visitors.

The three masks have been displayed in our permanent Japanese gallery; featured in a student-curated exhibition; supported university teaching; and contributed to our learning resources for schools. We are proud to display these works by Kitazawa in our museum where they showcase the beauty of Japanese art and noh theatre for the benefit of audiences of all ages and from around the globe.

Melanie Eastburn, Senior Curator of Asian Art, Art Gallery of New South Wales, Australia

In the Edo period (1603–1868), the paranormal beings of Japan began to take the forms still recognised today. Known then as *bakemono* (monsters or shapeshifters) and *mononoke* (things that transform), these creatures are now most often described as *yōkai*. The exhibition, 'Japan Supernatural' (November 2019–March 2020), at the Art Gallery of New South Wales in Sydney introduced Australian audiences to almost three centuries of *yōkai* and *yūrei* (ghosts) through exceptional paintings, *ukiyo-e* prints and sculptures. Works of art were drawn from the gallery's collection as well as from museums and private collections worldwide and ranged from Edo images by Toriyama Sekien, Kawanabe Kyōsai and Katsushika Hokusai to newly commissioned work by Murakami Takashi.

It was a great pleasure to be able to display this earliest work in the exhibition beside a group of masks for noh, *kagura* and kyogen by Kitazawa. Although Kitazawa's exquisite masks are innovative and contemporary, they present characters that Edo artists would likely have found familiar – a red *oni* demon tiny in scale because it was inspired by a mask for a child, a beautiful woman transformed by jealousy and obsession into a horned *hannya* demon, a long-nosed *tengu* skilled in the martial arts, a charming green *kappa* as imagined by Kitazawa, and a fine white *tenko* fox with an articulated jaw. This was the *tenko* mask's second trip to Sydney. The first was in 2015 when it was worn by Sydney-based dancer Yoke Chin in the contemporary English noh play *Oppenheimer* as performed at the Conservatorium of Music in Sydney. Displayed to meet the gaze of viewers eye to eye, the five masks were among the most loved works in the exhibition and are now in the permanent collection of the Art Gallery of New South Wales.

Antonio Zuñiga Chaparro, Academic Director, General Directorate of the National Centre for the Arts, Mexico City, Mexico

The National Centre for the Arts in Mexico (CENART) hosted the noh theatre programme 'The Art of Stillness and other Performing Traditions of Japan' from 3–17 November 2023.

This programme had as its central experience the exhibition 'Noh and Kyogen Masks by Hideta Kitazawa' featuring 13 masks by this master craftsman.

The exhibition promoted interest among the Mexican public in this ancestral expression – a stage art with traditional stories and characters that transcend time and borders and enrich the imaginations of new generations, as well as maintaining the validity of language and dialogue with performing arts from other cultures. The latter could be seen in the masks of the musician Robert Johnson and the painter Frida Kahlo which were on display.

The staging of *Río Sumida*, a work-in-progress directed by Richard Emmert, as well as a noh theatre conference featuring Emmert and Kitazawa, complemented the exhibition.

The numerous attendees of these events benefited greatly from the generosity and enthusiasm of these two teachers who shared their vast knowledge of the art of nohgaku and its masks.

At the National Centre for the Arts in Mexico we are very proud to have contributed to the realisation of a programme in which different disciplines converged to show that art and its diversity are the door to strengthening ties between cultures.

Glossary
and Index
of Masks

Kojishi (young lion), mask used by the young lion in the fifth-category noh *Shakkyō*

Kojō, old men, same as *koushi-jō* (small old man) masks

Kokaji (The Swordsmith Kokaji), fifth-category supernatural-being noh, author unknown

kōken, stage attendants, often senior noh actors who oversee the performance

Kokushiki-jō (black old man), mask used by *Sambasō* role in *Okina*

Komparu Zenchiku (1405–ca. 1470), an important noh playwright and theoretician

Komparu, oldest of the five *shite* schools of noh with roots going back to Kamakura period (1185–1333)

Kongō, one of the five *shite* schools of noh, dating back to the Kamakura period (1185–1333)

Kongō Magojirō, noh performer and mask maker of the *Magojirō* mask made in memory of his wife

Kongō Noh Theatre (Kongō Nohgakudō), theatre in Kyoto

Ko-omote (small face), young woman mask

Koshi Inori (Back-Straightening Prayer), kyogen, uses an *ōji* grandfather mask

koshoku (antique colouring), often added to newly made masks to give them an antique appearance

kotoba, stylised speech

Kotobide (small bulging eyes), mask which is the smaller version of the *ōtobide*

kotsuzumi (small drum), small hourglass-shaped shoulder drum one of the four instruments

Koushi Kyomitsu, early 14th-century mask maker

Koushi-jō, alternative name for the *kojō* mask used for old men, named after the mask maker Koushi

Kubihiki (Neck Pulling), kyogen featuring a tug-of-war between a warrior and a demon father who wants his daughter to practice 'eating a human'

Kyūgi sōshoku jūrokushiki zufu (Sixteen illustrations for traditional ceremonial decoration) by Inokuma Asamaro (1870–1945), published in 1903, includes a glimpse backstage at the costumes and props for a noh performance

Kurama Tengu (The Goblin of Kurama), fifth-category goblin noh, often attributed to Miyamasu

Kurozuka (Black Tomb), fourth- or fifth-category noh

Kurumazō (The Carriage Priest), fifth-category goblin noh, author unknown

Kuzu (name of indigenous people in Yoshino mountains in ancient Japan), fourth- or fifth-category noh

L

Lanki, Colleen, late member of Theatre Nohgaku, actor, dancer and founder of Tomoe Arts

Leung, Peter, choreographer and contemporary ballet dancer performer in *Opposites-InVerse*

LSO St Luke's London, venue for *Opposites-InVerse*

M

'Madwoman', half-mask in church parable *Curlew River*

maeshite (*shite* in the first half of a noh)

Magojirō, young woman mask by the noh performer Kongō Magojirō made in memory of his wife

maku, the five-coloured curtain at the end of the bridgeway on the noh stage

Makurajidō (The Pillow of the Young Boy), fourth-category Chinese noh, author unknown

Makura Monogurui (pillow story), kyogen with a grandfather in love with a young woman, uses *oto* mask

Manbi (ten thousand temptations), mature young woman mask

Marett, Allan, author of English noh, Theatre Nohgaku affiliate artist

Matsui Akira, Kita school professional noh actor, awarded Honorary Doctorate of Royal Holloway, University of London

Matsukaze (Pining Wind), third-category noh by Kan'ami, revised by Zeami

McLellan, Andrew, Head of Public Engagement, Pitt Rivers Museum, University of Oxford

Meiji period (1868–1912)

Meilin (Chinese name), mask representing a peasant woman in English noh *Pagoda* by Jannette Cheong

melodic chant (*yowagin* or *wagin*)

Michimori (The Warrior Michimori), second-category warrior noh by Seiami, revised by Zeami

Miidera (The Miidera Temple), fourth-category noh, author unknown, often attributed to Zeami

Miyamasu, late 15th- and early 16th-century playwright

Momijigari (Autumn Foliage Viewing), fifth-category demon noh by Kanze Kojirō Nobumitsu

Monjū Bosatsu, the Buddhist bodhisattva of wisdom

mononoke, paranormal beings that transform

Moore, Jubilith, Theatre Nohgaku member, actor and former artistic director of Theatre of Yugen

Mother Spirit (*zō*), mask used in English noh *Pagoda* to represent the Spirit of Meilin, and in *Between the Stones* to represent the Woman Gardener

mugen, phantasm/dream plays

Murakami Takashi (1962–), Japanese pop artist

Muromachi period (1336–1573)

Mystical Abyss, noh-influenced play by John O'Keefe

N

National Museum of Japanese History (Kokuritsu Rekishi Minzoku Hakubutsukan)

National Noh Theatre (Kokuritsu Nohgakudō), established in Tokyo in 1983

Narita Temple (Naritasan Shinshōji), temple in Narita City, Chiba Prefecture

nikawa, glue made from boiled animal bones

Nishino Haruo (1943–), Japanese literature and noh specialist, Professor Emeritus of Hōsei University

nohgaku, noh and kyogen theatre

nohgakudō, noh theatre hall

Nōgu Taikan (Compendium of noh equipment) collection of paintings by Yamaguchi Ryōshō (1886–1966). Published in 1924

Nōmenzu (Noh Mask Illustrations), an early 19th-century manuscript scroll containing 45 colour illustrations of traditional noh masks

Nomura Masashi (1970–) Kanze noh actor

Nomura Manzō VI (1898–1978), important kyogen actor, National Living Treasure (*Ningen Kokuhō*) and noh and kyogen mask maker, grandfather of present Nomura Manzō IX

Nomura Manzō IX (1965–), Izumi school kyogen actor and Kitazawa Hideta's teacher

Nonomiya (The Shrine in the Field), third-category noh, attributed to Komparu Zenchiku

nori-urushi, rice powder water glue mixed with lacquer

Nue (Nightbird), fourth- or fifth-category demon noh by Zeami, uses the *kotobide* mask

O

Oakujō (large evil old man), mask believed to be an old mask type with non-Japanese barbarian features

Obeshimi (large pursed mouth), mask representing a *tengu* – a long-nosed supernatural being

Oe kagami (Mirror of Pictures), lavish mid-17th century scroll with depictions of scenes from celebrated noh

Oeyama (The Demon of Oeyama), fifth-category demon noh, often attributed to Miyamasu

Oglevee, John, Theatre Nohgaku member, actor, director

Oji (grandfather), an old man kyogen mask

Okina, an ancient rite which predates the development of noh and uses *hakushiki-jō* and *kokushiki-jō* masks

Okura Eitarō, *ōtsuzumi* performer in several English noh

Okura Genjirō, *kotsuzumi* performer, head of the Okura Kotsuzumi School, National Living Treasure

Okura school, one of two kyogen schools

Old Groundsman, mask used in the English noh *Emily*, by Ashley Thorpe

Oni-buaku, demon mask created by Kitazawa to be more humorous than a regular *buaku* mask

Oni-demon, *kagura* mask

Oppenheimer, mask based on the physicist Robert Oppenheimer, used in the English noh of the same name by Allan Marett

Opposites-InVerse, a noh-opera-ballet collaboration by Jannette Cheong, part of the tribute *Noh Time Like the Present* programme for Matsui Akira at LSO St Luke's, London in 2017

Oshima Iori (2008–), Kita School noh actor, son of Oshima Teruhisa

Oshima Kinue (1974–), Kita school noh actor, main actor in *Pagoda* and *Between the Stones*

Oshima Masanobu (1942–), Kita school noh actor, Head of the Oshima Noh Theatre and father of Oshima Kinue and Oshima Teruhisa

Oshima Noh Theatre (Oshima Nohgakudō), Kita school noh theatre of the Oshima family, Fukuyama, Hiroshima Prefecture, only privately owned full-size theatre in the Kita school

Oshima Teruhisa (1976–), Kita school noh actor

Oto (young woman), kyogen mask of a rather unattractive young woman

Otobide (large bulging eyes), a fierce god or demon mask used in fifth-category noh

ōtsuzumi (large drum), large hourglass-shaped drum, one of the four instruments in noh (*hayashi*)

P

Pagoda, English noh by Jannette Cheong

Peter, mask based on the contemporary dancer Peter Leung for *Opposites-InVerse* by Jannette Cheong

Phoenix Fire, noh-influenced play by Kevin Salfen

Pine Barrens, English noh by Greg Giovanni

Priest Jakujō (late 10th, early 11th century), character in noh *Shakkyo*

Prince Genji (Hikaru Genji), main character in the novel *The Tale of Genji*

R

Raiden (Thunder and Lightning) mask, also the name of a fifth-category demon noh, author unknown

Robert Johnson, mask based on the blues singer Robert Johnson for *Blue Moon Over Memphis*

Rōmusha (old warrior), kyogen in which a grandfather wishes to drink with a young aristocratic boy, uses the *ōji* mask

Rowan, mask used in the English noh *The Rowan Tree* by David Crandall

Ryōanji, Kyoto Zen temple, originally an aristocrat's villa built in the Heian period, converted into a Zen temple in 1450, includes the most famous *karesansui* (drystone landscape) garden

ryū, stylistic school

S

Saiho (Japanese name), kyogen in which a grandfather names his grandsons, uses an *ōji* mask

Sakurai Hitoshi, *taiko* performer in *Pagoda*

Sakyamuni, one of Buddha's names, known as *Shaka*

Salfen, Kevin, Theatre Nohgaku member, author, composer of *Phoenix Fire*

Sanbasō, second half of the ritual piece *Okina*

sangaku, largely acrobatic arts brought from China in the 8th century

Sankō-bō (–1532), mask maker, creator of *sankō-jō*

Sankō-jō, old man mask named after its creator, Sankō-bō (–1532)

Saru (monkey), kyogen mask used in the kyogen *Saru Muko and Utsubozaru*

Saru Muko (Monkey Bridegroom), kyogen that re-enacts a monkey wedding, imitates monkey speech

sarugaku (sarugaku noh), former name of *nohgaku*

Sawara Grand Festival (Sawara no Taisai), Katori City, Chiba Prefecture

second category, noh featuring warriors

Sesshōseki (The Killing Rock), fifth-category demon noh, author unknown, often attributed to Saami (15th century), uses the *manbi* mask (Act One) and *kotobide* mask (Act Two)

Shaka (mask of Buddha), used in noh *Dai-e*

Shakkyō (The Stone Bridge), fifth-category noh; the stone bridge crosses over to the pure land of Monjū Bosatsu, the Buddhist bodhisattva of wisdom

Shakumi, middle-aged woman mask; its name, from the word *shakuregao*, describes hollow or concave (slightly dimpled) facial features

Shikami (grimace), mask used in the noh *Raiden*

Shimizu (Demon at Shimizu), kyogen featuring an angry servant who attempts to scare his master by wearing the demon mask *buaku*

shinmen, newly made mask

shinsaku, newly created noh

Shiro-shakumi, a whiter version of the *shakumi* mask

shishi, mythological lion appearing notably in China and other Asian countries

Shishiguchi (Lion Mouth) and *kojishi* masks are both used for the *shishi* roles used solely in the felicitous play *Shakkyō*

shite (pronounced sh'tay), main actor role

Shunkan, dedicated mask of priest Shunkan, also the name of a fourth-category noh

Silent Waves, *deigan* mask representing Spirit of the Silent Waves in English noh *Between the Stones*

Song of the Yanaguana River, English kyogen by Carmen Tafolla

stylised speech (*kotoba*), important vocal style in noh and kyogen

Sugawara no Michizane, 10th-century scholar-statesman, later exiled, whose angry ghost features as the god of thunder in the noh *Raiden*

Sumidagawa (Sumida River), a fourth-category noh by Kanze Motomasa

Sumida River, an English noh version of *Sumidagawa*, arranged by Richard Emmert

Sumiyoshi Shrine (Sumiyoshi Taisha), shrine in Osaka City, features in second half of the noh *Takasago*

suriashi (sliding feet), traditional style of walking in noh and kyogen

Susano–o, Japanese god, one of the five masks created for the contemporary dance-drama *Mystical Abyss* by Eric Ehn

T

Tafolla, Carmen (1951–), Poet Laureate of Texas, author of English kyogen *Song of the Yanaguana River*

Taiheki (Chronicle of Great Peace), Japanese historical epic from the late 14th century

taiko (thick drum), played with drum sticks, one of the four instruments in noh (*hayashi*)

tachimawari, dance in which the *shite* circles the stage

Tako (Octopus), kyogen in which the spirit of an octopus asks a priest to pray for it, uses the *usofuki* mask

Tamanoi (The Jewelled Well), first-category dragon-god noh by Kanze Kojirō Nobumitsu

Tamura (The Warrior Tamura), second-category warrior noh, author unknown, often attributed to Zeami

Takasago, first-category god noh by Zeami, one of the most well-known plays in the noh repertory

Takizawa Narumi, composer, noh flautist who has performed in several English noh

Tale of Genji, The (*Genji Monogatari*), early 11th-century novel by the female author Murasaki Shikibu, claimed to be the world's first novel

Tarō Kaja, typical servant role in kyogen

Tatsuemon, Ishikawa, important 14th-century noh mask maker who made the three *ko-omote* masks, later given the names *yuki*, *tsuki* and *hana* by Toyotomi Hideyoshi

tengu, supernatural goblin, generally portrayed in Japanese folklore as having a long nose

Tenko (Heaven's Drum), fourth-category noh, taking place in China, often attributed to Zeami

Tessenkai, Tokyo-based Kanze school group

Tessenkai Noh Theatre (Tessenkai Nohgakudō), a small noh theatre in Aoyama, Tokyo

Theatre Nohgaku, international English noh company founded in 2000

Theatre of Yugen, theatre company based in San Francisco

third category, noh featuring women

Thorpe, Ashley, Theatre Nohgaku member, author of English noh *Emily*

Tobide (bulging eyes), mask that represents a supernatural being such as a god or animal in the form of *ōtobide* and *kotobide*

Tōbōsaku (The Hermit Tōbōsaku), first-category foreign-god by Komparu Zenpō (1454, early 16th century)

Tōhaku, Deme (–1715) mask maker of the traditional Deme mask maker lineage

Tokyo Shimbun, major newspaper in Tokyo

Tokyo University of Agriculture and Technology (Tokyo Nōkō Daigaku)

Toriyama Sekien (1712–1788), woodblock print artist of Japanese folklore

Toyotomi Hideyoshi (1537–598), shogun and feudal lord in the late-16th-century Sengoku (Warring States) period, and performer/supporter of noh, gave the names *yuki*, *tsuki* and *hana* to three of his favourite *ko-omote* masks

Traveller, half-mask in church parable *Curlew River*

tsure (companion), character accompanying the *shite*

Tsuki (moon), name of *ko-omote* mask by Tatsuemon given by Toyotomi Hideyoshi to Tokugawa Ieyasu that was later reportedly destroyed in a fire in the Edo Castle

Tsukitaku Satoshi, *nohkan* performer performed in English noh *Pagoda*

tsuyogin (also *gōgin*), dynamic chant used in noh

U

ukiyo-e, Japanese woodblock prints

UNESCO Intangible Cultural Heritage, nohgaku achieved designation in 2001 in the first such UNESCO listing

Unrin-in, a temple in Kyoto, also the name of third-category noh

Usofuki (whistling lies), kyogen mask with distinctive whistling-shaped lips often portraying spirits of various animals and plants

urushi, lacquer, made from the sap of the Asian lacquer tree, used on the back of masks

utsushi, a copy of an older mask

W

Waka-onna (young woman), the main young woman mask of the Kanze school, basis for the Daughter Spirit mask in *Pagoda*

Waka-otoko (young man), classical noh mask, a younger version of *kantan-otoko*, basis for *Bai Li* mask

Waka-shakumi, a younger version of the *shakumi* mask

waki, secondary character role in noh

wakitsure, companion role to the *waki*

Warai-jō (laughing old man), a type of old man mask

Weaver and the Dress, The, noh-influenced play by Judy Halebsky

White Fox, *kagura* mask used in the English noh *Oppenheimer*, by Allan Marett

Y

Yakumo Shrine (Yakumo Jinja), Ashikaga City, Tochigi prefecture

yamabushi, a mountain priest

Yamaguchi Ryōshō (1886–1966), painter of the *Nōgu Taikan* (Compendium of noh equipment), a collection of paintings

Yamato no Yaseonna, a *yaseonna* mask from Yamato province, present-day Nara prefecture

Yao (village name), kyogen featuring a country man who meets Enma, the King of Hell, after he dies

Yase-onna (emanciated woman) mask, also the basis for the *Meilin* mask in *Pagoda*

Yashima (Yashima Bay), second-category warrior noh by Zeami

yōkai, supernatural creatures from Japanese folklore

Yokohama Noh Theatre Directors' Prize (Yokohama Nohgaku Kanchō–shō), awarded to Kitazawa Hideta

Yorimasa, dedicated mask of the warrior poet Yorimasa, also the name of a second-category noh

Yōrō (Nourishing the Aged), first-category god noh by Zeami

Yoshiya Miyoko (1965–), textile artist, Kitazawa Hideta's wife

yowagin (or *wagin*), melodic chant style in noh

yūgao (evening face), name of a flower

Yūgao, court lady from *The Tale of Genji*, also the name of third-category noh

Yuki (snow), this mask by Tatsuemon is in the collection of the Kongō school and is the most copied *ko-omote* mask

Yumi Yawata (The Bow of Yawata), first-category god noh by Zeami

yūrei, ghosts

Z

Zao Gongen, a deity in mountain ascetic religious practices, the fierce god in *Arashiyama* and *Kuzu*

Zeami Motokiyo (1363–1443), son of Kan'ami, most celebrated performer-playwright-aesthetician of noh, famous for his writings and his plays

Zegai (The Goblin Zegai), fifth-category goblin noh by Takeda Sadamori (1421–1508)

Zō, also known as *zō-onna*, a more mature and refined mask than the young women masks, named after the 14th-century actor Zōami

Zōami, 14th-century *dengaku* actor, after whom the *zō* mask is said to be named

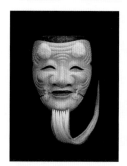

白式尉 Hakushiki-jō
38, 40–41

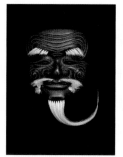

黒式尉 Kokushiki-jō
39–40

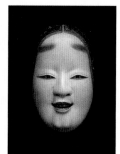

小面 Ko-omote
44–47

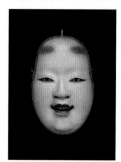

満媚 Manbi
48–49

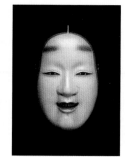

孫次郎 Magojirō
50–51

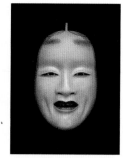

深井 Fukai
52–53

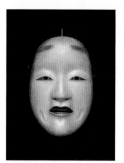

曲見 Shakumi
54–57

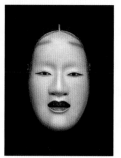

増 Zō
6, 58–59
Back cover

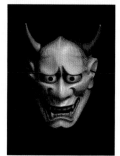

般若 Hannya
60–61

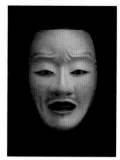

邯鄲男 Kantan-otoko
64–67

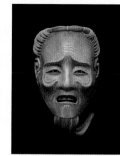

小尉 Kojō
68–69

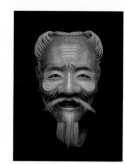

三光尉 Sankō-jō
70–71

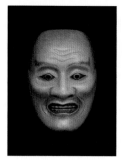

頼政 Yorimasa
72–75

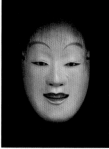

童子 Dōji
76–77

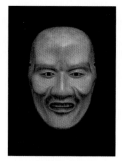

俊寛 Shunkan
78–81

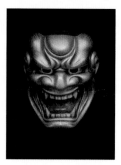

獅子口 Shishiguchi
84–85

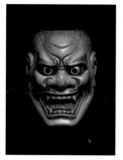

小獅子 Kojishi
86–89

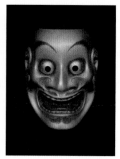

大飛出 Otobide
90–91

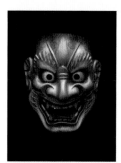

雷電 Raiden
92–93

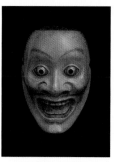

小飛出 Kotobide
94–97

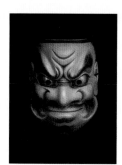

大癋見 Obeshimi
98–99

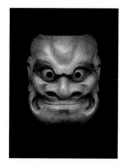

長霊癋見 Chōrei-beshimi
100–101

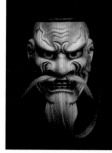

大悪尉 Oakujō
102–105

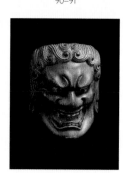

不動 Fudō
106–107

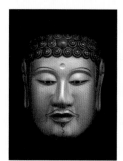

釈迦 Shaka
108–111

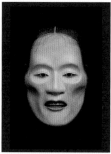

梅琳 Meilin
Yase-onna 5, 114–115

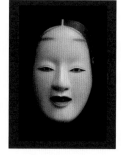

母性 Mother Spirit
Zō Cover, 2, 11, 116–117

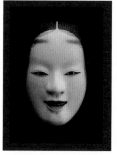

娘性 Daughter Spirit
Waka-onna 118–119

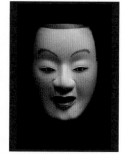

郢男 Bai Li
Waka-otoko 2, 120–123

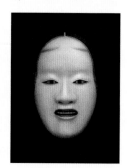

静波 Silent Waves
Deigan 124–127

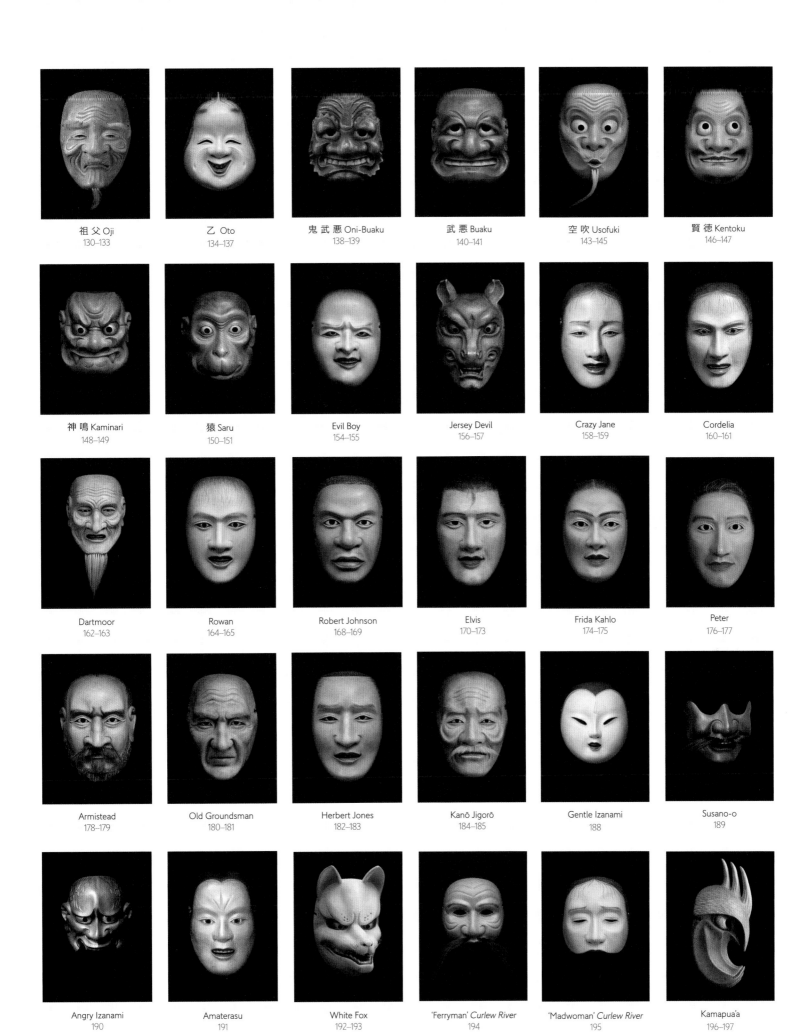

祖 父 Oji
130–133

乙 Oto
134–137

鬼 武 悪 Oni-Buaku
138–139

武 悪 Buaku
140–141

空 吹 Usofuki
143–145

賢 徳 Kentoku
146–147

神 鳴 Kaminari
148–149

猿 Saru
150–151

Evil Boy
154–155

Jersey Devil
156–157

Crazy Jane
158–159

Cordelia
160–161

Dartmoor
162–163

Rowan
164–165

Robert Johnson
168–169

Elvis
170–173

Frida Kahlo
174–175

Peter
176–177

Armistead
178–179

Old Groundsman
180–181

Herbert Jones
182–183

Kanō Jigorō
184–185

Gentle Izanami
188

Susano-o
189

Angry Izanami
190

Amaterasu
191

White Fox
192–193

'Ferryman' Curlew River
194

'Madwoman' Curlew River
195

Kamapua'a
196–197

About the Authors

Jannette Cheong is a poet, playwright, designer and Theatre Nohgaku-affiliated artist. London born, she has been involved with education and artistic collaborations internationally for almost 40 years. She is the author of the English noh *Pagoda*, the first English noh using traditional noh techniques written by a British person, toured by the Oshima Noh Theatre/Theatre Nohgaku (Europe 2009, Asia 2011). Her ballet-noh-opera collaborative piece, *Opposites-InVerse*, was performed for Matsui Akira's tribute programme: *Noh Time Like the Present*, London (2017). Her English noh *Between the Stones* (Europe, 2020) was again toured by Oshima Noh Theatre/ Theatre Nohgaku.

Richard Emmert is professor emeritus at Musashino University, Tokyo, where he taught classical noh and Japanese and Asian traditional performing arts. Born in Ohio (USA), he is a certified Kita school noh instructor and led noh performance workshops worldwide. Founder of Theatre Nohgaku, he has composed noh music for numerous English noh productions for which he was awarded the Koizumi Prize for 2019. He recently composed music for a French noh and arranged music for a Spanish noh. He co-authored a series of seven noh performance guides and authored the six-volume *The Guide to Noh of the National Noh Theatre*, both for Tokyo's National Noh Theatre.

Naming Conventions

Japanese personal names are written in the Japanese order, with family name first. Macrons in Japanese words, such as Dōjōji or ōtobide, indicate long vowel sounds. These have been omitted from capital letters such as the family name Oshima, common place names such as Tokyo and Kyoto, and Japanese terms now accepted into English such as noh and kyogen. Japanese terms such as the names of masks as well as the names of plays are italicised. Japanese terms common in English such as noh and kyogen are not. In general, the Hepburn system of romanisation is followed with a few exceptions: Komparu instead of Konparu, given that the Komparu school represents its name in this way; and Kitazawa Sohta instead of Sōta as he professionally writes his name in this manner.

Some Japanese masks have easily translatable names which we have given. Others do not, and the reason is evident in the description.

Most noh and kyogen plays have short names. Those which are place names are not translated and the reason is evident in the description. Others are translated under the heading, although the Japanese name is used in the description. Some are partially translated, such as *Sumida River* for *Sumidagawa*.

Images and Other Credits

We would like to acknowledge the support and kind contributions from all of the photographers.

Abiko: 213
Clive Barda/ArenaPal: 5, 10–11, 26, 65, 116, 124–125
Jannette Cheong: 210
Paul Laikin: 206–207
Kuwada Naomi: 46, 72–73, 94–95, 103
Lee Nutter: 166–167
Kitazawa Sohta: Cover, back cover and all mask photographs unless otherwise credited, plus 2–3, 6, 18–19, 22, 24–25, 28–29, 30–33, 120–121, 130–131, 134–135, 139, 142–143, 202–205, 206, 208–209
David Surtasky: 54, 155, 156–157, 159, 169, 170–171, 178, 194
Shutterstock/Onemu: 200
Ikegami Yasuharu: 78, 86–87

Noh Summaries: Based on entries in *The Guide to Noh of the National Noh Theatre* Books 1–6 (2012–2017). Published by National Noh Theatre, Tokyo. Copyright Richard Emmert, Japan Arts Council.

Illustration references pages 14–16: Courtesy of The British Library: Or. 17019; ORB. 40/1068; ORB. 40/1069.

Typefaces: London Kono designed by Eiichi Kono (originally produced for Center for Contemporary Art, CCA Kitakyushu).
明瞭 Meiryo designed by Eiichi Kono, Matthew Carter and C&G/Arphic for Microsoft Windows ClearType Library.

Acknowledgements

We wish to acknowledge the important role of the late Minister Iida Shinichi of the Embassy of Japan, London, for his support and encouragement from the beginning of the *Between the Stones* project which led to this book.

Our special thanks also to actor/writer/director, Simon Callow; Hamish Todd of The British Library; Oshima Yasuko of the Oshima Noh Theatre; Kano Ryōichi, Matsui Akira, Oshima Kinue, Oshima Masanobu and Oshima Teruhisa of the Kita School of Noh; David Crandall, Elizabeth Dowd, Jubilith Moore, John Oglevee, Ashley Thorpe and Kevin Salfen of Theatre Nohgaku; Professor Emeritus Nishino Haruo and Yamanaka Reiko of Hosei University, Tokyo; Julie Iezzi of the University of Hawai'i; Allan Marett of Sydney University; Andrew McLlenan and Julia Nicholson of The Pitt Rivers Museum, Oxford; Craig Barclay, Oriental Museum, Durham; Melanie Eastburn, Art Gallery, New South Wales, Australia; Antonio Zuñiga Chaparro, Academic Director, General Directorate of the National Centre for the Arts, Mexico City, Mexico; Mitsubishi Corporation, London Branch; The Great Britain Sasakawa Foundation; Mike Hou of The International Wood Culture Society; Mike Markiewicz of ArenaPal; Andrew Hansen, and Rochelle Roberts of Prestel; Margaret Coldiron, Brian Donnelly, Kano Isao, Kitazawa Ikkyō, Paul Laikin, Graham Marchant, Julie Rogers, Nick Sanders, Takada Akihiko, Takizawa Narumi and the many supporters of this book for their vision, encouragement and kindness.

© 2024 Prestel Verlag, Munich·London·New York.
A member of Penguin-Random House Verlagsgruppe GmbH
Neumarkter Strasse 28 – 81673 Munich
© Jannette Cheong and Richard Emmert (texts), 2024
© For images see image credits throughout

Cover: Spirit Mother (*Zō*) mask, see pages 118–119
Back cover: Reverse of *Zō* mask
Photos: Kitazawa Sohta

Library of Congress Control Number is available; a CIP catalogue
record for this book is available from the British Library.

Editorial Direction: Rochelle Roberts
Copyediting: Martha Jay
Design: Jannette Cheong
Production management: Corinna Pickart
Separations: Schnieber Graphik, Putzbrunn
Printing and binding: TBB, a.s.

MIX
Paper | Supporting
responsible forestry
FSC® C022120

Penguin Random House Verlagsgruppe FSC® N001967

Printed in Slovakia

ISBN 978-3-7913-7753-7

www.prestel.com